**TAI**

After war service as a tank gunner and commander in North West Europe and Palestine, Ken Tout worked with the Salvation Army, Oxfam and other agencies, visiting more than 50 countries and living overseas for 17 years. Later he became a writer and publicist, serving as Press Officer of both Oxfam and Help the Aged. He travels widely in Latin America and the Caribbean, setting up and advising on welfare programmes for the aged and is a delegate to international conferences on ageing.

His experiences range from membership of the Archbishop of Cape Town's watchdog committee on race relations to hitching a lift with one of Che Guevara's guerillas in the Amazon jungle. He has conducted choirs and massed bands, written and produced musical plays and pageants, performed on the bass trombone, and organized earthquake relief.

In 1984 he organized the first return of his regiment to the Normandy battlefields, where farmers still plough up Yeomanry shells. The lasting effects of war on the landscape and on the human spirit are the reasons behind this book.

# TANK!

## KEN TOUT

ROBERT HALE · LONDON

© *Ken Tout 1985*
*First published in Great Britain 1985*
*First paperback edition 1994*

ISBN 0 7090 5583 8

Robert Hale Limited
Clerkenwell House
Clerkenwell Green
London EC1R 0HT

1  3  5  7  9  10  8  6  4  2

Printed and bound in Malta by Interprint Limited

# Contents

## MAPS

In memory of Lieutenants Bobby McColl and Vaughan Green, SSM Turton, Sergeant Valentine, Corporals Hickson, McGranahan and Stanley, Lance-Corporal Madelaine, Troopers Wellbelove and Tyler, and so many others of 1 and 2NY who did not return from Normandy in 1944.

. . . and with apologies to Ken Snowdon, Rex Jackson, Harry Graham, Jack Aris, Don Pateman and others who may think they notice parts of themselves intruding into the imagined characters of this story.

# Foreword

By Brigadier Bryan Watkins, MBE

I would have liked to have had Ken Tout in my troop – courageous, competent and compassionate, with that sense of humour and of the ridiculous that has for so long stood the British soldier in marvellous stead in battle, particularly when the going has been tough and death seems to lurk just round the next bend in the track or in the shape of an SP gun behind that ruined cottage. Indeed, I would have loved to have had his whole crew – and, in effect, I did. For in this book he has most brilliantly portrayed the story of a tank of C Squadron, 1st Northants Yeomanry in forty hours of really hard fighting during General Guy Simonds' Operation TOTALIZE in which the 2nd Canadian Corps, with 51st Highland Division and 33rd Armoured Brigade under command, advanced by night through the strongly held German positions south of CAEN in Normandy on the 7/8 August 1944.

It was some battle. But the story of Roger 3 Baker could well be that of any one of a thousand British crews in that Normandy fighting and after. In Corporal Keith McAlpine, Lance Corporal 'Bookie' Hooker, Troopers Harvey Oxford and Stan Barber and in Ken Tout himself, you can recognize countless soldiers with whom it has been a delight and a privilege to serve and to count amongst one's friends.

At the time of the battle, Tout was only twenty but had clearly already shown that he was something of a natural leader. Later when a commander was injured by the recoil of the 75mm gun, Tout took over command of the tank and fought it through the rest of the battle, with conspicuous courage and success – although Tout himself would be the last to make that claim.

There have been some splendid books written by tank soldiers but, to my knowledge, there has never been one quite like this. Ken Tout tells us just what went on in his young and highly intelligent mind, and in the bantering conversation between the crew members, throughout the whole forty hours. Much of what

he has written is pure poetry and reflects, in a most remarkable way, the kaleidoscopic torrent of thought which goes through the tank crewman's mind in battle, much well below the normal level of consciousness. If you too have been in such a situation, every line of this book will ring a bell. If not, it will tell you much. Not only has he drawn a unique pen picture of the relationships which existed between him and the other members of the crew but he has given us a portrait of a first class Yeomanry regiment, hardened by several years of war and reflecting a blend of comradeship and military efficiency which was and is typical of all the best armoured regiments.

In his preface, Tout tells us that whilst the personalities and events represented are, in the main, an amalgam of real men and actual events, the more senior officers of the regiment are described by their own names – one, indeed, is now a Peer and Chairman of a major Bank – and a fine lot of officers they were. After a life-time spent in the service of others – the Salvation Army, Oxfam, Help the Aged, in many parts of the world, the author mounted a return to Normandy for the Old Comrades of 1 NY in 1984. Over sixty were back in the little village of St-Aignan-de-Cramesnil in 1984, to awaken old memories and honour their fallen friends. This magnificent and deeply moving story will mean much not only to those Old Comrades and their families but to all who have pride in the spirit and traditions of the British soldier. Although a writer and publicist by trade, this is his first book – let's hope it is by no means the last.

B. W.

# Preface

In 1984 a party of nearly seventy former Yeomen and wives toured the 1944 route and battlefields of the old 1NY. I had organized the tour which was based on St-Aignan-de-Cramesnil, that little village whose 340 inhabitants had kindly found room to billet more than fifty members of our party. Amid rapturous welcomes and luxurious banquets laid on in several villages liberated by the 1NY, three points impressed themselves on my memory.

Firstly, the events of 7/8 August 1944 had remained totally unrecorded on the actual battlefield, just as they have remained largely uncelebrated in the pages of war histories (whose writers so often seem to account a British defeat more interesting than a victory). We rectified this omission locally by planting in St-Aignan a tree from Northamptonshire as a symbol of friendship and peace. Secondly, the events of 1944 are indelibly engraved on the minds of local people. A representative youth speaker declared, 'If you men had not come to St-Aignan and triumphed that day, we the children would never have enjoyed the liberty and happiness in which we now grow up.' Thirdly, the scorch marks of burned-out tanks still remain in the crops. Numbers of our hosts had seen the wrecked British and German vehicles still *in situ* in 1944. There is no doubt in their minds that the greatest German tank ace of the war, Captain Wittman, was actually killed in one of the Tigers eliminated by Tom Boardman's little hunting party.

In 1944, as a kind of mobile jack-of-all-trades, I served in C Squadron, 1NY, as gunner or commander in several different tank crews. It would obviously be impossible now to write with total accuracy of the personnel of any one of those crews. I have therefore written about an amalgam, an *imaginary* but still very typical crew. But certain senior figures in this story cannot be fictionalized. What they did was unique. I have therefore adopted a rather unusual system as follows: the Colonel, Majors, Captains and Sergeant-Majors all parade undisguised under their real names. I too am real! Lieutenants, Sergeants, Corporals and unadorned Yeomen appear under

assumed names, sharing between them personal attributes and military deeds which were factual.

The general history and geography of the Night March and St-Aignan battle are accurate, but I have tried to perpetuate the somewhat blinkered and simplistic viewpoint of a twenty-year-old at the Front, untainted by critical hindsight. And having operated as both a turret crew member and a commander, I felt this story needed to be told from those two very different points of view. I have therefore advanced by two days my own promotion, which took place in the famous gully. In the month following St-Aignan I *did* take command not of one but of two tanks in the manner described, through accidents in battle. The incident of identifying the dead also took place a little later, as did that of the singing prisoner. Strange things happened in battle.

Tom Boardman MC became a government minister and was elevated to the House of Lords. David Bevan MC never returned to the Stock Exchange but became an artist, sculptor and latterly landscape gardener. Bill Fox MC died just before our 'Return to Normandy' in 1984 but had attended the dinners of the Regimental Association which was kept alive after the war mainly by the enthusiasm and unstinting service of a remarkable man. He was the lad gunner of World War I, the RSM of World War II, now octogenarian, George Jelley MBE, whose voice still commands instant respect and obedience, even when simply proposing a loyal toast.

Those who died during the St-Aignan battle are buried in the war cemetery at Banneville-la-Campagne, one of the most beautiful of such places. The white, or silver, horse of Hanover still runs lightly across their headstones.

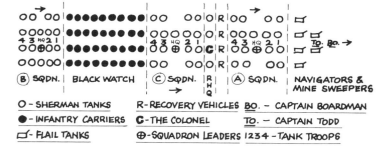

O – SHERMAN TANKS     R – RECOVERY VEHICLES     BO. – CAPTAIN BOARDMAN

● – INFANTRY CARRIERS     C – THE COLONEL     TO. – CAPTAIN TODD

◻ – FLAIL TANKS     ⊕ – SQUADRON LEADERS    1234 – TANK TROOPS

**N.B.** IN THE ACTUAL MARCH THERE WOULD HAVE BEEN MORE RECOVERY AND OTHER MISCELLANEOUS VEHICLES AS ALSO MANY MORE BLACK WATCH PERSONNEL CARRIERS, WITH A TOTAL OF ABOUT 200 VEHICLES IN ALL ON THE MARCH.

Map 1: Night March Formation

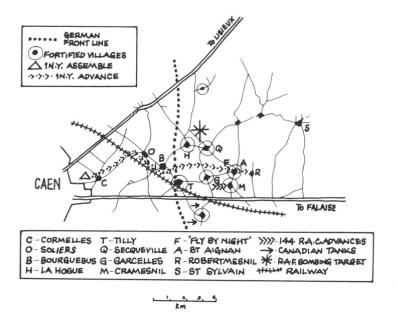

| | | | |
|---|---|---|---|
| C – CORMELLES | T – TILLY | F – 'FLY BY NIGHT' | ≫≫ – 144 R.A.C. ADVANCES |
| O – SOLIERS | Q – SECQUEVILLE | A – ST AIGNAN | → – CANADIAN TANKS |
| B – BOURGUEBUS | G – GARCELLES | R – ROBERTMESNIL | ✳ – R.A.F. BOMBING TARGET |
| H – LA HOGUE | M – CRAMESNIL | S – ST SYLVAIN | ┼┼┼┼┼ RAILWAY |

Map 2: Night March, 7/8 August 1944

# *Prologue:*
# The Tank at Night

We travel through a night within a night within a night.

The outermost night belongs to 7 August 1944. The brief, warm summer darkness descending gently over the Normandy fields will last from about 22.45 hours on 7 August to about 03.45 hours on 8 August. This darkness will cover an action termed 'a turning point of the war' – only one of a hundred such 'turning points' but each one vital enough to cause a major change of fortunes for the contesting armies.

But, within the calendar night, another more gruesome darkness is being created – darkness of smoke and dust, permeated by the smell of hot oil and death, intensified by a noise as of a thousand thunders. Machines, invented by human beings, roll through this double darkness, casting up clouds of nauseating filth. Each tank creates its own night within the night, tracks milling the earth to fine dust at the front and throwing up the dust as dense clouds behind. And the entire column rumbles on in a series of insulated, self-perpetuating palls of confused darkness.

The incredible din obliterates every human sound and reduces logical thought to imbecilic imaginings. And so within the double darkness we ourselves retreat into an ever deeper darkness. For this is world's end, the final precipice of chance. Ahead, along the crest of the unseen hill, Death lies ready to leap on us, on the chosen ones among us. So each of us digs a little dug-out among the rubbish of our adolescent beliefs and ambitions. And burrows for comfort into the most secret places of the soul's darkness to avoid the outer realities.

We have reason to be fearful. We are packed inside a tank as inside a dark, tight, odorous, moving sewer. In a moment our mobile home can be transformed into a self-igniting crematorium . . . a self-sealing mausoleum . . . or a self-detonating bomb, its own walls shattering into lethal shards of sharp steel projected in wild ricochets, back and forth through the confined space. At best it is simply a cramped, bruising caravan, alternating between arctic cold and equatorial heat.

But, most of the time, nothing happens. The truest literary representation of a typical hour of war might well be fifty pages

left completely blank, which the reader is compelled to read through at the same speed as if they were printed pages. During that time nothing happens. Nothing at all except noise and dirt and smoke and confusion.

The crewman experiences a tank engagement at four distinct levels. The first level concerns the small, close family of five within the vehicle. All-pervading noise of engines and explosions makes it impossible to speak to each other even whilst physically close enough to touch. Conversation must take place through a special channel (referred to as I/C, short for inter-com) of the tank's wireless set, utilizing microphones and headsets.

The second level of experience also filters through the headphones. It comes through the external radio network by which tank communicates with tank, and troop with squadron and regiment. The network is audible to each member of the crew, and the continuous emissions paint their own picture of the battle, either through brief messages, sometimes disciplined, sometimes frantic, or through an ominous, crackling silence.

Shut up in his tiny niche within armoured steel, during the intolerable silences, the individual crewman lapses into a third level, inhabiting his own private haven of imaginings and reminiscences. The mind seeks to escape from its claustrophobic confinement and its subjection to horrific noise levels, tortures beyond the concept of any medieval sadist.

The crewman's introspection is interrupted at intervals by the fourth experiential level, that of sight and touch. As he peers through a periscope, his vision is both restricted and intensified, narrowed down to a small field in which any visible object acquires inordinate importance. At any moment a new, apparently insignificant smudge or blur upon the landscape may prove to be a killer factor. Rarely does it materialize in the clear form of an enemy tank or gun. The sense of hearing is rendered useless by the continuous noise in and about the tank. So the eye has to be quick, both to perceive and to translate the intruder element within its vision. The sense of touch adapts itself to a constant sensation of discomfort and petty pain. But this at any moment may erupt into a violent impact and agony. In which case it is already too late . . .

# ACT I

*Tank!*

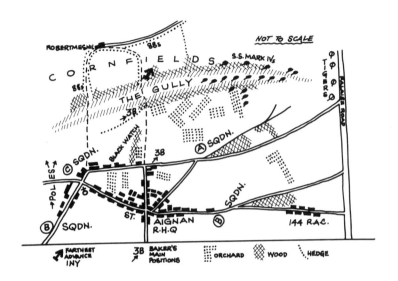

Map 3: St-Aignan, 8 August 1944

# Preparations

**4 AUGUST 1944:**
We were by now quite used to driving in columns of tanks from one point of the bridgehead to another. An independent armoured brigade, such as ours, was something like a fire brigade, liable to be sent off to any sudden point of emergency. But now the order was given to line up all our tanks of C Squadron, 1st Northamptonshire Yeomanry, in fours like an old-time infantry marching formation. Then another order was given to advance, slowly but in the same formation. This was strange, for normally on roads there was only room for tanks to advance in Indian file, one after the other. And when advancing to attack across country, the practice was to move in well-spaced, irregular groups, thus presenting less easy targets, constantly changing shape, for the enemy anti-tank gunners.

'Blimey! Square-bashing in tanks!' commented Stan Barber, our wireless operator from London, chatting on the I/C channel. 'They must have brought a load of bull over on the last lot of landing ships and now they're spreading it out, around the happy troops.'

'Yes, next they'll have us polishing the outside of our turret until it shines, just so that Jerry can see it more clearly,' cut in Driver Harvey Oxford, unseen down in his separate compartment.

'It's a plot,' said Lance-Corporal Hooker who, as co-driver, shared the forward compartment with Harvey. 'They're forming us up close-like because Jerry has complained that it's too hard to hit us when we're in open formation. Half the Generals, English and German, went to school together.'

I had been surveying the surprising scene from my gunner's periscope. 'What's the bright idea, Keith?' I asked the commander, tapping his knee which was jammed into my back. Corporal McAlpine squinted down inside the tank from his commander's perch and gave me a puzzled shake of the head. He pressed the switch of his microphone and informed us all, 'Great Secret! No battle orders. Just a simple instruction: keep station on the tank in front . . . Driver, left a bit.'

Like armoured troops commanded by some latter-day Grand

Old Duke of York, we drove-marched up to the top of the long
hill and drove-marched back again. Always in fours. Always
slowly. Always ten yards between the tanks front to rear.
Always fifteen yards between the tanks left to right.

'Hello, William 2. Hello, William 2. Who's that bloody man of
yours lagging behind? Tell him he's driving a tank not a deck-
chair. Over.'

'William 2, OK. Hello William 2 Baker. You heard! Keep level.
Over.'

'William 2 Baker. Engine trouble. Doing our best. Over.'

'2 Baker. You ought to be able to keep up at this speed. Do it!
Off.'

That Friday night, as we were wearily preparing to bed down,
they called us out again. 'Crews mount!' 'Tanks in formation of
fours.' Then 'Move off . . . rear lights only now . . . keep
station.' Comments are inevitable . . . and possible. When our
microphones are switched to I/C, we hear external news, but our
speech cannot be heard beyond the tank.

So Stan Barber, operator, growls, 'This beats the band. I've
done some parade-ground bashing in my time, but never in a
tank, and never, repeat NEVER, by moonlight.'

Harvey Oxford, driver, moans, 'They think they're a lot of
bloody admirals since we waded ashore in eighteen inches of
water. Keep station, 1st Northamptonshire Sea Squadron!'

Jim Hooker, co-driver, snorts, 'I'll lay you two to one against,
the King is coming over and we are going to do a march
past.'

And Stan Barber again, 'Or else Monty is starting his keep-fit
stunts over here, and this is his idea of cross-country running for
tank crews – sitting down! At the double, knees bend!'

**5 AUGUST 1944:**
They let us sleep in after our night exercise. They let us cook
breakfast and refuel tanks. Then it was 'Tanks form fours' again.
In the afternoon they told us to sleep as we would not have much
sleep at night. As it got dark, we formed once again into ranks
with fifteen yards one way and ten the other. 'All Stations
William, Drivers advance.' Up the hill. Down the hill. Across the
hill. Advance. Halt. Advance. Slow down. Speed up. Wireless
silence. Keep Stations. 'Hello, William 3. What the hell is your
Charlie tank doing waggling his great trunk ten yards out of
line? Over.' Until at last God sent the lovely daylight to end this
madman's pastime of tanks mimicking the Trooping of the

Colours at midnight on a desolate hillside somewhere in the Normandy beachhead.

'God, I'm tired,' said Corporal McAlpine, dropping into a squatting position behind my seat inside the turret as we finally halted and switched off.

'Did your mother ever tell you Father was a black man?' grinned Stan Barber from his corner beyond the big gun.

'What?'

'Your face,' I explained, 'it's black with dust.'

'Clouds and clouds of dust,' complained Keith McAlpine. 'Everywhere you look. Dust and more dust. I don't know how they expect us to keep station on a single tail light.'

Harvey Oxford's face appeared, somewhere round about the level of Stan Barber's boots. By swivelling around in his downstairs seat and leaning over backwards, the driver can look up through the steel fretwork cage which constitutes the lower part of the tank turret. His head is then on a level with the floor of our turret. With the breach of the 75mm gun immensely filling the centre of the turret, I contemplated the extraordinary monster – apparently a huge square steel body with a human head superimposed and another human head looking out underneath, side by side with two feet!

'Don't worry about the tiny red tail light, Corp,' spoke the lower head. 'You can trust me to steer for the dimmest red light in France at maximum range. As long as I can hope it is hanging over the bed of a nice fat French wench with . . .'

'All right! All right! All right!' snapped Keith, who is a bit of a prude. 'Shut up all of you! Dismount! Petrol up! Food up! Clean up! And then kip!'

**6 AUGUST 1944:**

They let us sleep until 9 a.m. – not because it was Sunday, which it was, but because we had been advancing in columns of four until dawn. After breakfast there was a brief conference for tank commanders with the Squadron Leader and Troop Leaders. Soon Keith McAlpine returned carrying a new map, conspicuously marked with red lines and arrows.

'Start in half an hour. We follow 2 Troop. Cross the River Orne, past the Colombelles factory – what we left of it – and concentrate at a place called Cormelles, just beyond Caen. And believe it or not, we are joining the Canadian Army.'

'What? Flipping Mounties! Baseball fanatics! Don't believe it!' we replied in chorus.

'You'll see, my boys, you'll see. Come on, then! Pack up, mount when you are ready and start up!'

An active man might walk from Gazelle to Cormelles in about two hours. In our 30 m.p.h. Sherman tanks it took us twice that time, forming up, trundling along slowly in column, queueing to cross the Bailey bridge, trundling on again, queueing at crossroads, moving slowly across exposed ground to reduce dust and to avoid enemy artillery attention around Demouville – Demouville, a name already ominous for us who had spent a week there, dug in and easy prey to the local mosquitoes, which were more pestilential than the German 88s.

The scene at Cormelles-le-Royal was like a circus assembling. Hundreds of grey armoured vehicles stood parked or were manœuvring slowly around in a wide, hollow plain where the slopes beyond Caen levelled out at the outskirts of the city. A bulge in the last section of the slopes made this parking place invisible to the German gunners on the crest of the slopes above. Therefore it was fairly safe.

As we drove in to join the mass of vehicles, the tall, slim figure of Major David Bevan, our Squadron Leader, appeared on the road, waving us towards a bare stretch of grass outside a large factory. Our Troop Leader, Mr Macgregor (2nd Lieutenant in rank), hopped down from his moving tank, trotted over to the Squadron Leader and saluted smartly. 'Hank' Bevan touched his cap with his riding crop and spoke over his shoulder to Hughie Macgregor, whilst still vigorously directing traffic – a task normally reserved for lower ranks.

By the time we had parked the four tanks of the troop in a neat row, Hughie Macgregor had joined us.

'Any news, sir? What's going on? Have we joined Barnum and Bailey's circus, sir?'

'Aye, ye might well ask, for ye're highly honoured,' grinned the tough little Highlander. 'We are joining the 51st Highland Division as a part of the Canadian Army, and Captain Boardman is out on a recce to choose a route for an attack. That's all ye'll know until tomorrow. Commanders to Squadron Leader's Conference, please.'

Strange information indeed. A Northamptonshire Territorial regiment, comprising lads from all over Britain, was to supply tank support for the Highlanders as a reinforcement for the Canadians. But there was no information yet as to when we would attack and in what strength. It was not the custom for the Generals to trouble about briefing mere Troopers until a

few hours before action. There was a gathering of the clan at Cormelles. Highland regiments were marching in, each with at least one piper working on full bellows. Meanwhile, apart from keeping an eye open for the return from his explorations of Captain Tom Boardman, there was little to do beyond catching up on some sleep. After some rough storms in June and heavy rains in July, Normandy was welcoming us with holiday sun in early August. We rolled out our blankets on the lush grass, took off our boots and shoes and lay down to sleep, or merely day-dream on an afternoon when even the most malicious of German gunners must have been sun-bathing . . . or fighting mosquitoes.

A sabbath silence reigned. Yes, of course, it was Sunday. Just like lying in the garden at home. Except that the smell was different. The reek of hot oil dripping on hot steel, and the ever-present stench of corrupting flesh.

I looked around the sleeping crew of the Troop Corporal's tank of 3 Troop, C Squadron, 1NY. In 1939, on the outbreak of war, the Yeomanry Regiments (Territorial Army cavalry) were mobilized and equipped with armoured vehicles. As the war went on, some Yeomen were drafted to regiments fighting in the Middle East, and they were replaced by younger reinforcements coming from the new training regiments. Our present crew was a mixture of those elements, a microcosm of armoured regiments everywhere.

Tank Commander and Troop Corporal was Corporal Keith McAlpine 699 (it was custom to identify soldiers as much by the last three numbers of their seven or eight digit regimental number as by their initials), aged thirty-two, religion OD (Presbyterian). An original Yeoman who had joined at the outbreak of war in 1939. A teacher in civilian life, born in Edinburgh, he had married a Northampton girl and lived in Buckingham. Average height, very dark hair, large moustache and bushy eyebrows, he had a slight stoop and conspicuously failed to look like a soldier. Even in uniform he had the attitude and stance of a teacher or professor. Pipe-smoker and teetotaller. Quietly and precisely spoken, slow to laugh, kindly but straight-laced and perhaps rather a puritan.

Driver: Trooper Harvey Oxford 717, aged twenty-five, religion C of E. Joined the infantry in 1940 and transferred to the Yeomanry to join his brother in 1942. An unmarried electrician from Birmingham. Played for Squadron football team. Excellent mechanic, the handyman of the crew. Inclined to indulge in

pornography and dirty jokes. Heavy drinker, eater and smoker, but not known to go with women in spite of frequent boasting. Short and tubby.

Co-driver: Lance-Corporal Jim Hooker, 006, known as 'Hookie' or, more frequently, because of his betting activities, 'Bookie', aged thirty-four, religion C of E. Joined the Yeomanry in 1934 and has served throughout the war. Farm labourer from Brackley, the heart of C Squadron country. Married with four children. Had been given a Lance-Corporal's stripe when the regiment was equipped as a reconnaissance unit, for he was an excellent driver of a bren-gun carrier. Has never been able to cope with a thirty-ton Sherman. Favourite joke: 'You know Joe Loss? I'm his brother, Dead Loss.' Retained as co-driver but main claim to fame is that he will make bets on anything. Made a 'book' on the location of the D-Day beaches and won the raffle himself with a ticket for a place which he had written down as Arromanchesters. When it was pointed out that the name should be Arromanches, he said, 'I don't believe it. Nobody could be so stupid as to give a place a name like that.' Tanned but gaunt, with greying hair, yellow teeth, tall, thin.

Wireless operator: Trooper Stan Barber 803, aged twenty-one, religion RC. Called up with his age group in early 1942. Had just left school (Christmas 1941). From Dulwich, London. Grammar school education. The knowing one of the crew. Quick-witted but inclined to lose interest in duties, and unreliable at times. Always ready for a lark or for a pub crawl, although enjoying the company rather than the drinking. Claims to be engaged to a local girl, daughter of a Brigadier-General, but shows no photo of her and does not receive letters from her. Average height, well built, red-faced and blond hair, almost albino.

These four had crossed over to Normandy on the tank which, like all the Squadron's tanks, bore a Northamptonshire name, in this case Stony Stratford, stencilled on the hull. The original commander having been wounded, Keith McAlpine had been given a second stripe and the command. Stan had taken Keith's place as operator. I had arrived from the Reserve Troop to reinforce the crew, surrendering the Lance-Corporal's stripe which I had held as commander of the Stuart light tank. 'Gunning' in a first-line Sherman was regarded as far superior to 'Commanding' in a reserve echelon.

So I was the last member of Stony Stratford's crew: gunner, Trooper Ken Tout, 14344147, aged twenty, religion SA. ('What's that stand for?' asked the Orderly Corporal at my Reception

Centre when I reported to the Gordon Barracks in Aberdeen to enlist. 'Salvation Army, Corporal,' I replied. 'Can't put that,' he argued. 'That's not a religion. That's a place where you go to get a cup of tea and a kip.' I persisted, 'It is a religion, Corporal, approved by a special Order of the Army Council.' The Corporal had stared at me long enough before grinning, 'I really thought you were bloody trying to be funny, Jock.') Educated at Hereford High School, I had left school in 1940 and worked for the interim in the County Health Department, administering – among other things – the thriving war-time VD clinic. Called up with my age group in November 1942, two months preliminary training in Aberdeen with the Gordon Highlanders and Cameronians, six months training as 'Driver Operator' (which was in fact a global course including driving, operating and gunnery) with the 60th Training Regiment RAC at Catterick Camp. Posted to the 1NY with the last and youngest batch of reinforcements in July 1943, a dozen or so pale schoolboys among a host of seasoned warriors. Reserve gunner and operator on the Squadron Leader's tank. Posted back to Reserve Troop to command a light tank for the crossing to the beaches. Now six feet tall, dark wavy hair, blue-green eyes, still somewhat pale and overgrown.

So there we were at Cormelles-le-Royal, sleeping in guileless innocence under a hot summer sun, whilst the Padre sang hymns with a few of the more faithful, or more fearful, C of E flock in a corner of the field (SA padres never appeared in my front-line vicinity) – for it was Sunday, was it not? And somewhere Tom Boardman reconnoitered sunken roads up the long slope leading to the invisible and invincible 88mm guns which had already widowed and orphaned a sad number of Northamptonshire stock.

**7 AUGUST 1944:**
Bank Holiday Monday, the traditional day of seaside and country picnics in Britain. Most of us still find a holiday element in this life, touring through quaint French villages, sleeping out in the verdant countryside and listening to the strange sounds when the guns are silent. In those idle moments there is much laughter and jollity, for many of us have only lately left school. Were it not for the war, some of us would still be in the sixth form or continuing at college, striving for nothing more arduous than a 1st XI cricket cap.

**08.00 hours:** Reveille. In the field we sleep around or under the tank. At Reveille the last shift of the night guard wanders round

the Squadron tanks, banging on echoing storage bins welded to
the armour plate, prodding sleeping bodies, shouting appropri-
ate insults to those who have been fortunate enough to get a full
night's sleep.

Today there is a session of breakfast hate from the enemy.
Amid the sustained roar of our own guns, ebbing and flowing,
there is a sudden crump-crump-crump sound. High, thick
splashes of dirt leap up among the tanks of A Squadron a couple
of hundred yards away. German shells. A Squadron dive for
cover. We continue dressing, cooking, eating. There is a tin of
bacon for breakfast, yielding a decent rasher each, fried in rancid
French butter and accompanied by a French egg each. The
French provisions have been obtained by bartering with local
peasants, paying with ration chocolate. A thick, hard, issue 'dog
biscuit' serves instead of bread. To drink we add boiling water,
stinking with chlorination, to a few teaspoonsful of Compo tea, a
mixture of tea leaves, powdered milk and grey sugar.

**09.00 hours:**   Squadron Leader David Bevan has been to see the
Brigadier with the Colonel and has now called a brief meeting
of Troop Leaders. We sit and watch the quiet group as Major
Bevan nonchalantly chats to them. A few sentences only. Mr
Macgregor turns away with the other Lieutenants and heads
back to us. 'Bookie' Hooker hazards his usual bet. 'Short Confer-
ence! Six to four on we don't do anything today.'

Hughie Macgregor stops by his own tank. His crew are sitting
on the side of the tank. He says a couple of sentences. They
cheer, wave, jump down and start rushing furiously around the
tank.

Stan Barber says quickly, 'I'll take you up on that bet, Bookie.
Five francs at six to four on, and I say we *do* make a move today.'

Hughie Macgregor is near enough to hear. He grins at Bookie.
'Well, how much did you lose on that bet, Corporal? We *do*
move, but not until late evening. Full briefing this afternoon.
Meantime fill up, check everything and be ready for action by
18.00 hours.'

Action? Action is still a great adventure, a thrilling experience
like going to a Cup Final or seeing the sea for the first time. We
have seen a few dead bodies, had some casualties, smelt the
smells of destruction and decay. But we have not yet been hurt
badly. One man, the former commander, has left this tank with
his skull smashed and his scalp bleeding. But it was all so
sudden and quick and unreal, like a painting at a Christie's'

auction, displayed momentarily, then quickly sold and whipped away to be replaced immediately by another.

There was no need for detailed commands from Corporal McAlpine at this point. We all knew our functions on the tank and set about them with minimal comment. Our thirty-four-ton Sherman M4 tank is a huge and complicated machine. Twenty feet seven inches long – as long as the house I used to live in; eight feet nine inches wide – as wide as the street I used to live in; and nine feet high – as high as I was when leaning out of my bedroom window at home. The Sherman is equipped with a 500-b.h.p. engine, big enough to power a small plane up into the sky. It carries a 75mm gun so heavy that all five of us together cannot lift its barrel. There are also two Browning .300 machine-guns, a four-channel wireless set and large stocks of ammunition of various types and sizes.

Keith and Bookie climb onto the flat back of the Sherman behind the domed turret and help Harvey to lift up the large armoured flaps covering the engine. Then, whilst Harvey peers down into the huge engine compartment and begins checking oil and fluid levels, Keith and Bookie vault down to the grass and start examining tracks and wheels.

Tank tracks have a peculiar habit of spooling up anything which is lying loose on the ground. On one occasion we spooled up a mile of telephone wire from the side of the road before anyone noticed.

'Hey, fancy Montgomery calling his generals. "Hello! Hello! Hell-O! Hell-bloody-ho,"' laughed Stan Barber at the time. 'And nobody replies. And so he sends out the entire 150th Regiment of Signals to find the break. Meantime Jerry launches a counter-attack and breaks through to the beaches.'

'Yeah, and when they find the break in the cable,' added Bookie, 'Monty says "What buggers were daft enough to do that?" and Eisenhower says, "It could only be those stupid farmers' sons from Northamptonshire."'

'Well, let's get this crazy cable unwound and dumped in the ditch before the court martial convenes,' Keith had grunted, plucking at a few thousand feet of coiled wire.

So it is necessary to check the two tracks thoroughly to ensure that no retarding tangles have been picked up. Each track consists of many flat links, each large and heavy enough to trouble an individual needing to lift one. For ordinary road travel the links have solid rubber treads, but for battle service the steel cross-country tread is used. Spare links are fixed along the

sloping front of the tank to afford extra protection against armour-piercing shot. The track links are held together by large steel rivets. Links can be replaced by slackening the track and knocking out the retaining rivets.

'Shall I help you clean the 75 before anything else?' Stan asked me. The 75 gun is a good friend but a hard master. It needs endless cleaning, servicing, checking, pampering. To clean the barrel there is a stiff brush with an extremely long handle, like those used by old-time chimney-sweeps to clean narrow chimneys. Two of us together can summon up enough strength to force the tight-fitting brush up the seemingly endless barrel. Rifle grooves inside the barrel cause the brush to spin, making it doubly difficult to control. Once the barrel has been thoroughly scoured and polished from without, the breech can be tackled from within. The big gun's recoil mechanism and breech fill the centre of the tank turret. We crouch around the gun in confined space and wrestle with the breech block, a heavy, unco-operative lump of polished steel which, if carelessly handled, has been known to crunch fingers beyond repair. The loader, alias the wireless operator, is provided with a thick glove, to guard against burns from the hot brass of expended shell cases and also to protect fingers against the clashing menace of the breech block.

The next chore is the cleaning and checking of the smaller guns, the Browning .300 machine-guns – neat, squared, black, mass-produced but highly efficient American weapons. Whilst I extract and dismantle the turret Browning and then the other Browning from the co-driver's compartment, Stan gets busy on his wireless set, checking out all his spare valves to see that everything is in working order. Stan, Keith and I can all strip a Browning blindfolded, disconnecting it bit by bit down to its dozens of component parts, large and small. The Browning has a very strong spring to counteract its recoil when fired. It is a special art to be able to twist the highly compressed spring, take the massive pressure of it, twist it out of its socket and remove it from the gun. It only needs a finger's slip to turn the Browning into a vicious crossbow, discharging the spring at a range of inches to smash through the skin, muscle and bone. Tanks are hazardous places in which to live, even when the Germans 88s are not firing.

'Are you coming today, Stan? Southeby has butchered a cow and there's steak for everybody.' Southeby was a butcher in civilian life. Now he drives a tank in 2 Troop while a former Post

Office van-driver cuts up the meat in the camp cookhouse. Here in the field there is no cookhouse, and every tank cooks its own food.

'I hope the cow was dead before he butchered it. I don't want Southeby's bad butchering spoiling my cooking, like the last time he provided steak.'

'You need to hope the cow *wasn't* dead,' says Bookie. 'Any dead cow you find around here is likely to have been lying around for a week or two.' The fields of Normandy, green and fertile, have been tragic with dead and dying cattle and horses, caught in the cross-fire of battle. A familiar sight is a dead cow lying on its back with all four legs pointing rigidly towards the sky like a battery of anti-aircraft guns. Frequently the cow is bloated to twice its normal size. Sometimes only the skin is left where the scavengers have been busy. Sometimes only the white skeleton.

'I hate this stupid war when I see dead cows,' says farm labourer Bookie. 'I hate it even more when I see half-dead cows. Hey, come on up, Stan. Keith says you can start cooking and I can come in the turret and help.'

'Oh, no, you don't, Bookie. Not in my turret. We want it spotless clean and we want it working and we don't want you buggering it up. You stay down in your own little pig-sty in front.'

**12 midday:** As Stan and I haul ourselves up out of the turret, we suddenly have the feeling of a huge aeroplane crashing on top of us. There is a noise of indescribable violence, a lashing of eye-searing flame, a breath of angry, incinerating heat. At this moment every British gun has started firing. It seems that the entire Royal Artillery has lined up twenty yards behind our tank. The main barrage has commenced.

At our backs huge flames leap from the muzzle of every gun, increasing the summer midday heat to baking point. I have been working bare-chested in the sweating turret. Now I hastily pull my overall top around me to shut out the burning heat. Overhead each departing shell seems deadly close and sluggardly, like an aeroplane taking off with insufficient power, screaming and whining as it tears into its patch of sky. After some seconds the initial ferocity of thunder upon thunder slackens sufficiently for a shouting voice to be heard. Stan, as usual, speaks loudest and soonest.

'*"Donner und Blitzen!"* says Jerry. Don't stand up too straight

on the turret in this lot, lads. If there's one dud shell, we've had it, stuck here. Why in God's name do they always put us right in front of the guns and not behind them? Hey though, stick our steak on forks and stand a bit nearer that crowd, and the steak'll be grilled in no time.'

'So will you,' I shout, ducking back into the comparative quiet of the turret and pumping my eardrums with my middle fingers. My last task is to check the gun sights. Crawling under the gun and into the loader's perch, I exert all my eleven stone ten pound force on the breech lever and swing open the breech block. I can now peer up the brilliant, silver-blue steel barrel to the bright, cobalt-blue sky beyond. Oh yes, August Holiday Monday at home today! I crawl back under the open gun, stretch up, hook fingers over the turret hatch and haul myself onto the flat dome of the turret, then slide down the steep front of the turret, down the lesser angle of the front of the driving compartment, onto the ground.

I pull two hairs from the abundant growth on my head. The muzzle end of the big gun has tiny slits in cross shape and, with a little grease, I fix the hairs to form a cross at the end of the orifice. Back up the steep tank front, in through the turret hatch, down and under the gun. Wedged in the loader's seat, I look up the barrel again and see the cross hairs outlined against the sky. Under the gun again and squirm into the even tighter gunner's seat. Jam my eye against the telescope fixed to the gun. Fine lines on the telescopes indicate exactly where the gun is, or should be, pointing. My left hand reaches out for the wheel which raises and lowers the gun. I depress the gun until the distant cornfield comes into sight, then a lorry nearer at hand. My right hand turns the wheel which traverses the entire turret by manual power.

The turret turns so that the gun sight comes to bear precisely on the top of the white identification star painted on the door of the lorry. Now all I have to do is check that the hair cross seen through the gun barrel is also dead on the same spot. If not, I adjust the telescope sight to correspond to the actual aim of the gun as indicated by my two surrendered hairs, freely given up for King and Country.

'If you do that often enough, you'll end up bald, not to mention blind from doing the other thing too often,' says Harvey, who has finished his job and has been watching me. 'Right! I've been doing the dirtiest job. I bags first wash.'

Keith McAlpine is standing at the back of the tank, watching

the artillery display and wiping his hands on cotton waste. 'All right, lads. We might as well scrub up, have some eats. Take a break. Fill in our Will forms. Supplies are coming up about 14.00 hours.'

'Give us a shower, while you're up there, Ken,' calls Harvey. We have a number of sawn-off petrol tins, rather bigger than the average kettle. One is full of hot water, heated over our primus stove. A second tin is used for washing in. Harvey has already washed his hands. He has stripped naked and is dancing around on the warm grass. He stops dancing for a moment and hands me up two more tins as I stand above him on the back of the tank. One of the tins is full of cold water. The other is empty and has a roughly perforated bottom. I pour water slowly into the per- forated tin and direct a gentle shower on Harvey beneath me, whilst he dances up and down, soaping himself until he looks like a leaping silver fish in the sparkling sunlight. The pounding of the guns and the rushing of shells overhead simulate the sound of an immense waterfall.

Three or four French children have appeared, and they too dance up and down, imitating Harvey. An old French woman walks slowly between the rows of tanks and passes near us, ignoring Harvey's naked gambol. 'What's the matter, mother? Too old to be interested?' bawls Harvey. The old woman moves on, impervious, pathetic in long, dirty skirts and big, broken German boots. The children clap and laugh, uncomprehending of the English but comprehending the sentiment.

Bookie throws them a boiled sweet each. 'Now push off,' he shouts, not unkindly. 'Pissez-vous off, enfants, back to your own maison.' Again they laugh, clap, dance – then as Bookie chases them they gallop away towards another tank, begging sweets and biscuits, viewing naked bodies and savouring the hilarious frivolities of war. From above I rinse the last soap from Harvey's body. He runs around the tank, shaking himself like a delighted dog emerging from a plunge in the river. 'Hey, Harvey,' shouts Graham Harris from the turret of a nearby tank, "you could get arrested for that in Blighty.'

Soon we eat steaks from our war-casualty cow and more 'dog biscuit', swilled down with chlorinated tea from chipped enamel mugs. It seems that both the Royal Artillery and Jerry have gone off to lunch too.

'Everything stops for tea,' comments Stan, sipping his bitter brew and glancing over at our silent artillery. 'They probably got mixed up between a.m. and p.m.'

'More likely got the date wrong,' suggested Harvey. 'I'll still lay two to one on an attack before nightfall,' argues Bookie. 'They'll have switched off the stonk to fox Fritz.'

'. . . who is sitting up on top of the hill, watching through his Zeiss binoculars and seeing every ruddy thing we do, in between reading *Mein Kampf* and eating frankfurters,' concludes Stan, throwing away a large portion of fat.

'Hey, don't you know there's a war on,' I protest. 'Wrap that up and send it home to your poor starving mother.'

**14.00 hours:** Whilst we have been lazing about, washing up our mess-tins, writing a letter or ticking the formal messages on a field postcard, a number of supply lorries from other units have driven past. But this three-tonner is different because from the side window beams the large face of George Jelley, the Regimental Sergeant-Major. 'Come and get it, me lads!' he shouts in a voice loud enough for the Germans to hear at the top of the hill.

Several lorries follow the RSM into the Squadron lines, and each lorry has its special cargo for each tank. There is a petrol lorry, an ammunition lorry with large shells, another lorry with small arms. The QM truck brings supplies of 'Army Form Blank' (toilet paper) as well as wooden crosses to grace our graves. The food truck will arrive with tinned rations neatly packed in large cardboard boxes.

'Mail up! Come and get it, C Squadron! Corporal Beecham, Trooper Swallow M., Jones A. K., Sar'nt Jameson . . .' My name is called three times, twice for letters from girl cousins – 'Give me their addresses,' says Harvey – and the third time for a large brown-paper parcel. 'Hide it quick,' says Harvey. 'Don't let the vultures see it.' He seems oblivious to the fact a hundred hungry Troopers saw the parcel arrive, and my mother's fruit cakes are famous. Fortunately other parcels appear in the Post Corporal's gift, and so we retreat safely to the shelter of our tank.

'Let's go for the rations,' Keith calls to Stan and me. A ration truck has dumped some boxes in the middle of our Troop of four tanks. Someone has opened the boxes and spread the contents out like a grocery store on the grass. Typically the army is not able to supply rations for the normal five-man tank crew, nor the four-tank troop. The army appears to cater only for seven men who eat six rashers of bacon between them every two days, or who in the same time consume 7¾ hard biscuits each. So

representatives of the four crews sit on the grass and barter for the odd ends which are not divisible by four.

Keith, Stan and I pile our rations into one of the cardboard boxes and carry it back to the tank. We stow the communal items. We count out the boiled sweets, ration of seven per person per day. Chocolate, one bar of Duncan's blended each. Cigarettes, ten each. I don't smoke, so my cigarettes go into the kitty. Keith mainly smokes a pipe, so half his cigarettes go into the kitty. As I don't draw cigarettes, I keep all my chocolate. The others put half of their chocolate into the kitty. The same with the sweets.

The kitty, reinforced by the odd addition of corned beef, peaches, soap or razor blades, will be used to barter with French farmers and peasants *en route*, in exchange for eggs, butter, milk, rough brown bread and sometimes an entire chicken. Barter values are almost as specific and stable as the value of the pretty franc notes specially printed for, and honoured by, the allied liberation forces. A bar of chocolate, rare in France, normally buys five eggs, one for each crew member. A tin of corned beef, also apparently a rarity to the locals, will merit a loaf of sawdust bread for us who have no ration bread as yet. Soap has a high value, too, and on one occasion we obtained a small and tender chicken for ten English cigarettes.

As we carry the rations to our tank, spurts of dirt and smoke shoot up between the parked tanks two hundred yards away. The troopers over there dive and hug the ground. We continue our stroll, ducking slightly and instinctively, hurrying the pace just a little, watching each other's reactions, all waiting for one to dive. Nobody dives, so nobody dives. Panic and un-panic are very similar in their causes, if not in their effects. Superficially nonchalant, we take slightly longer paces and slightly deeper breaths. But the enemy violence stays far enough away. Except for one piece of shrapnel, a freak piece of jagged steel which buzzes frantically like a toy aeroplane or like a wasp's attacking signal magnified a thousand times. The buzzing traces wild, skewing patterns across the field, over our heads and finally fizzles out fifty yards beyond. We stare at each other a moment, then saunter on, hands clasped resolutely around our rations as we whistle tuneless sounds.

Another novelty appears. Groups of Scottish infantry, recognizable by their bonnets, come marching over to our left. One company is actually headed by a bagpiper playing solitary, lonely wails.

'Who's killing the cat?' asks Harvey.

'Don't insult your respected tank commander's national music,' admonishes Stan.

'Not healthy though, to have the Ladies from Hell around,' observes Bookie.

'Why not? I would think it would be a lot flaming safer with them around,' argues Harvey.

'Famous regiments. They attract rotten jobs. Bloody battles. I lay five to one on, we're going into something special if the Highland Jocks are in on it.'

'You don't take chances with your bets, do you?'

An elderly Corporal, prematurely bald, comes round the back of the tank, approaches our operator, Stan Barber, slips a piece of paper into his hand and says, 'Netting at four o'clock.'

'Watch that,' crows Bookie. 'There might be a copper about. Passing betting slips is against the law of the land, Corporal Accrington.'

Stan opens his slip of paper and reads the row of numbers on it. At four o'clock he will switch on his wireless set, tune into the frequency indicated on the slip of paper and dial in to a fine tuning on a test signal sent by Corporal Accrington for the whole Squadron. Pressing his netting button, he will hear a low whistle if his dial is slightly off 'net'. On adjusting the dial, if he tunes away from the perfect net the whistle will rise higher and higher. But if he adjusts correctly, the whistle will descend to a moan, a gurgle and then silence. On! Net!

**16.00 hours:** Stan is in the turret at his task of netting the wireless set. He fiddles with the dials with his right hand and clutches a piece of my mother's fruit cake in his left hand. The rest of us squat down in the grass, resting our backs against the tank track and eating our fruit cake. The size of our crew has doubled. Fruit cake has considerable recruiting powers.

Little Hughie Macgregor happens by. He is not wearing his beret and we do not leap up and salute him. The four tanks of the Troop are a tight family unit, and Hugh has been somewhere in the vicinity all day, so we take no notice of him unless he requires our attention. I offer Mr Macgregor a piece of cake. He grins, accepts and goes on to our 'Charlie' tank, munching the cake. 'Charlie' tank is a 'Firefly', a Sherman into which a larger gun than the usual 75mm has been mounted. There is one Firefly in each Troop and three ordinary Shermans. The huge, new seventeen-pounder gun sticks out a yard farther than the 75mm.

It is devastating, both at the despatching end when it fires and at the receiving end.

'Stand up there! Stand still! What d'you think you're doing bloody well sitting down when an officer is talking to you?' The gruff roar of RSM Jelley's voice sends us jumping to our feet. We didn't see him coming. He must have been watching, the crafty old beggar. We turn round to face the wrath to come. And meet only loud laughter. RSM Jelley's voice was the work of Graham Harris, the star impersonator of our own Squadron concert party. I should have spotted the impersonation because I write some of the comedy material. The give-away is simple. The imitation RSM throws in the occasional 'Bloody'. The real RSM never swears at a Trooper. He was a young soldier himself in the Great War and treats this war's youngsters with respect.

'All right! Take it easy, lads,' Graham continues in the RSM's voice. 'There's a very important person coming to see you-u-u-u!' The very important person turns out to be an official War Photographer who has chosen to photograph our tank because the angle is good for covering the panorama of a hundred vehicles parked along the slope. He speaks to Keith, obviously discussing a good pose for a photo.

'What about cleaning the gun barrel?' I suggest.

'How do you do that?' – focussing his massive camera. We get out the barrel brush and screw it onto its long, jointed handle. Then Harvey and I push the brush into the barrel, strike a heroic pose and wait to be photographed for posterity. 'I think it would look better with more men pushing the brush,' comments the photographer, squinting through his view-finder.

'Two of us is enough. We don't need more to brush through.'

'I'm talking about what the photo needs. That handle looks bare with only two people holding it, in front of a huge tank.'

'Come on, you'se guys,' bawls Graham Harris, still in George Jelley's voice but using his own Scouse twang, 'You heard what the man with the camera has said. Get on parade to scrub out gun barrels. Left, right, left, right, left!' He leads a rush of eager lads from other tanks, all anxious to get into the picture. Soon there are as many as twenty of us, crowded together, straining at the brush handle like a tug-of-war team.

'That's it! That's great!' cries the photographer, clicking away. 'Again. That's right! Put a bit of biff into it. Let's see some sweat glistening in the sun. And again. That's the spirit that wins the war. Push!'

He hands out cigarettes, imitating Montgomery, no doubt.

Then he will go away to compose a suitable caption. We were photographed at Noyers. Later the photo appeared in a daily newspaper. White patches appeared on our black berets instead of our silver horse badge. Presumably some German spy in England might spot the photo in the paper and send a report, 'Soldiers wearing a silver horse badge are reported to be on the Western Front.' By devious routes via Lisbon, Vichy and Berlin, couriers might speed the report to Hitler's bunker. Adolf himself would stroke his moustache and say *'Hoch, hoch, mein Gott,'* and the secret would be a secret no more. Allied strategy might be imperilled. Thrones might fall. So the censor in Britain draws white patches over our badges. Yet any German soldier at the top of the slope, using his Zeiss binoculars, could spot our badge on the beret of each commander looking out of his turret, for we never remove our badges. And the Black Watch and Gordons are even easier to identify. Who was the censor fooling? Certainly not Rommel or von Rundstedt!

**17.00 hours:** The little clique of officers is breaking up. A Major, two Captains, four Lieutenants and the Squadron Sergeant-Major deciding our immediate destiny. For an hour they have squatted close together in a clearing amid the vehicles. David Bevan on a camp stool. The rest on the grass. Now they are standing up. They salute. Hank Bevan taps his cap with his riding crop. The Lieutenants move back to their Troops. Keith McAlpine picks up his map case and, whistling under his breath, goes to meet the Troop Leader, who has our destiny marked in red and green lines on the perspex map cover under his arm.

**17.30 hours:** Corporal Keith McAlpine strolls slowly towards us, studying his notes. Now we can stop surmising. Now we must each write down the vital details of our task. Crew members must be ready to interchange if casualties occur.

Keith gathers us together. 'Bookie loses his bet,' he announces. 'We go in at 22.45 hours, just after dark.' We grin, partly at Keith's joke – for he jokes little enough – and partly in relief at knowing the worst. We go in at 22.45 hours. Some of us are marked not to come out, by a higher authority than David Bevan.

In his precise schoolteacher voice, Keith teaches us the lessons we must learn. Successive daylight attacks up these slopes have failed, with horrible casualty lists to show for their efforts. Now we go up the slopes in the dark. We have to cross four miles of

open country dominated by the German 88s, possibly one of the strongest defensive screens known in warfare. But we shall drive right through their front line and end up at dawn sitting in their rear. They will wake up (having slept through all the noise) and panic when they find an entire army behind them. Simple!

Our objective is St-Aignan-de-Cramesnil at the top of the hill. Before attacking St-Aignan at dawn, we will rendezvous short of the village at this point on the map – code-name 'Fly by Night', which is the corner of a hedge a few hundred yards short of St-Aignan. The Germans have fortified the small villages between here and St-Aignan but we do not stay to attack them. We keep on rolling, whatever happens. On our right will be another, similar column with 144 RAC, keeping close to the Falaise road. On their right, on the other side of the road, two more columns of Canadians. (Real, live, hairy Canadians.) On our left, nobody. Behind us, nobody.

German infantry are in position in the villages but it is thought that an SS Panzer Division may be moving across the rear. (God! The SS and the Gestapo, the mainstay of Hitler's power and terror. The SS, hand-picked, fanatical, physically superb cream of the Nazi army, conforming to no normal codes of military behaviour, hated by the ordinary German soldier almost as much as they are hated by us. Cruel, arrogant, unbridled, lethal, professional killers.)

Note down the various code-names: start line . . . and we look at the map with lines of advance neatly marked in and imaginative code-names marked against them. Another military mystery: when the Germans see us coming through Bourguebus and hear us on the wireless claiming conquest of 'Dragon', they will learn that 'Dragon' is none other than Bourguebus, whereas if we refer to Bourguebus by name, they will know that we really are where they can see us to be! Someone is playing at war games again. Field Marshal von Keitel tramps into the Hitler bunker and states that wireless reports show 1NY to have occupied 'Dragon'. Thereupon Hitler commands his Secret Service to bend all their wits to discovering where 'Dragon' is. 'Ah,' says Keitel 'but "Dragon" is where Rommel is.' But Hitler storms, 'But who the *Donner und Blitzen* knows where ROMMEL is???'. That's another of Graham Harris's favourite jokes.

Corporal McAlpine's voice becomes more clipped. 'Wireless silence until we have crossed the German front line. Right! Let's synchronize watches!' As a commander he has been issued with

a service pocket watch. 'It's precisely 17.55 and coming up to 30 seconds . . . now!' Stan and I have wristlet watches. Harvey works by an old alarm clock hung up on a string in his driving compartment. Bookie does not have a watch. His ancestors have told the time by the sun for generations. At 22.45 hours tonight the last light will fade. So Bookie, even without a watch, will be on time for the battle – unlike the Guards with all their gold watches during Operation Goodwood, according to what we hear.

I stand and look out over the tanks and the slopes of corn and the factories of Cormelles. It all looks so ordinary. The crowds of men gathered about their tanks on the greensward could be farmers gathered to inspect farm machinery at the Three Counties Show on the Racecourse at Hereford. The sky is not ominous with the colours of blood; there are no clouds shaping themselves into prophetic formations; even the guns are taking another temporary rest. So I can hear an unfamiliar bird singing. But no skylark soars suddenly as a symbol of hope. So I stand there looking at the dull, stationary machines and the indolent men in drab overalls, and I poke around in the mind for a great thought before battle.

My own thoughts are usurped by Alan Seeger's memorable declaration: 'I have a rendezvous with death at some disputed barricade . . .' or McLeish's 'But we shall meet death running, with our lips still glad of the morning.' The nearest I get to a great thought is to wonder why at this point the thought of battle provokes only an occasional icy prickle up the spine. The real heart-searching is not yet. Nor is the exhilaration of speeding advance. As for death, there is no pain beyond death. And it is the pain, dying or not, that scares me.

Shall I remember for ever more that, at this moment, a group of lads from other tanks strolls towards us? There's Corporal Astley, who sports a Hitler moustache and parts his hair Hitler fashion, his own tiny gesture of derision towards the great dictator. Trooper Sonny Bellamy is a little boy, younger than me. In khaki uniform he looks like a young Boy Scout. Trooper 173 Judge, on the other hand, is reputed to be the ugliest bloke in the Regiment. Yet he it was who successfully wooed the gorgeous country girl who serves in the canteen on Salisbury Plain. They are now engaged to be married.

'Do you think the Germans will really stay asleep with all this lot chugging around the countryside in the dark?' asks Sonny.

'And in low gear,' adds Astley.

'Trooper Judge will turn his Gorgon stare on the Jerries and freeze them in their slit trenches,' comments Stan.

Trooper Judge, whose Christian name appears to be non-existent and who responds only to '173 Judge', enquires 'What the Hell are Gorgons?'

'They're a Highland Regiment, you twirp,' blurts Bookie in all innocence. Gusts of laughter wash around the uncomprehending faces of Bookie and 173 Judge.

Then flames, lightning, blizzards of fire, skull-shattering noise, earth, stones, smoke, Devil's laughter! By a freak of coincidence the German and British artillery open up at the same instant, and a huge shell, apparently one of our own duds, erupts among our Squadron lines. We stop laughing, dive, grovel in dirt. Sackcloth and ashes in the face of fate! Scores of shells howl overhead, travelling in both directions.

'Silly bleeding sods!' shouts Corporal Astley at the distant artillery, his fright slowly changing to humour. 'Pull the effing cork out before you fire next time. You Schwein, I vill haf you for mein frankfurter meat next time you vil at your Führer schütten.' He waggles his little Hitler moustache at the distant dots of artillerymen. Then in a quieter voice he groans, 'How can we hope to win the war? If our artillery can't hit fifty of us at a hundred yards range, how can they hope to hit one little Fritz sitting in his slit trench miles away?'

Hughie Macgregor has been sitting by his own tank, combining the pep talks of both Troop Leader and tank commander. Now he comes over to us. He is wearing his beret. We stand up and Keith gives him a salute. 'Business this time, lads. For real. Nobody has been able to get up these slopes in daylight so we are going up in darkness. Orders are simple. Keep rolling. Keep moving. Keep in sight of the tail light of the tank in front. And if ye get lost and end up in a village, ye will be in the wrong place. All the villages have been fortified by the Hun. Any questions?'

Harvey Oxford responds first, 'If we lose Corporal McAlpine, sir, how do we know which way to go in the darkness, especially if we lose the tank in front, too?'

'Good question, Harvey! There will be Bofors guns firing green tracer overhead, aiming at the objective. Keep beneath the Bofors tracer and head in the direction in which it is aiming. If ye're going uphill, ye're going in the general direction. But whatever ye do, don't stray too far left. Go right rather than left. We are the far left-hand column, and the RAF will be making a

big raid on the woods nearby, where there are thought to be
German tanks hiding.'

A small procession heads towards us. We know the slim,
six-foot figure of David Bevan, strolling along like a lazy cowboy
and hence nicknamed Hank. His indolent style hides a calculat-
ing mind. Although only a Territorial, he more than once
outwitted regular units opposing us during 'schemes' on
Salisbury Plain, by working out new methods of operation not
quoted in 'the Book'.

Beside the Major ambles the Squadron Second-in-Command,
Bill Fox, son of a baronet and looking like a country farmer going
to a fancy-dress ball as a tank Captain. According to Squadron
lore, Bill has knocked around a bit as a jockey, a cowboy and a
Trooper like ourselves. He walks with his head thrust forward
and hands clasped behind his back. He has a rasping, autocratic
voice and an obvious disdain for those unnecessary military
disciplines known to the troops as 'bull'.

On the other side of the Squadron Leader is the older and
more staid figure of the Colonel, the highest ranking officer we
normally see. Once a Midshipman, he exchanged a naval career
for a military one. Now middle-aged, and blind in one eye,
he still walks with a naval stoop and more than anything
resembles a very large Teddy Bear. Behind these three officers
walk the RSM and SSM. Our Regimental Sergeant-Major,
George Jelley, is a big man in every sense. In the Great War he,
like many other lads, falsified his age in order to be able to
volunteer. He fought on the Somme as an artillery observer. He
has a very loud parade-ground voice and is the fiercest and most
vocal of soccer referees. The Squadron Sergeant-Major, by con-
trast, is a small, sharply chiselled, alert man, always immacu-
lately turned out. He can be very sarcastic, and some Troopers
do not like him. He is as perky as a sparrow, as neat as a
blackbird and as wounding as a hawk. His peculiar perversion is
making outrageous jokes on parade and then defying the troops
to crack a grin on their faces. 'Gather round, 3 Troop,' the SSM
shouts. 'Wakey! Wakey! Pick the whites out of your eyes, but
put them back later. Jerry's going to need them to shoot at.'

The Colonel stares at us with his one eye, smiles wanly and
fumbles in his mouth for the words of his little speech. It is an
open secret that he doesn't like sending more lads out to die.
'The Commander-in-Chief has sent a message to say that this
attack is absolutely vital. The Germans are now almost sur-
rounded. We are being asked to slam the door on their retreat.

When we advance tonight, I shall be just in front of you. Keep closed up. Whatever happens to anybody else, keep moving. We are due at code-name "Fly by Night" at 03.00 hours. Nobody really expects us to do it. But I shall be there waiting for you.' He taps his cap badge, surrounded by a silver oval and set on a bright blue background. 'Our little silver horse does not look very savage. But he can gallop across country. Good luck, all of you. Carry on now, please!'

We grin and nod back. Hughie snaps another salute and we click our heels. The atmosphere is genial and informal. The old Colonel is going to be nearer the 88s than we are. He nods back at us as he turns away towards the Squadron Leader. 'That's all your lads then, David. Good bunch of boys. Look after them. I'd better go and look at Peter's lot now. By the way, the Colonel of 144 was telling me . . .' The officers drift away over the grass, chatting unhurriedly and tapping their rears with their riding crops in some kind of atavistic throw-back to the days when they would have ridden horses down the slope to inspect us before battle.

The SSM pauses and looks us up and down, then stares fixedly at our assorted footwear. 'Stone a bleeding crow! What a shower! Roll on the day when we can get back to proper soldiering. Shining brasses, polished boots, mess tins used for seeing your face in, not for eating bleeding porridge out of . . .' He gives an exaggerated shudder. Then follows the Colonel, grinning broadly.

**19.00 hours:** 'Any mail, lads? Last Post! Any more final words from the departing warriors?' The Post Corporal plays a macabre game of Patience, picking envelopes blindfold out of the stack of Blighty-bound mail to divine which are, indeed, 'last words'. A game something like reading tea-leaves. Fortunately he does not inform the tank crews as to the results of his 'last letter home' rites.

'19.00 we pack. 20.00 we eat. 21.00 we move,' Keith has ordained. Before we left Aldershot, our fitters went round the tank welding sundry storage bins and ammunition boxes on the flat rear deck and sloping front face of the Sherman. In these we stow personal kit, food, tools. Our large kitbags do not travel on the tanks but on a rear-echelon lorry. But in a tank it is possible to carry the odd personal item: a football, a bottle of Calvados, a book or two. I keep a promise to my mother that I will carry a Bible with me. From personal choice I carry also a book of

modern verse (mind-stretching) and a book of comic verse
(mind-relaxing). My fourth book is Sassoon's *Memoirs of an
Infantry Officer*. It is fascinating to share Sassoon's thoughts, so
close to our own and so far from the wildly imagined war-thriller
story.

We strike camp. Roll our bedding bundles inside ground-
sheets, tie them tightly, lash them to the flat rear deck, keeping
the bundles long and flat so as not to impede the traversing
75mm gun. Spare kit in storage bins. It looks like a hot night, so
four of us opt to travel in our one-piece denim overalls with only
a pair of pants or shorts underneath. I wear a singlet as a kind of
sweat shirt. Stan wears a khaki shirt under his denims. Bookie
and Harvey go bare chested. In theory we wear battledress,
thick, suffocating, under the denims.

The British Army has never been able to come to terms with
the fact that regulation hobnail boots can be dangerous on an
iron tank. Early on in my training a tank started unexpectedly as
I was climbing up the front. The iron nails in my boots skated on
the armour plate and I found myself diving under the tank,
fortunately just clear of the churning tracks. So of the five only
Bookie, who has always worn boots, is regulation shod. Even he
has removed the hobnails. Harvey and Stan wear PT pumps,
giving good purchase on the armour plate but quite illegal. I
wear a strong pair of brown shoes from Stead & Simpson.

In contrast Keith, who feels the cold, dons full battledress,
shirt, blouse, thick trousers, denim overalls on top. He has a pair
of jaunty black civilian leather boots. All of us wear the black
beret of the tanks, with the silver horse badge eternally galloping
over an oval patch of bright blue cloth. Bookie sometimes wears
the special tanker's steel hat, a plain basin-shaped helmet with-
out the infantry rim. But the tin hat is unpopular and unwieldy
inside the tank. Driver and Commander will wear goggles as
protection against the thick dust clouds cast up by columns of
tanks when on the move.

Those of us who carry revolvers – Keith, Harvey and I – wear
our webbing belt with revolver holster and ammunition pouch.
Stan and Bookie, with a little more space, carry sten sub-
machine-guns. I also have a Thompson sub-machine-gun similar
to those seen in old films of American gangsters of the Prohibi-
tion era. We each have a pint-sized water-bottle which can be
attached to the webbing belt. In the tank the bottle is lodged
within reach of its owner, the seat space often being too cramped
to admit a man wearing a water-bottle at his hip.

We are ready, dressed for action – not quite like the Buckingham Palace Guards and yet not completely ruffians – and hoping that Jerry is putting on his pyjamas or nightshirt at the top of the hill, secure in the knowledge that today is a Bank Holiday in Britain and that we show no signs of attacking on our holiday. Normally when an attack goes in, it is timed to allow it to succeed or be called off before nightfall. At 19.30 hours Jerry must feel it is a little late for an attack today, and he will be looking forward to a plate of sauerkraut in peace.

**20.00 hours:** Time for our Last Supper. We eat slices of bully beef on thick 'dog biscuits'. We feel snared in a net of indecision, knowing that zero hour is remorselessly approaching and wanting to delay it, yet, because it must eventually come, wanting to hurry the time along and get moving.

While we eat and wait, we muse on the higher strategic implications of these very slopes. Bookie begins it: 'They say that hundreds of our 2nd line [the 2nd Northamptonshire Yeomanry] "got theirs", trying to get up this hill.'

Harvey continues: 'It's logical, isn't it? If there are rows and rows of 88s lining the ridge, the best gun that's ever been invented, what vehicle could get up there in daylight? Certainly not flaming Shermans, nor infantry carriers.'

'Flaming Shermans is an appropriate term,' I say to myself.

Bookie: 'Then why did Montgomery send all those blokes up there to get shot, all to no advantage? I'm only a bloody farm labourer but I wouldn't be so daft as that. Three armoured divisions, they say.'

Harvey: 'He couldn't have realized . . .'

Stan: 'Of course he realized. He's not that daft, even though he's a General. He did it to keep the Huns away from the American front. Like he said.'

The sun is now discernibly lower towards the west. A poet might say, 'The twin black angels of Night and Death trail their hems toward us across an enslaved continent.' We are made very aware of the slavery existing in the rest of Europe by the emotional way the French villagers hail us as liberators. We are, of course, the BLA, the British Liberation Army. Behind the frivolity and 'micky-taking' and 'shooting a line' there is a real awareness that launch sites are sending V2 rockets over London from just up the coast. Our advance will mean quietness and safety for Stepney, Camden and Camberwell Green. Meanwhile we scrape the last globules of fat from the corned beef tin,

and the last crumbs of hard biscuit from the packet, and chew
them at great length, dreaming of Sunday dinners at home . . .
    A great cheer sounds from the next tank. The SSM and SQMS
appear round the back of the tank, carrying a stone jar. 'Come on
there. Look lively. Rum ration up. Get lubricated,' chirps the
SSM. We empty the horrid chlorinated tea from our battered tin
mugs. I don't drink but my mates will enjoy the extra quarter-tot
each from my mug.
    'Go on,' laughs Harvey, 'makes you blow your euphonium
louder. Have a sip.'
    'No thanks. Anyway they say the SQMS thins it down with
battery acid.'

**21.00 hours:** I look at my watch for the hundredth time this
evening. Nearly 9 p.m. August Bank Holiday. Before the war
our extended family used to go on holiday in 'August Week'.
Now, summer 1944, we are off on what some term 'Churchill
Tours' of Normandy in the sun. And I stand at the bottom of a
long, low Normandy ridge which is itself the beginning of slopes
rolling up to the highest ridge. On those slopes, parts of which
now look like a lunar landscape, lads wearing our own badge
still lie undiscovered and unidentified. Like so many others who
have trodden or ridden this Via Dolorosa.
    With an entrenching tool I have dug a small hole and thrown
into it two corned beef tins, a biscuit packet and some other bits
of rubbish, keeping a landscape clean which is littered for miles
around with wasted bodies and scrap iron in every shape and
size. I have filled in the hole, for this is one of the niceties of
discipline that our Squadron insists on. We fold our mess tins
one into the other and put them into our small packs, together
with other oddments. We grab projecting pieces of the tank and
haul ourselves up onto the flat deck at the back. Harvey and
Bookie swarm up the front where they each have their own tiny
hatches into the shared front compartment.
    The American-built Sherman carrying an English name, Stony
Stratford, alias Roger 3 Baker, stands waiting. A clean tank,
tall in comparison with equivalent British tanks such as the
Churchill. Its turret is much more of a dome than the square,
flat shapes of British or German turrets. Its steep, sloping
front is also distinctive. Behind the turret the line of the deck has
a slight backward tilt which gives the tank the appearance of
squatting back on its haunches.
    At the side of the turret the deck is almost non-existent, and

one has to cling onto projections. Stan and I haul ourselves up another stage onto the turret top. For a moment we stand there, tall, high above the ground, watching the busy panorama, glancing southwards up the ridge through the cornfields the way that we must go. Saying farewell to the sky.

Then Stan first, I following, we drop through the turret hatch into our tight little den and wait for Keith to follow us in, stopping up our only exit. We have suddenly become subterranean. Death beetles inside a steel wall. Mobile troglodytes. Keith's boots, legs, stomach appear over our heads. Jam the exit. Douse the daylight.

**21.15 hours:** We have been checking again that everything necessary is to hand. Even down inside the turret we hear the concussive commotion as the barrage starts up, the real barrage for attack. We feel the tank buck on its springs with the blast and draught of our own guns. In the same moment Keith calls, 'Driver, start up!'

I reach for my headset, two earphones joined by a thin, curved piece of metal which fits down over my black beret. From now on we shall be able to talk to each other only through the microphones and earphones. Behind my head the huge engine kicks into life and drowns the reverberating barrage of the guns for the moment. My right hand instinctively finds the metal grip which controls the turret. I twist left, and the turret swings smoothly to the left. I twist right, and the turret swings back, smooth, swift and silent, powered by its efficient Westinghouse system.

I sit upright on my narrow seat. The rough, hard turret wall is close to my right shoulder. My left shoulder is pressed into the equally unyielding guard of the big gun. There is some room for my feet, and I feel around with my left foot to find the firing buttons set there on the turret floor. In front of me the turret wall sweeps up closer and confining. At eye level are a periscope, giving me a general view of a segment of the outside world, and a telescope fixed to the gun, giving me a very much enlarged firing view and aiming sight.

I am now wedged in tightly but fairly comfortably, and shall remain in this position indefinitely. It is something like the physical pose of a mountain climber ascending a chimney in the rocks and wedging himself firmly to avoid falling. Or, perhaps to carry the simile of chimneys a thought further, like a Victorian boy sweep jammed inside a dark, tight flue. This position has

even something foetal about it, a sealed-off, wrapped-about, doubled-up feeling. The thought might be extended even to the other extreme, with elements of both the womb and the shroud, for the position reminds me of those ancient people who buried their dead doubled-up in ceremonial urns. For some of us the latter reference may become very relevant.

On the other side of the great 75mm breech sits Stan, with rather more room than I have. I do not need to move. He does. At any moment he may need to swing away from his wireless set, pick up a 75mm shell – an armful indeed – and slam it into the breech of the gun. The Browning machine-gun is also on Stan's side of the 75mm, mounted co-axially – and so called the 'co-ax' – so that when I traverse the turret and elevate or depress the gun mounting, the 75 and the Browning move together, respond to the same gun sight through which I take a single aim and, if fired by the separate floor buttons, will hit the same target without further adjustment.

Keith McAlpine is positioned behind and above me. There is a collapsible seat at about level with my shoulders, on which he can sit, although generally the commander stands with his head out of the turret. There is also a higher seat in the top of the turret which he can use when travelling outside the battle area.

Down in front of us the driver's compartment is low but fairly spacious as to width. Harvey and Bookie sit side by side. Harvey needs fair space to move the two brake levers, large sticks rather like the old-fashioned levers used in railway signal boxes. There is also a large gear lever. Bookie has no driving controls but in front of him he has another Browning machine-gun which protrudes through its own small mantle in the front of the tank below the turret ring. He both loads and fires that gun. This means that we can fire in two directions at once. The co-driver can fire over most of the front area even though the turret has been swung to one side, or even to the rear, and is firing at another target. But the time for firing is not yet.

**21.30 hours:** 'Driver, advance. Come left and follow the Firefly.' Harvey throws the heavy gears into motion, and Stony Stratford moves forward, noisily but gently. The Sherman is the Rolls Royce among tanks. The British tanks in which we have ridden tend to start with a huge jerk and have an extremely jolting motion. A good driver can set a Sherman in motion without upsetting or spilling a full mug of tea standing on the turret floor. The tracks creak and rattle menacingly but our

movement is smooth. We roll forward across the grass with a slightly swaying motion, more like a boat than a land vehicle. We follow the Firefly and head towards the rest of the Squadron. The Firefly carries a huge seventeen-pounder gun, considerably longer and bigger than our normal 75mm. The Firefly is something of a secret weapon. The 75mm Sherman is reputedly unable to destroy the German Tiger tank with its immensely thick armour plating. So one tank in every troop of four tanks is the Firefly Sherman with the ferocious seventeen-pounder, which we hope will scare away Tigers.

So we trundle along, three 75mm Shermans and one seventeen-pounder. On the way to war. We have a clear run for about one hundred yards. Then we halt. Wait. This seems to be the very essence of war. Halting. Waiting. Advancing a few yards. Halting. Waiting.

**21.45 hours:** 'Driver, swing round to form file with the rest of the Troop. The Squadron is forming fours in the way we rehearsed at Gazelle.' There is wireless silence. That means Keith can give us orders over the I/C, which does not broadcast, but nothing is coming over the A or B sets. Our commanders are working to prior orders. I nestle my head into the rubber shock-absorber above the periscope, partly to avoid damage to my skull if we crash and partly more comfortably to be able to survey the countryside, although there is little new to see, as the sun goes down and the intensity of light slackens. Objects begin to blur and smudge. The shadows of the tanks stretch across the grass like the shadows of skyscraper buildings.

My periscope is at the moment pointing directly ahead. As I am sitting on the right-hand side of the tank, I can see the right-hand leading edge of the tank, but most of the left side of the tank is out of my view. In tank terminology, taking straight ahead as being twelve o'clock on a clock face, I can see from about two o'clock through to about eleven o'clock, and even that requires some squinting and movement of the head. It will be the commander's task to watch the remainder of our flanks and rear. He is much better positioned to do this. But the restricted vision always gives me a creepy feeling. I would prefer to be able to see for myself what is creeping up behind or at my left shoulder.

Now that we have formed up as a Squadron, we halt again and wait. My periscope shows only a 2 Troop tank, the commander lounging on top of the turret, a patch of cornfield beyond him,

and above him the darkening August sky. The artillery barrage is sustained and continuous now, but not much response is coming from the Germans. We wait silently, looking through our periscopes expectantly at nothing. At this moment we are too bored to be scared. We could be sitting in an English field. There is no exultation. We simply wait, patient and unmoving as a cinema queue waiting to see a poor film.

**22.15 hours:** 'Driver, follow the tank in front. The Squadron will be falling in with the Regiment now.' The landscape has darkened into that state of gloaming where the colours only remain as a faint tinge on the blacks and greys. It is as though an artist had painted a watercolour and then drawn the same landscape in pencil over the top of the watercolour. The tank ten yards in front of us has become merely a stronger splash of grey on a greying background. We have not yet switched on our lights. We follow the tank in front at ten yards distance. When it halts, we halt. It jerks forward. We jerk forward. It halts. We halt. Jerk forward. Halt. Swing slightly left. Straighten. Forward. Halt.

I swing my periscope to get a view of the darkling procession. In front there are rows of familiar Shermans breasting the slope, with their distinctive turrets like flattened domes. To the left are our other three tanks of 3 Troop. Fifteen yards away is Charlie, the Firefly. Next the Troop Leader's tank. Then 3 Able, the Troop Sergeant. To the right nothing except a few wheeled vehicles moving away from us into the dusk.

Behind us we now have a close-up view of the turretless Shermans, hastily converted to serve as infantry carriers. Sitting about on top of the carriers, not knowing quite what to do on their unfamiliar steeds, are the officers and sergeants of the 1st Black Watch, wearing their Highland bonnets rather than tin hats. Very cheerful and reassuring people to have at one's back. Way beyond them are more rows of normal Shermans where B Squadron guard the rear. On this march there will be no distinction of safety between front and rear ranks, for at any moment any rank may become the 'front line'.

We sit and wait. The darkness deepens. The barrage slackens a little. When other helpers fail . . . I know something nobody else knows. In a moment of weakness Harvey, the bawdy member of our crew, confessed to me. As we wait, he sits slumped over his levers in his tiny cockpit. The others think he is dreaming of naked women. Actually he is repeating his

favourite prayer from his choirboy days in Birmingham. And he is making contracts with God as to his post-war conduct 'when all this is over'.

A hand taps my ankle. By squirming round in my seat and squinting under the turret ring, I can see Bookie in front of me, his head about level with my knee. He taps a breast pocket of his overall and partly withdraws an envelope from the pocket. Then he pushes his right hand through the gap in the turret cage in which Stan and I sit like imprisoned canaries. I shake Bookie's hand briefly. This is Bookie's defence against fear. He KNOWS 'it' is going to happen to him. So he carries a last letter written to his wife. And I am to deliver it one day, by hand and uncensored.

Each in his own way we sit and wait. I imagine the Colonel sitting on his tank turret – I can dimly see him just ahead – waiting and thinking that he might have been commanding a battleship instead of a tank. Hank Bevan sitting tight-lipped, apparently impassive, but glad to be out of the Stock Exchange routine, perhaps even doing a quick pencil sketch of the scene. Captain Bill Fox sitting restlessly, cussing under his breath. Captain Tom Boardman sitting in the lead tank, checking his compass for the last time. Jerry, up the hill, frying his frankfurters and laying bets on whether the barrage signifies a dawn attack. All waiting for darkness to close in . . .

# ACT II

# Moonscape at Night

**22.40 hours:** Keith taps me on the back. 'Come up and look,' he shouts in my ear. I stretch my arms high in the well-rehearsed escape movement, clutch the hatch ring and pull myself up out of the gunner's seat in one salmon leap. Keith points directly upward. 'That's what we steer on.' A quick-firing Bofors gun is directing green tracer shells from behind us, over our heads and away up the slope. Keith switches his microphone on. 'Driver, start up. Tail lights on.' Shouts at me, 'Get down and check tail lights, will you? Be quick. Move off in about four minutes.'

I vault down the side of the tank, trot to the rear, check tail lights, give Keith the thumbs-up signal. Sandy Robertson is checking the Firefly lights. He doubles over to me, cups his hands at my ear and bellows, 'Just like August Bank Holiday in Blighty. Getting the charabanc back home at the end of the day, eating fish and chips, picking the sand out of your toes.' I reply with the well-worn, all-purpose platitude, 'If only our mothers could see us now!'

A monstrous force lashes out and knocks me off balance against the tank. Our own guns have stepped up into full unison voice immediately behind us. I lip-read Sandy's shout, 'Christ Almighty! It's a war!!' He slaps my shoulder, ducks his head and runs back to his own tank. I catch the eye of little Sonny Bellamy behind his tank a row in front of ours. He makes drum-roll signs and indicates that it is he who is making all the noise. I give him the 'screw loose' sign, screwing my finger into my temple. He gives me the 'fancy salute', a pukka salute but with the hand trembling back and forward like the needle of an audiometer with the sound up too high. We both grin and climb back onto our tanks.

A green Very light shoots up from our front and soars back over our head. 'One for ready. Two for go. Get in,' yells Keith, pulling his goggles down over his eyes, as I squirm down past him into my little armoured den again.

**22.45 hours:** 'Driver, advance, ten yards behind your leader in

front. Gunner, keep your guns straight ahead until we are through our front line. Off we go!'

I press my mike switch: 'How shall I recognize our front line?'

'You won't. I will tell you when we get there . . . if I recognize it myself!'

In spite of the mounting barrage and the protecting earpads of our headsets, we hear our engine gun fiercely, our tracks shriek and scream. Stony Stratford – tonight Roger 3 Baker – jolts back on its haunches, then lurches forward pointing slightly upward like an aircraft taking off. After a moment the hull levels off on the springs, rocking gently along the smooth slope.

2 Baker ahead is already running into dust from vehicles further ahead and throwing up its own detritus to thicken the grey-dun clouds. 2 Baker's tail-light glows a sad pink on a heavier mass of grey within the moving clouds. A light wind blows from left to right, bringing us more dust from the three files of tanks on our left. 'Steer straight, you drunken bugger,' shouts Harvey into his mike (which does not, of course, transmit the insults to Old Daddy Jenks in 2 Baker ahead). 'Can't you call him, Corp, and tell him to drive straight?'

We are now driving up the slope beyond Cormelles, a gentle rise of cornfields. Darkness would be absolute but for the Bofors tracer passing overhead, and the constant flashing of our own artillery coalescing into an almost continuous glare. Suddenly the entire world seems to light up one degree more, as though somebody in Heaven has flicked a switch. It is an awesome, eerie, inexplicable light seen through the periscope, something like the prelude to the appearance of angels over Bethlehem fields on the first Christmas. I shudder a little and press the mike switch. Stan's voice beats me to the statement: 'The whole ruddy world's lit up. What is it?'

Like me, the other crew members inside the tank are restricted to the small, oblong slab of vision offered by their periscope, and can extend that vision only by swivelling the periscope back and forward, up and down.

'That . . . is artificial moonlight,' explains Keith. 'Searchlights shining on the clouds. It should help us a little.'

'Much better to send along a load of dustmen to clear up all that muck ahead,' complains Harvey, who is already having to concentrate hard to pick out Daddy Jenks' bobbing tail light in the swirling duststorm which we ourselves are creating.

Gradually the column's pace and steadiness improve and we pick up speed to a fast walking pace or trot. Excitement begins to

simmer and ferment. An intensity communicates itself through the tank, everyone adjusting themselves to the movement, settling into seats, carefully scanning the outside world through periscopes. There is nothing to see as yet, but if there is, then we are not going to miss it. Even Harvey will be more relaxed now, sitting with his hands loosely on the sticks, letting the tank ride – as it will do without the constant control needed by a steering wheel. In England sometimes on a straight road we would set the tank rolling in low gear, then all climb out and walk alongside it, to the obvious horror of passing civilians.

Perhaps the growing excitement is a reflection also of the growing wireless activity impinging on our consciousness. There are no messages yet for our regimental code-signs, but others are not observing the wireless silence with the same discipline. Way out on the ether more distant voices are active, their messages indistinguishable amid the constant static. It is like approaching a new and unknown planet whose signals are obviously rational but incomprehensible. Stan has been listening to it as well. I hear his mike click.

Stan: 'Do you hear that? Morse! That's the first time I've heard Morse code being sent in action.'

Keith: 'In our sort of action there's no time to send messages in Morse. And no need. That must be a long-distance signal. It's too distorted to read.'

Stan: 'Think of all the ruddy time we wasted at Training Regiment. Day after day. Week after week. Walking around in our sleep saying "Di-dah, Dah-di-di-di, Dah-di-dah-dit". All for nothing. Never use it.'

Stony Stratford sways, stumbles, bucks and lunges forward again over a rough track. We have topped the protecting slopes above Cormelles-le-Royal and are out on the desolate, pitted lunar landscape of the 'Goodwood' battles. Country fought over and destroyed like the Somme or Passchendaele battlefields of the Great War. Pocked with shellholes. (We detour to avoid a deep hole, and our dirt road disappears entirely.) Scarred with slit trenches. Littered with shattered vehicles and instruments of war. Studded with shredded trees and crumbled houses. Sullied above all by the stench of unburied dead, animal and human. The stench creeps in through the periscope fittings like a live, breathing fog.

Moonscape, wilderness, desolation, ruin, catastrophe, chaos, obscenity, devastation. I have plenty of time to think of the words as we rumble along. Each word has its own distinctive

connotations and all of them are present here. Perhaps the most apposite word is 'waste'. (Bookie: 'Somebody's been muck-spreading the fields.' Harvey: 'Jerry, with his guns!' Bookie: 'What? I don't get it.' Stan: 'Don't try explaining, Harvey. It's too complicated.' Bookie: 'It stinks anyway.' Stan: 'Dear mother . . .')

Turning my periscope to the right, I see a small green light drift past, like a distant lightship in the fog upon a troubled sea. A few moments later another tiny green light set against a piece of tin with numerals on it.

Me: 'Forgive ignorance! Route markers? Those green lights?'

Keith: 'Yes, we have those as far as the front line and then a bit. Also white tape where there are minefields.'

Harvey: 'I hope Jerry has the decency to lay white tapes on his side. I can't see any white lines or green lights. I can hardly see Daddy Jenks for dust. Corp, can I open up for a while?'

Keith: 'I don't see why not. Gunner, don't traverse.'

Until now Harvey has been driving on periscope vision (as per Battle Orders), not the easiest task even in broad daylight. Now he will be opening his own heavy hatch cover down in front of the turret, raising his seat, putting on his goggles and looking out directly into the night. If I have to fire, he will have to duck quick or risk being blinded and deafened by the muzzle flash of the 75. So we trundle on at little more than walking speed, following Daddy Jenks, who is following someone else, around the edge of the larger craters. War for me at this moment is the sight of a small oblong of dust cloud penetrated by a feeble tail light. The inescapable reek of sweet, horrid decay. The filthy breath of a million million maggots. The all-penetrating noise, unidentifiable as to its constituent parts.

And we halt. And we wait. And we move again.

**23.30 hours:** A thick mist has risen around us, adding to the obscurity of the night. Mist that creeps into the turret and brings a chill damp which does nothing to relieve the sweaty dankness of our metal cell. 2 Baker is now a wraith of grey, dappled with white mist – a kind of piebald tank – enveloped in a moving grey-brown cloud. On our flanks we can see only the uneven ground, rucked and pitted by shell-fire. Ghosts of mist drift in the wind across this dark haunting ground, and now and again a denser ghost shows where our Charlie tank keeps level with us fifteen yards away. This mounded shape here is a shattered farm cottage, dead, still, amputated. That square shape there is a

destroyed British tank, its gun hanging loose like a broken limb, the mist smoking from it like a visible echo of its final agony.

Stan: 'How far do you reckon we have gone now, Keith?'

Keith: 'About a mile and a half, I should think.'

Stan: 'A mile and a half? In forty-five minutes? I could walk it twice as fast.'

Keith: 'Would you like to get out and try?'

Me: 'At least he would be able to see. I can't see a thing through my firing sights. How am I expected to fire?'

Keith: 'If we need to fire, we'll just have to point the gun in the general direction of the enemy and then continue by trial and error.'

Harvey: '*Hoch, hoch, mein Gott*, what a bloody fine lot . . . !'

**23.53 hours:** Our engine plays a kind of fearsome tuba concerto with a whole orchestra of more distant engines maintaining the rhythm. If they can use real guns in the *1812 Overture*, then they should also experiment with tank engines in *The Sorcerer's Apprentice*. Farther away now the unceasing reverberations of our guns are like sea breakers on a pebble beach, rising and falling and blending a myriad individual shocks into one continuous pounding. Overhead the traffic of shells sounds like huge express trains riding on rusty wheels.

But at this moment a new and even more powerful sound drives through the rest and rushes in on our noise-hypnotized minds. A new and more lurid light blazes into the distorted world beyond our periscopes. The new sound is a series of separate, deep, crunching concussions, each like a hundred of the biggest guns going off together. The new light penetrates the dust clouds around our tanks, and every mote of dust turns into a spark of flame so that the dust clouds become galaxies of fire.

Keith taps my back, beckons. I swing up beside him. He shouts in my ear. Ragged shreds of words sieve through the din. 'Called you . . . I/C . . . hear me . . . up . . . can't see . . . can't fire . . . stay . . . look out.' 'You mean you want me to stay up and help you keep watch, help you keep watch . . . HELP . . . YOU . . . KEEP . . . WATCH?' He nods and points. The tanks in front have two ghostly heads peering out of each turret. One man's eyes are not enough in this dazzling kaleidoscope of obscurity and light. Keith points to the left. '. . . AF . . . woods . . .' 'WHAT?' '. . . F raid . . . RAF . . . believe tanks . . .'

We give up the impossible struggle to communicate. There is just room for two people to squeeze together in the turret top so I

jam myself into the tiny space beside Keith and stare into the wastes. To our right there is a thin, shimmering curtain of haze, compounded of dust, mist, smoke and reflected flickering light – and, beyond it, a phantom countryside, a mutilated and murdered countryside coming back to haunt us. Above us the searchlights' artificial moonlight and the green Bofors tracer constantly change colour in mad variations on the theme of fire. In front of us the blurred outlines of the four juddering, swaying Shermans are hardly discernible in the shifting patterns of haze.

Over on the left the holocaust swells. Over on our left the other three tanks of our Troop are mis-shapen black beetles swimming in a cauldron of fire. Beyond them the sky and land have become brilliantly clear. It is as though the laws of perspective have been reversed. Images close at hand are indistinct of form and lacking in colour. Distant features assault the eye in clarity of shape and vividness of colour.

Great spouts of flame illuminate a long vista of forest. Some of the fire spouts are brief, momentary. Others rise and fall. Others poise erect and permanent. The main source of light, seen through thick woods, stencils each tree, each branch, each leaf individually, although a thousand yards away. In a hurricane of blast the tops of the trees dance against a sky of incandescent orange. The explosions, starting as vermilion pinpricks, bulge into leaping rainbows of light.

A huge square object rises lazily above the trees, turns slowly over and over, then drops back into the writhing forest. '. . . man tank!' yells Keith, through the bomb detonations, each blast a brief, individual sensation like a thunderclap highly compressed, packing more intensity into less time. The blasts go on and on and on and on, so appalling that the drone of hundreds of planes, great four-engined bombers, passing overhead, is hardly audible.

The physical sensation here on our turret is that of standing on a beach during a cyclonic storm. Warm, evil-smelling air rushes and rips about us, lashing us in the face and tearing at our collars. A spray blows in our eyes, not the clean salt spray of the ocean but a dead, burning spray of dust and filth. And we are still a thousand yards distant from the nearest bombs.

We cruise along on our rough, obscure sea of darkness and, as we pass by, stare like astonished mariners at this wooded island of light with its ever-springing volcanoes and geysers of fire. We are mesmerized by the immensity, the ferocity of fire. We cannot resist its attraction. The sight is so utterly removed from any-

thing we have ever known and imagined that we possess no emotions to match it. Not fear. Not horror. Not terror. Only awe.

I tell myself that there are human beings in those woods, bodies shredded by blast and grilled by flame, minds paralysed or deranged by demoniacal torture. But my emotions and thoughts refuse to respond to the information. It is all too unreal. The ultimate nightmare, confined to a desolate island of somebody else's experiences. Us? We are only drifting past on an endless ocean of night. Drifting past and watching from the bridges of our little, rocking, wallowing ships.

A new thought jars me. If I can see our three fellow tanks as black beetles swimming on a lake of fire, an unseen enemy behind me can see US just as clearly. I swing from the light to the darkness out right. That shattered terrain, devastated by earlier bombings, now reflects the distant wildfire, so like a reenactment of its own travail. And, as I shudder and close my eyelids for a moment, fearful reds and oranges and yellows have seared their complementary colours into my weary retinas: green, blue and purple splashes and flickers have been branded onto my vision.

I open my eyes again. In the gloom I see a Sherman tank. I ask myself why that tank is out of line. Then I realize it is a casualty of earlier attempts to mount this ridge – a lonely, empty, iron monster, a high point of a former tide of enthusiasm and heroism, a roosting place for rats and shadows. I would like to go across and see if its crew is still sitting there like some we have seen, grilled into wizened little black monkey shapes, each shrunken and hard like a beef joint roasted in too hot an oven. But there is no time to stop and sympathize. As we move slowly onward, the abandoned Sherman seems to be swimming away into a lost twilight, a gruesome parody on *Swan Lake*. The haze curtains close behind us and I return to scanning old shell holes. We pass a large crater filled with water. The present fires cause it to glimmer and glow like a torch with fading batteries.

Tanks in front are slowing, halting, becoming erratic in their advance. We ourselves halt. I look out across a meaningless moonscape, whilst behind us and to the left and up above the incredible pandemonium goes on, trailing streamers of scintillating colours.

Harvey asks, 'What's up, Corp? Why have we stopped?'

Stan interjects, 'It's probably a level crossing. They've closed the gates and we're waiting until the train goes by.'

Keith explains, 'Truly, there is a railway line around here

somewhere. This delay might also be caused by a sunken road.'

As we wait, I ask, 'What time is it, Bookie?' who replies 'How the hell can I tell?'

Harvey comments, 'That's not fair on Bookie, Ken. He can usually tell the time at night. He tells it by the stars. But this isn't an ordinary night. It's the belly of Hell, mate.'

Stan pipes in, 'Yeah, I remember one night sleeping out on Salisbury Plain when I had just joined. I said to Bookie, "What time is it?" and he simply took a look at the sky for a while and said "About two o'clock." And it was. So I said "How do you do it?" and he said, "Well, you see the sky goes round the earth like a damn big clock so you can tell the time by that."'

2 Baker rolls forward again. His tail light disappears in the murk. Harvey bangs the engine into gear, revs up, jolts forward and almost crashes into 2 Baker, which has stopped again. As soon as we have slithered to a stop, 2 Baker charges off into oblivion again. I think back again to that broken Sherman which we passed a few moments ago, an inanimate metal thing, yet almost human in its miserable loneliness. Shermans are adequate to live in but susceptible to several methods of instant destruction. The most feared and frequent event is a shot into the engine, which inevitably produces an instantaneous inferno. This has given rise to the nickname applied to the Sherman by the crewmen themselves, of 'Ronson' – after the Ronson cigarette lighter – and the equally graphic description given to it by the Germans, the 'Tommy cooker'.

Very funny, unless you're the Tommy who is about to get cooked!

**8 AUGUST 1944:**

**00.35 hours:** Harvey's next question is 'How far now, Corp?' and Keith calculates, 'About 2½ miles, I reckon. We must have crossed our own front line near Bourguebus now. The green markers have just ended.'

'It isn't like a real front line, is it?' says Stan. 'When my Dad used to tell me stories about the Great War, there was always this huge trench, deep and wide and barricaded with barbed wire. There was no way to get across it. Only down into it. Here there are only bits of holes dotted across the countryside and odd thickets of barbed wire between.'

Keith adds, 'Yes, but with hundreds of land mines hidden in between. Lucky there are flail tanks up ahead!'

'. . . Whacking the ground with those big, rusty chains fixed to that bloody great spinning drum on the nose of the tank' (Harvey).

'Ugly, but beautiful!' (me).

'Yeah. Bookie's going to buy one of those after the war to beat his wife with' (Stan).

'When I beat my wife, I don't need the British Army to help me!' (Bookie).

The distance comes alight with quick splashes of red fire, closely bunched. Each flash is a momentary brilliant blotch of flame surrounded by a wig of curling grey smoke. But just as quickly the black night snaps shut on each flash with the efficiency of a camera shutter. The hazy mist swirls about the darkness again. A louder crash sounds once, twice, thrice. A fan of fire shoots high into the sky, silhouetting a distant Sherman tank. Tiny figures of crewmen come squirming from its turret like maggots out of a ripe Camembert cheese, a new puff of fire lifts the turret into the air. Then there is only a Roman candle of flame spurting the usual fireworks. There is no recognizable shape of Sherman left. There is silence amid the cacophony.

The column shunts forward again, sending up clouds of dust to snuff out that horrendous Roman candle. Stan's microphone clicks, 'God, that dust! When my Dad told his stories of the 1914–18 lot, it was always deep in mud, and water slopping in the trenches. People falling off duckboards and getting drowned. They must have had some dusty days, some Junes and Augusts. But he never told of those.'

Harvey's mike answers, 'With my Pop they were always marching back, just a few survivors behind a brass band, and the French girls saying how they looked young and old all at the same time. "That was glory!" he used to say, "that was glory!" But he could never get around to saying where or what they were coming back from.'

I press my microphone switch. 'My father's greatest moment was making a new pair of riding boots for the Prince of Wales in France. He was a saddler. Joined up in his trade.'

Stan clicks, 'Who? The Prince of Wales?'

'Hullo Oboe 2 Baker. Firing on right. Over.' (Oboe is A Squadron.)

'Hullo Oboe 2 Baker. Those are our other friends. Don't interfere. Over.'

'Oboe 2 Baker, OK. Off.'

**01.00 hours:**  Rumbling. Jerking. We are shunting again. Harvey says that we should train for tank warfare in a railway goods shunting yard. The column has slowed to a halt, engines still booming. The dust falls away. Dim shapes of tanks moving in disarray, breaking up the neat formation of fours. A Sherman is lying jammed diagonally in a gap in a hedge, a huge square shape in a wreath of dark bushes. An ARV (Recovery Vehicle) has linked on a tow-rope already and is struggling to drag the Sherman free. An officer standing on the back of another tank waves vigorously, directing us to look for another way over the hedge. We do not recognize the dark profile of the officer in the multihued darkness but we know he is an officer because he is waving a riding crop. So riding crops do have a purpose in modern war!

Keith orders, 'Ken, get down and find a way through to the left. Bookie, get out and help him. Stan, have you got a cigarette for Ken?'

Stan objects, 'Ken doesn't smoke.'

'He needs a cigarette to guide us in the dark, you idiot,' growls Keith, 'Otherwise how are we going to see him?'

Stan lights a fag, sucks it into a bright glow and, grinning hugely, hands it up to me. 'Don't let the Salvation Army Captain see you, mate!'

I jump off the tank onto rough ground, holding the cigarette carefully away from me. I see somebody lying on the ground. In the darkness I bend down to give him a lift up. He doesn't need it. He is someone left over from a former battle. It seems suddenly to have gone ice-cold. Thirty-ton tanks loom on all sides like impatient elephants. A few pedestrians like myself emphatically wave fag-ends to keep the monsters away from crushing flesh and blood. We are not at ease out here on our feet, treading the dangerous earth. We are not infantrymen. We inhabit a different element, as different as are sea and air. Or perhaps a more pertinent comparison would be the difference between mariner and submariner.

A large hedge looms over us. Bookie and I walk along it, further to the left. I wave the cigarette, and Stony Stratford trundles obediently at my heels, trailing two or three other tanks behind it. I walk on tiptoe, not to avoid scaring the enemy but in the mistaken hope that if I tread on a mine the fact of my weight being transmitted through tiptoe will prevent the mine blowing me up!

It is getting colder. Or, at least, I am. Colder and more fearful.

Or perhaps they are one and the same thing. Then a large gap appears in the hedge.

'No bloody Engineer blew that one,' shouts Bookie at my ear.

'Must have been made by a tank.'

'Too wide for a Sherman by far,' says Bookie, assessing it with a driver's eye. 'Probably a Tiger then?'

'Hope the bugger's not waiting the other side of the hedge.'

'Let's go see.'

We climb up a bank about two feet high. In the darkness the great Normandy hedge towers above us. God! These vast Normandy hedges! We slide down into a narrow lane. There is a similar gap in the far hedge. I return and wave the cigarette in a 'left hand down' sign. Stony Stratford swings left and comes towards me, trailing a cohort of other tanks. Stony Stratford lunges across the lane and bulldozes the opposite bank. Bookie is waiting beyond the hedge, unharmed by Tigers.

We plod into the field beyond. A tiny train of light leaps from the darkness and hisses past our heads. Sounds like rats' claws scratching at the side of Stony Stratford send us diving for the ditch as we hear the unmistakable ripping noise of a Spandau machine-gun, so much faster than our weapons. We cower in the deep ditch by the hedge. Another burst of Spandau swings farther and farther away. 'Firing on spec,' I yell at Bookie. 'Let's move!'

There is a sudden, shattering scream of vertical sound. It could be huge lorries driving down out of the sky, slamming on their brakes, skidding noisily on that vertical road, smashing through brick walls, crashing down on us. That is the noise! And the light is like whirling cauldrons of blistering flame as shell after shell explodes. Heat, noise, dust, poison gases around us, above us. And the force lifting us up and flinging us back into the ditch from which we have just emerged.

'Bloody get down!' screams Bookie.

'I'm underneath you,' I yell back.

The night seems to have become white-hot with the breath of the explosions, the very curtains of blackness roaring into flame from the constant ignitions of blast. It is like sitting under a descending mass of molten steel pouring from a blazing furnace. We try to crush ourselves as flat as cardboard cut-outs. The ditch stinks with the comforting reminder of natural decay.

Stony Stratford still stands in the gap in the hedge. A shell explodes inches in front of it. Another hits the front of the tank and rages upward in fiery frustration. Smoke wrestles with the

darkness. Shrapnel screams over our ditch. A red-hot lump of something hits my hand a glancing blow. In a split second I visualize all the ways in which a human body can be ripped apart, butchered, squashed, spattered, spread-eagled, grilled, racked with a million agonies.

Lord, let me be a tree standing guard on a Normandy hedge-row, asking no more than to befriend rooks, bees and squirrels, my greatest act cross-pollination with some distant sibling. But then war destroys trees too, smashing some and leaving others to die, their barks stripped, in unimagined agonies. Then let me be a mole or a grass snake, able to squirm into the safer recesses of the earth far deeper than this exposed ditch. But then war delves under the earth itself, flinging inanimate sods and living creatures alike up into the flaming horror of human-invented destruction.

Someone turns off a tap far away, and the shower of shells stops. Stops! Stopped!! Stony Stratford lurches forward from the gap in the hedge. Slowly, painfully, fearfully, suspiciously, we begin to slither out of the ditch and, flat on stomachs, crawl . . .

'Have you Yeomen had your legs shot off? Or got them caught in a game trap out poaching?' drawls a voice high behind us. A dark figure in a beret stands on top of the bank at the gap in the hedge.

'You can get shot up if you effing want, Sergeant Bloody Prendergast,' says Bookie heatedly. 'Me, I don't mind filthying my belly as long as my backside is safe.'

'Now, now, that's not a nice way to speak to sergeants, Lance-Corporal Flaming Hooker,' chortles Tommy Prendergast. 'Here, Ken, lend me that cigarette, will you? I've got my entire troop waiting to come through.'

'This is our hole. You go find your own sodding gap in the hedge,' yells Bookie, heading for home in his safe co-driver seat.

I flick the still-glowing cigarette to Tommy, run after Stony Stratford, swing myself up onto the back deck, gingerly avoid-ing the flailing, skidding tracks. Ahead in the darkness there is a vibrance and a yellowish-brown tinge. Then a faint red light shows through the eternal eddies of dust. Fresh bright fire streaks out ahead, away from us. Lines of fire interspersed with odd flashes.

I shout, 'Keith, do you realize we are now on the left of the march since we came through that hedge?'

Yells back, 'Yes, I know. But we're all out of formation

anyway. We'll just keep moving. Get back in and traverse left.'
(And into his mike) 'Driver, close down again.'
I hit my seat, grab earphones to hear Harvey sing, 'OK, Corp, going down. Ground floor – perfumes, toiletries, ladies' knickers. Closed down now, Corp.'
And before Keith can utter . . . 'Hullo Oboe 3 Able. Nasty people in holes. Over.'
'3 Able. Keep moving unless they interfere. Over.'
'3 Able. OK. Off.'
Slotted into my hard, narrow seat I feel more secure behind solid steel walls. In my own element again. My right hand closes over the metal grip, twists to the left; the turret spins swiftly left. Through the periscope I see the burning woods clearly, with the ground in between fitfully lit. I look through the gun sight telescope. Individual trees stand clearly in the light of the raging fires. Stony Stratford rolls over the bumpy terrain and I travel sideways, looking out on my own private oblong of blazing world.
Harvey's voice chuckles through the earphones: 'God! They've got some long miles in France.'
'Well, I reckon we should be just about on the German front line,' replies Keith. 'But no trenches like my old Pop used to march back from after capturing them,' says Harvey.
The front line! My father did not talk about it, but I have read Sassoon and Blunden and Ian Hay. This is so different from the leap into the endless trench, stretching from Vosges Mountains to North Sea coast, packed with enemy. We do not struggle with him, bayonet against bayonet, but we have, since landing, invaded his shelters and his dug-outs after he has retreated. We have picked up his letters and tried to decipher the strange Gothic script. We have seen him surrender in his baggy, field-grey uniform and his easily recognizable pudding-basin helmet. We have heard his guttural language and smelled his strange, animal smell, a foul odour acquired from chemically treated clothing (we also carry that smell on our khaki), constant proximity to putrefying flesh and consumption of rancid food.
We have not yet had opportunities to converse with our prisoners. We have simply waved at them, frightened, grey-faced men, frequently much older or younger than any of us, often shocked into incontinence, indoctrinated with a fear of being shot on surrender. We have waved at them in a rather sympathetic manner and have pointed them back towards the rear.

Now we are moving through their front line. Yet all that is happening to me is that I am sitting at a periscope, as though in front of a tiny television set, watching a slow war film and travelling sideways-on sedately in the wake of known comrades: Tom Boardman, Colonel Forster, Daddy Jenks, Sonny Bellamy, Trooper Judge, Old Uncle John Peel and all!

**01.30 hours:** New flame ahead and right! Too much like splashes of incandescent blood on the night! 'Oboe 2 to all stations. Nasties right front . . . Wow! Got one! Got one! 2, off.' Fire mushrooms up from our right front. A slow spread of fire. Too slow to be a Sherman brew-up.

'Oboe 2 Able. Two Nasties at two o'clock. I've been hit. Engage! Off.' Slamming guns. Vicious, aimed, intended death. Not like the more patient grumble of the artillery, fired from afar. Another slow, slow fire-mushroom. '2 Able. That's another Nasty gone. Are you all right, Sunray? Over.' '2 Able. Hit but still aboard. Keep shooting. Off.'

BANG-SLAM! BANG-SLAM! A fast fire. Roman candle! 'Ronson!' God! That's a Sherman gone up. 'Somebody in 2 Troop, A Squadron,' comments Keith. More fires linking into a chain of brilliance against which our tanks move as black blotches surrounded by haloes of crimson, shimmering silk, their own haloes of dust catching the firelight.

'Hullo Oboe 2 Able. Oboe 2 has bailed out. Have brewed another hornet. 2 Able to 2 Baker, 2 Charlie, look out right! Off.'

More vicious close explosions, gunfire and burst together, against the continuing background of barrage and tank engines. Flashes upon flashes upon firelight upon the more distant flickering battle glow. We come to a halt behind another Sherman, known only by its tail light and humped turret. We wait. Silent. Thinking. Almost able to hear each other think in the close proximity of sweating bodies within the darkened tank.

Stan: 'That makes . . . three of ours . . . for three of theirs.'

Harvey: '2 Baker and 2 Charlie of A have bought it.'

Stan: 'That's not bad though, three of them for three Shermans. They usually say three Shermans for every one of them.'

Keith: 'Three Shermans for every Tiger. Three to a Tiger.'

Streaks of light shoot out of the ground on our left. The Sherman in front starts to traverse left. I twist the pistol-grip, spin the turret, eye to telescope, crosswires swinging and dip-

ping at the source of the firing. Keith orders, 'Gunner, fire! Reload HE. Driver, swing left. Co-driver, fire when on.' I stamp on the firing button of the 75mm, then on the co-ax button. The huge breech of the 75mm leaps back into the turret, jams against its springs, slides forward again into place. It thunderclaps in my left ear. The automatically opened breech coughs stifling cordite fumes. In my telescope the mighty muzzle flash of the 75mm obscures and blinds momentarily as a tracer spark leaps across the brief space and slams into the ground by the German machine-gun. Stony Stratford rocks back on its haunches under the power of the 75 recoil. Streaks of smaller tracer from our Browning follow the same trajectory as the larger shot, sparking around a hardly visible dug-out. The tank in front also bangs off a 75mm shot.

All this within a second, without breathing, without thought. Our 75 had been loaded with AP (armour-piercing shot), not necessarily effective against men in a hole in the ground but a very discouraging package to receive, travelling at two thousand feet per second with force sufficient to split open any tank but a Tiger. Now Stan is ramming a high-explosive shell into the breech. He slaps my leg, signing 'loaded' – even while I think, 'Those must be SS fanatics in that slit trench.' A touch on the traversing grip, stamp on the button, flame, thunder, shock, leaping tracer hitting target. Then fire, massive, sudden, vivid, brief. A flame of sunset condensed a thousand times, mixed with a thousand lightnings with their accompanying thunders, compressed into an area in, and above, and around the dug-out. Expired in a split second. But in that brief flame a whirling mass of sandbags, a shattered machine-gun, metal objects, equipment, boxes, helmets, pieces of human bodies, all clear, distinct, in Technicolor, quickly dying.

The tank in front of me fires half a second after me, and the shell exploding seems to catch the descending vision of hell created by our shell and throw it up even higher, more brilliant, more rapidly disintegrating. Leaving a silence even more stunning. And the darkness, double black darkness blooming with purple and green flashes. Which allows me to go green myself, unashamedly, and swallow the bile rising in my mouth.

Keith comments, 'Good shooting! But keep your eyes peeled.'

Good shooting? Artillerymen fling mightier shells but are not sitting a few yards away from the victims, watching their fate. The infantry move closer to the enemy, but they do not wield a weapon like the 75mm, HE. RAF bombers and fighters hurl their

own types of devastation at the earth, but they swoop past at 300 m.p.h. and are gone before the explosion erupts. The Navy uses immense shells, but fires them at an enemy beyond the horizon. We sit here, within yards of the enemy, as though sitting in our, or their, own kitchens and parlours, press a button and then watch a human being shredded to death. And cheer. All right, he was a Nazi. All right, it was 'him or us'. All right, we did it under orders.

Good shooting! I suppress the desire to ask if any evil thing can ever be good. But then that would only be reviving the old, old questions. Questions which I had answered the day I registered to wear the King's uniform. The day my friend told me that he was going to register as a Conscientious Objector. And I had said, 'And I'm a Conscientious Objector to swastikas!'

**01.50 hours:**    Once again we have fallen into the pattern of stopping and starting, crawling forward slowly over the shattered fields. The famous formation of fours has now completely broken up. We push on in random groups. The barrage still continues overhead but there is an increasing network of blazing tracer bullets criss-crossing our front, coming mainly from our flanks. Much of it seems aimless and partly spent. Rumours from other battles. Fairly harmless while we stay inside the tank.

'Hullo, all stations William.' (That's the Colonel's voice and code-sign.) 'Hullo, all stations William. Our friends on right have been held up. Message from Supreme Sunray asking us to keep moving at all costs. I'm relying on you all to keep moving, keep pushing on, whatever happens. All stations William, off.'

Harvey: 'And who the Hell is Supreme Sunray?' (Sunray is the tanker's name for Commander.)

Keith: 'That must be Montgomery himself.'

Stan: 'Sunray? I like that. Supreme bloody thundercloud, that's Monty.'

Harvey: 'Monty at this time of night? He must be having a bad dream.'

Me: 'Aren't we all?'

Stan, sharply: 'Commander! People left, ten o'clock, slit trench.'

Me, shouting: 'I see them. Can't depress the gun. Too near. No go!'

Keith: 'Hold it. I'll try a grenade.'

I feel behind my head for the little satchel containing Mills

bombs. Before Keith can act, the tank commander in front and someone in the slit trench have thrown grenades at each other simultaneously. Twin flashes light slit trench and tank turret. Commander's head disappears. Keith grunts, lobbing a grenade. Commander in front pops up, flings bomb. Two flashes. Both down by slit trench. No more movement down there.

Commander in front, unrecognized, points energetically down right. I traverse swiftly. Through periscope see another slit trench. Eye to telescope, depress gun fully, cannot see trench. Back to wider periscope. In the trench, feet away, wearing familiar coal-scuttle helmet . . . a German, pale face turned upwards toward us, a kid, staring in frozen, paralysed horror. He does not move. Neither do I. Our tank rumbles past, almost shaving his grey chin. I realize what we look like to him: thirty tons of crushing steel, fifty feet of churning iron track swaying towards him like a diabolic mincing machine. And our great gun, yawning steel-black, probing down, straight at his head.

Had I fired the gun, our shell would have screamed over his head. But the flame and concussion would have killed him. Already the memory of that pale, paralysed face is imprinted for ever on my mind's eye. I shall take him, nameless and for ever unmoving, with me wherever I go. And I want to go back and tell him that it is only Stan and Harvey and I and the others who were passing by. Just ordinary, inoffensive youths like himself.

**02.02 hours:** I sit bolt upright in my seat. I must have been dozing. The constant sway of the Sherman on its springs, the incessant, unchanging thunder of the barrage, the interminable roar of our engine, the steady hiss of the wireless in the headphones, the repeated sequences of flashes and darkness, flashes and darkness, through the periscope, the stuffy atmosphere permeated by sweat and cordite, the lateness of the hour – all these induce sleep. This is one of the great problems for the turret crew.

I blink furiously for several seconds. Reach for my water-bottle. Take a swig of the nauseating chlorinated liquid with a formula hardly approximating to $H_2O$. I breathe more deeply, but the foul, oxygen-starved air gives me no boost towards wakefulness. I rub my eyes vigorously. Bounce up and down in my confined seat. I reach for my water-bottle. Cannot find it. Eventually encounter it lying on my knees. Take another mouthful. It has not improved with keeping. Normandy vintage 1944.

Not nice *eau*. I find myself dozing again. Sleep is one of the worst
problems . . .
   It is dangerous! Dangerous for me to sleep when at any
moment I may need to swing the guns blazing towards a target
capable of destroying me within seconds. It is even more peril-
ous for the driver down in his little secluded compartment. If he
and his co-driver doze off, nobody need know. Once he has set
the Sherman moving in gear and taken his hands away from the
levers, the tank will go on and on for ever if he falls asleep. On
and on past the fortified villages, past St-Aignan and past
Falaise, on and on through France with the crew fast asleep and
nobody able to stop the tank. Crewed by the Sleeping Beauty
and the Flying Dutchman and Rip van . . . sleep is the . . . sleep
is . . . great problem . . .
   I rouse, ask, 'Harvey, are you awake? Harvey?'
   Harvey: 'Of course I'm awake. Who do you think is driving
the ruddy tank?'
   Stan: 'The speed you're going, we would move faster if we all
got out and pushed.'
   Harry: 'Well, then, do me a favour. Shut your cake-hole . . . or
else get out and push old Daddy Jenks or whoever it is there in
front, and then we can speed up.'
   Keith: 'We lost Daddy Jenks ages ago. I don't know who is in
front of us now.'
   Stan: 'The Ancient flooding Mariner!'
   Harvey suddenly begins to tell a yarn, 'Remember Weston-
super-Mare? And camping on the golf course? Remember the
latrine was a big pit? And just a long pole over it, to sit on? And
on the Saturday night old Preece W. had been out on the booze
and had come staggering in and was sitting over the pit. He says
he fell asleep. But really he was dead pissed. Whatever it was, he
suddenly sways backwards and forwards like one of those
clowns on a stick. And his legs go up in the bleeding air and he
does a perfect high dive into the pit, head first! Oh boy, poor
stinking Preece W., up to his neck in it – the wrong way up!'
   The sufferings of Preece W. down in the miry pit carry us
another fifty yards on the route to a sterner Hell, laughing fit to
bust. We must look like a Hogarth caricature or an illustration
for *Pilgrim's Progress*, of sinners carousing on their way to
Damnation.
   Stan: 'And then he crawls up out of the pit, does Preece W.,
and looks over the edge like Chad looking over his wall, and
somebody shouts, "Wot! No rhubarb?" '

Harvey: 'And somebody else, "Doesn't your mother use Persil?" And Jim Bradford yells, "Don't go down the mine, Daddy, there's plenty of manure in the midden!"'

Stan: 'And we all grab him and carry him down to the shore and drop him in the sea. And he would still be there now if we hadn't scrubbed him in sea water and carried him back to his tent.'

Harvey: 'Poor old Preece W. He still smells different from the rest of humanity. A bit like Bookie, really.'

Bookie: 'Next time I see you digging your little pit, son, twenty-five yards from laager, I'll push your face in it!'

We sit staring into the dust haze of the treacherous night, chortling at the blessed memory of Preece W. Our headsets are silent: the guns grumble into our consciousness again. Stabs of uncertainty, of dawning fear, throb through us as we view the unfamiliar, yet so similar landscape of enemy territory. (This is France, under the horror of enemy occupation, the sinister domination of the enemy's will.) But the tragedy of this night is interrupted again and again by little explosions of mirth from those apostles of Preece W. who had been destined to be there to witness his transfiguration in the pit. Saving visions of Preece W. crawling out of the hole vie with images of Tiger tanks lurking beyond the haze. My favourite Preece W. wisecrack came from our learned clerk-corporal who said that Preece W. evidently had ambitions towards 'Ordurely Corporal'.

'Hullo, Oboe 4. Intense firing on my right. Oboe 4, over.' (Troop Leader reporting to Squadron Leader.)

'Hullo, Oboe 4. Press on ahead, over.'

'Hullo, Oboe 4. Shall I engage? Over.'

'Oboe 4. Engage if impeded, but don't hang about. Over.'

'Oboe 4. OK. Off.'

Sporadic bursts of tracer still spurt in and out of the eternal clouds of dust around us, their freakish light making the tanks seem even more insubstantial and ghostly. Tracer bullets speed back and forth in every conceivable direction, at all angles to the horizontal, and in all stages of ellipse, as the muzzle velocity dies and the bullet goes cold. There is a naked feeling about advancing through a jungle of shadows and false lights with our left flank wide open, behind the enemy lines. In front, on the right, behind, the massed column trundles on in perpetual bottom gear, flinging up its conveyor belts of dust. But on the left we are alone, unprotected, menaced. Enemy troops are out there, and some of them belong to the SS, the name we have been brought

up to dread. But our periscopes reveal only a few yards of rising land. And then the darkness, constantly splashed by flashes which paint alien faces and enemy tanks and hostile guns on the black canvas of lost night. Now and then something taps or scratches in ghostly seance on the outer wall of the tank. But we are safe if we stay inside, safe from the unmentionable hordes that people the darkness, safe until a mine explodes underneath or an 88mm erupts in sudden fire out of the darkness and smashes through the turret wall . . .

Overhead the Bofors gun still flings its fiery shells amid a confusion of contending flashes. But we here seem to be marooned on an island of darkness. We move from one anonymous, unidentified spot to another. The lack of definition contributes to a continuing sense of unreality and non-event which blunts the scalpel-edge of fear. But fear hovers around us, nearer than the close, hard turret walls, ready to spring back into our minds at the slightest variation in the pattern of flashes across the night.

Stony Stratford, our cramped but efficient Sherman, sways back and forward like a boat on a gentle tide as we follow someone's red light at little more than walking speed across an unknown, devastated cornfield.

**02.38 hours:**   The constant crackle of A set atmospherics clicks into a more subdued and expectant hum as someone nearby presses a microphone switch and his A set begins to transmit.

'Hullo, Oboe Able.' (Tom Boardman in the lead tank.)

'Hullo, Oboe Able. Code-name "Fly by Night" now! On target on time. All clear. Halted. Over.'

'Hullo, Oboe Able.' (The Colonel's voice.) 'Jolly good show. All stations William press on to "Fly by Night". Oboe Able over.'

'Oboe Able. OK. Off.'

Stan: 'The lead tank is there then? That's the objective, isn't it?'

Harvey: 'Gawd, that was an easy battle.'

Keith: 'It isn't finished yet. It depends how Jerry reacts now we are behind him.'

Bookie: 'I know how I would react with a Hun armoured division behind ME!'

The tremendous percussion of the barrage seems to have been left behind, back with the burning tanks and blazing woods. The erratic crossfire of machine-guns has also fallen away behind us. The ground is noticeably more even every minute, less pitted by the fury of former battles. We are now coasting along comfort-

ably within our own private dust cloud. The night has become much darker as the fires have died away. I am still riding sideways, traversed left, watching out over our exposed flank. There is only blank blackness to be seen. Nothing moves, nothing looms on that side.

**02.55 hours:** The haze has taken on a much more silvery sheen. It cannot yet be dawn. I wonder about the strange radiance on our left. At the same time I am struggling against sleep again as we meander slowly through the abandoned country. I wonder whether I have dozed momentarily as I become aware of a continuing conversation.

Stan is saying, 'That means that Hank has arrived already? We can't be more than a few yards behind.'

Keith: 'Don't forget the formation got completely mixed up back at the sunken road. We should be nearly there, so keep a special look-out. We don't want to run down any pedestrians.'

I reach for my haversack and find my bar of chocolate. It is Duncan's blended chocolate and comes up as part of the rations. (The Yanks get ice-cream and fresh bread.) Duncan's blended has a mauve wrapper. Duncan's are an Edinburgh firm of which I had never heard before I joined up. I wonder whether Duncan's have a monopoly of supply, because we never see any other type. I carefully break off two squares of Duncan's blended. Keep-awake tactics! At the moment all eternity and the entire universe are embodied within my two squares of chocolate.

The atmosphere in the tank is now fetid and enervating. Bookie, down in front, has difficulty in holding his water for long periods. Some time during the night he has relieved himself into a tin ammunition box. In the turret when such things happen we pass the box up immediately and empty it over the side. Keith, Stan and I share the joke of shouting 'Gardez loo!' in the style of London chambermaids when they emptied their pots into the streets centuries ago. But Bookie does not empty his tin, and a rancid smell emanates from his corner of the tank (Stan says it is like a Duchess's bedroom the morning after), causing further deterioration of the already poisonous air.

The shadowy group of tanks ahead is slowing to a stop. We shunt forward. Stop. I doze. Shunt forward. I chew the chocolate still in my mouth. Stop. Doze. Shunt . . . trees close left. Perspiration from my forehead and eyebrows has smeared into my periscope. Take out handkerchief. Wipe the lens. Polish it.

Really I am polishing my consciousness. Polishing away the sleep. One more lurch forward. Halt! The silver radiance continues to increase. More Bethlehem angels? Or angels of Mons?

**03.00 hours:**   It is like ringing up the curtain on the first act of a play, the darkened theatre giving way to the vivid detail on stage. Or perhaps it is like watching a grey photograph in the developer gradually clearing into black and white. The column has halted. The dust cloud has subsided and the new breeze moves the mists away – rather like the falling of the Seven Veils. A brilliant full moon appears. In the moonlight the fields are a dull, flat pewter. The details of trees, branches, leaves are etched in fine black detail on the dull silver background. Scores of armoured vehicles are square, solid, black shapes near at hand. A long, shadowy hedge runs across our front. This must be the objective code-named 'Fly by Night'. The Regiment is strung out in bunches of tanks and single vehicles along the line of the hedge. Behind the tanks are low, flat personnel carriers moving up, each emerging from its own private shroud of dust.

Reluctantly I traverse the gun away from the confused but fascinating pageant of the Regiment sorting itself out. My view to the left is restricted by another high hedge or small wood. I am alone on the edge of a strange, uninhabited world where man has never trodden. I know that tonight we have successfully achieved one of the most unusual and imaginative feats of arms in modern war. We have used the tank to the utmost of its ability, taking up station well to the enemy's rear. But it is all unreal and has no more substance than a small rectangular photograph of a moonlit field and a dark hedgerow. So I sit in my little monk's cell all alone, wearing the contemplative habit of khaki denim, and I study my little world, and think . . .

First I try to stop myself thinking, but only find that I am thinking about the stupidity of stopping myself thinking. Then I try to think about 'out there': about the enemy and what they are doing and what would be my reaction if . . . But that is aimless and superfluous because my mind and body are trained to react instantaneously to any abnormal movement out there. If something, anything happens, my fingers, eyes, feet will have responded even before I begin to think. So why think? Because I can't stop thinking? Because those horrific hordes of murderous SS fanatics and thugs rush forward and occupy and terrorize the vacant mind! Very well then, leave eyes, fingers, feet to react to

the mysteries of the moonlit vista and let the mind travel its own route. But are my thoughts worth thinking? Are they of value or interest? What am I but an extension of the tank gun and the wireless set, a more subtle, adaptable and considerably cheaper version of a solenoid, a mechanical joint in a mechanical system? Well, don't think about thought. Just feed on mental images whilst the eye holds the physical image. Populate the mind with benign images so that there is no room for the Hunnish invaders: think about the December day on the golf course at Aberdeen when, clothed only in vests and shorts, we watched an immense black blizzard drive in on us from the North Sea and then, abandoning our physical training antics, huddled together for warmth, for very life, in bunkers on the golf course. Waking at daybreak upon a bed of snow on Thetford Heath and finding my eyelashes frozen together. Winter nights in a rusty Nissen hut, jammed with sweating humanity, the old iron stove raging red hot and the Troopers trying to surpass each other with stories of amorous adventures. Marching over Scottish hills, fifteen miles at a stretch, in driving rain. Standing all night on a train and seeing Highland cattle for the first time. Learning to drive a clumsy truck through the frozen dales of Yorkshire. Firing a mighty gun at paper targets on a freezing Welsh coast range on Christmas Eve. The Drill Sergeant's profane insults ('You lot waddle like pregnant ducks' – they all said it). The Training Instructor's command to wade a rushing river, fully dressed ('Never mind if your mother did tell you to keep your feet dry'). The Duty Officer's harsh insistence that I parade every evening behind the guard until I had removed from the barrel of a 1914–18 rifle a rust spot which the Armourer himself said was irremovable.

Moments of rare exhilaration and fascinating surprises amid the endless deserts of meaningless functions and idle repetitions and needless obscenities and odious environments. Already the pains of eighteen months soldiering soften in the memory, and the happier moments remain. In soldiering the suffering is like mud, the joys are like diamonds, and time is the sea which swills away the mud, leaving the diamonds sparkling clear.

Now Normandy: an oblong silver field and black hedgerow. The clarity and utter stillness of the scene have a Wagnerian effect of grandeur and inhumanity. Why is it that the human mind can escape to fly free in many worlds whilst the body remains clamped within an immobile physical trap, as cramped and solid and material as a halted tank? I realize that Stony

Stratford has started rolling. We are moving into a line of tanks much more spaced and ordered than when I last looked in that direction. Infantrymen crouch by the hedge, staring through and beyond it. Others set up mortars and move equipment.

We swing right and left again, and come into a gap between two Shermans. The well-known profile of Hughie Macgregor looks down from one of the tanks. He climbs out of his turret, judges the distance, leaps across the gap onto our tank as we roll into line.

'Driver, halt. Switch off. Gun front. Crew, rest.' Hughie Macgregor's voice sounds from above. Heard in the new silence. 'We did it. We reached "Fly by Night" on the dot and within fifty yards. A little mixed up in the ranks but all sorted out. Good work, all of you.'

Stan shouts from behind the gun. 'Did we lose anybody, sir?'

'Only one tank of C Squadron missing. Sergeant Pearce. No sign of him. Nobody saw him hit or in trouble. Probably down a bomb crater somewhere. We'll keep on hoping. Right, ye can get out for a while, one at a time. Empty bladders. Have a smoke. But keep close. Don't wander off. We don't know about mines. And things might get sticky at first light. I'll keep you genned up.'

His boyish face disappears from the circle of silver sky above me. Keith's moustache and bushy eyebrows interpose. He shouts down past me. 'All right, Harvey. You stretch those driver's legs first. Five minutes.'

Harvey grumbles, 'About time. My arse has as many corns as a postman's feet.'

'Bookie, take the driver's seat while Harvey is out! But empty that stinking tin of yours first. Out of your own hatch, for God's sake!'

# ACT III

# Dawn Attack

**8 AUGUST 1944:**

**03.10 hours:** I take my five minutes breather. Climb stiffly out of the turret. Drop gingerly to the ground. Pins and needles shoot up through my cramped ankles and calves. I trot vigorously on the spot for a few moments. After the clammy heat of the turret it seems cold here outside, with wisps of damp mist rising from the fields. I move to the back of the tank where the engine outlets are still hot from the night trek. I lean against the warm armour and sniff the peculiar homely odour of hot rubber, iron and grease.

A weather-beaten Black Watch Corporal strolls up and leans beside me.

'Cigarette, Jock?'

'No thanks. I don't smoke.'

'Good lad. Keep it up. Me, I smoke forty a day. If can get. They started me on it when I was a boy soldier. Now I can't break the filthy, sodding habit. Hard on yese when the ration's only seven a day.'

'We share out the fags and sweets on our tank between smokers and non-smokers.'

'Don't have any non-smokers in our lot, selfish buggers!'

A group of tank officers stands near us, talking to the Black Watch Colonel. The officers look as though they are dressed for a fancy dress ball. One has a leather jerkin. Another is wearing denim overalls. One has a cricket sweater on. Others are in full battledress. One or two are in shirtsleeves. Trousers range from sloppy corduroys to neatly pressed serge. The Black Watch Colonel has a red hackle in his bonnet. Our Colonel is there, and David Bevan and Tom Boardman. Several carry the habitual riding crops which serve for nothing more lethal than to decapitate inoffensive dandelions.

Corporal: 'Cooking up some more nice, enjoyable warfare for us.'

Me: 'Looks like it. What was it like for you, riding in those new carriers?'

Corporal: 'Hell. Shattering, shaking Hell. Better than walking.

I wouldna be a tank man for a General's pay. Only advantage yese have got is wearing shoes.'

Me: 'At least we don't risk treading on anti-personnel mines.'

Corporal: 'Very small beer, Mac, compared to these 88s yon Jerry throws at tanks. Me, I've walked all the way from Alamein and s'w'elp me God, I'll walk all the rest of the way tae Berlin and back again, so's I can keep away from them kipper-smoking furnaces, yon Shermans.'

We stand there moon-gazing for a few moments in one of those frequent casual encounters thrown up by the ceaseless permutations of war. The Black Watch Corporal carefully pinches out his cigarette half-smoked and equally carefully puts it away in a packet. Will he ever smoke the other half?

'My time's up,' I say. 'Must get back in now and let somebody else get a breath of air.'

'Guid luck, t'yese, lad. See yese in Berlin or Glasgae. Won't catch me getting in one of those buggers. Nice safe hole in the ground, that's me. Who wants tae sit up there waiting for Jerry tae blow his head off?'

While Keith takes his stroll – and makes a rather self-conscious pause behind Stony Stratford, hurriedly 'doing himself up' when another Black Watch Jock accosts him – I sit on the turret top and study the line of sixty tanks, nosed up behind the endless hedge, nameless until christened 'Fly by Night' by some witty Canadian Staff Captain. Away in the distance, back towards Caen, sound of machine-guns and heavier explosions. Behind us and to our right rear the moonlit night is red with flashes. But here all is doom quiet. Is it possible that the Germans have not realized that we are here?

**03.30 hours:** 'Driver, start up!' The great engine roars into life again. We grab our headsets and pull them on over our berets. 'Driver, advance. Come right. There's a hole in the hedge about twenty yards along. Loader, load with HE [high explosive]. Gunner, keep your guns pointed through the hedge and ready to fire co-ax.'

Harvey drives the Sherman through a gap too large for it. Obviously Tigers have passed this way. Other tanks are moving ahead of us. As we pass through the hedge, we fan out on the other side. Hedge 'Fly by Night', like most Normandy hedges, is sky-high and forest-thick. Now, passing through it, we can see, three or four hundred yards away, the jumbled outline of a small village with woods or orchards at each end. ('All the villages

have been fortified . . .' said Hughie.) Mist still obscures the distant houses, but nearer at hand the bright moonlight turns a large expanse of corn stubble into the semblance of a snowfield. 'Hullo, all stations William. Fire in your own time. Now! All stations William, off.'

Keith: 'Gunner, take the edge of the village straight ahead and douse it with co-ax. Co-driver, same target. Fire in your own time.'

I make a small adjustment of height and direction, a touch on the traverse grip to the right, a push on the elevating wheel forward and downward. Stamp briefly on the co-ax button. The familiar dotted line of fire leaps across the space as the Browning thuds for a moment or two. The tip of the tracer hits what might be the roof of a house in the huddle of shapes. I depress the guns fractionally. Through the telescope I can see our artillery shells bursting along the target. I can hear their explosions coming with the rhythm and frequency of a dog barking excitedly. I touch the floor button again with my foot, feeling the metal disc clearly through my illegal thin-soled shoe. Hobnailed War Office issue boots do not make for efficient firing in a Sherman. (Perhaps that's why we have a better firing record than 'regular' regiments.) Tracer streaks again, right on target. I put my foot down and keep it down, at the same time twisting the traverse grip in my right hand. Tracer hoses the distant village edge as the Browning thuds solidly away.

Down in the front compartment Bookie is also firing his Browning, which he controls directly by hand (which I cannot do because my Browning is invisible and inaccessible to me on Stan's side of the big gun). My tracer overlaps and merges with the tracer from other tanks. Alien tracer, probably enemy, crosses our front from the right. The multiple lines of fire criss-cross and interconnect like the warp and woof of a brightly coloured oriental carpet.

I keep the Browning firing until the entire belt of 250 bullets is exhausted. A dull click. Stan whips the old box away, pushes in a new box, threads the metal end of the new belt under the flat cover of the Browning and out through the other side. Cocks the gun manually. Slaps my thigh. Loaded! Again I tread the button. Traverse back and forward along the front edge of the village. More large shell flashes mingle with the sparkle of our tracer. This is like a tremendous firework display. Correction: this *is* a tremendous firework display. Great fun. There is no response from the enemy. There is no feeling of wounding or killing men.

We are simply directing pretty jets of fiery sparks into the mists
and the half-seen huddled buildings, just as we did on the
Stanford battle area in East Anglia.

The sight and sound of thousands of bullets a minute
coughing from sleek black barrels, and fifty jets of brilliant red
dots from our other tanks playing at patterns over the field, the
sense of power under my hands and feet, the telepathic unity of
so many pals who, with me, have dared to ride right through the
invincible defences around Bourguebus – all these sensations
add up to exhilaration and excitement. Fear, death and blood-
shed do not obtrude into our thinking. Actual enemy bodies and
machines are nowhere to be seen. So the symphony of disci-
plined noise and the tapestry of flaming colours and the ballet of
moving vehicles and men create a kind of glory. And the misty
village walls add an element of mystery and intrigue to the
splendid pageant.

As I traverse left and right at will, I catch glimpses of the entire
scene. All the tanks of at least two squadrons – and that will be
nearly forty – are strung out in a straggling line a hundred yards
or so in front of hedge 'Fly by Night'. The moon continues to
silver the wide field and to throw up the tanks as huge, bleak,
vulnerable masses of black. At the far side of the vast field,
hedges and trees merge with the mist and smoke into an
incomprehensible medley of shapes, writhing and changing.
Among the jagged, leafy contours of nature about a dozen
houses show as squared, lighter grey blotches, dancing wildly in
the swirling smoke and haze. Shell flashes appear like brief, fiery
grins – red mouths momentarily opening and closing amid the
greys and blacks. Into this lunatic scene quick, random machine-
gun bursts frisk in dotted arrows of flame as distinct from the
long, continuous dotted lines of earlier firing. Where tracer
strikes against a solid wall, a tiny sprinkle of sparks radiates
upwards and as quickly falls away. The noise of the bursting
barrage slams back at us, still with that irregular barking dog
rhythm – whoof-whoof; whoof-whoof-whoof; whoof-whoof;
whoof; whoof-whoof-whoooof!

The only perceivable reaction to our pandemonium consists of
a few unidentified curls of tracer flighting straight across our
bows, the overspill from another battle on our right. Then, to left
and right, the low, headless tanks – the infantry carriers – crawl
slowly, cautiously forward across the wide field. Surely some-
one will contest the progress of the infantry carriers? As I think
that thought, six small but angry red flashes merge into six puffs

of acrid black smoke along the moonlit ground near one of the carriers.

Harvey: 'Jerry Minnies on left.'

Keith: 'Yes, I see.'

These are the German multi-barrelled mortars which drop shells in neat batches, causing consternation, if not fatal injury, to the person who happens to be sitting at the centre of the bursts. Infantry and dismounted tankmen hate the 'Moaning Minnies'. You hear them coming as a chorus of distant howls, but when they start to drop there is no time for dodging, simply a swift swishing noise before the six drum-roll explosions occur. Inside a tank one is normally fairly safe, but here again the tankmen have a vivid idea of what will happen the day a Minnie drops vertically, straight down inside the turret.

A world-rending flash between two cottages! An earthquake rages out of the flash! I swing the turret. Stamp. Watch. Other tracers join mine in pursuing the author of the earthquake between the cottages. Flash, flash, flash of our shot impacts. And that's it! Before the fear-chilled blood can heat into battle frenzy, that battle is over. An SP (artillery gun mounted on a tank chassis). It would have retreated even as we fired.

The effect of its one shot is evident on an infantry carrier which is now crawling round and round in circles like a cockroach with its back legs crushed. There is frenzied activity around the carrier, which slows to a halt facing back towards us. The SP's shot had probably smashed one track of the carrier. The driver had been hit or had baled out, leaving the carrier running in circles on its one good track. The distant figures of the infantry-men rise from where they had thrown themselves on the ground. Their steady advance starts up again, shadowed closely by 4 Troop. A Highlander doubles up and collapses. Another bends over him for a while and then moves on. A group of Minnies lands in the midst of 4 Troop, obscuring the Shermans. They plough through the dispersing smoke like Navy destroyers through heavy seas.

Radio static dies and changes into the hum of an A set switched to transmit. 'Hullo, Roger 3.' (David Bevan calling Hughie.) 'Support Roger 4 at a distance. Roger 3 over.'

We trundle slowly forward. The Highlanders are now moving into the mists on the outskirts of the village. 4 Troop, well spaced out, sit and watch a hundred yards behind. We move half way across the field and halt, also watching the infantry, watching 4 Troop, watching the menacing houses. The artillery has gone

quiet for the moment. Another group of Minnies falls in the general area of 4 Troop. Two more infantrymen topple over. The ripple of a Spandau filters through the tank noises. All the Highlanders throw themselves flat or duck behind carriers. Two of 4 Troop's tanks fire into the houses. There is a long pause. The Highlanders get up and move forward again, running into the shelter of the houses and out of our sight. 4 Troop moves forward a hundred yards. We follow suit.

A vicious clang and crash sets Stony Stratford rocking back on its springs. My forehead jars against the head-pad again. Thick clouds of dust and smoke shoot up into the vision of my periscope. The entire moonlit world disappears. A succession of similar crashes and clangs all around the tank! A sound like rain or hail upon the turret top. The periscope gradually clears of the airborne refuse. Moonlight shows clearly again. Harvey: 'Bloody Minnies! Where's our artillery?'

Silence. Engines ticking over. Waiting. Watching. Shoals of shells skid through the air above us, groaning, howling, moaning, screeching, rumbling. Again we wait. Flashes in the dawn mists ahead. The thump, thump, thump of individual shells grows and merges into a continuous pandemonium beyond the nearest houses. As if in defiance, the Minnies hit back, once again creating their own black fog of smoke and dirt in the general direction of 4 Troop. We sit watching, motionless. There is nothing to shoot at. Somewhere among the houses and hedges the Jocks are moving forward. Machine-guns add to the general noise. The frantic blitz of Spandaus. The steadier stutter of infantry brens. The hard, persistent thud of tank Brownings. 4 Troop move to the side of the buildings, firing as they go.

Keith: 'Driver, advance. Gunner, hold your fire until you see a target. Driver, right a bit. Steady. Left a bit. Steady. Slow down. Halt. Gunner, watch your front.'

My oblong of vision through the 'scope has apparently narrowed, although I know that this is an optical illusion. At first I had a wide panorama of the field with 4 Troop and the Black Watch ahead. As we advanced nearer the houses, I lost 4 Troop and the infantry, and then the field and the boundary woods. Now, as we draw even nearer, some of the houses slither out beyond the edges of my vision. We are down to two farm cottages with a lane running between them, just a rutted dirt track. Beyond is a strip of road crossing our front. Beyond that, an orchard wreathed in mist.

In the lane stands an empty hay waggon, the shafts pointing

at the sky. Nothing moves. We hear the incessant din of a. shells crashing into the cottages, orchards and gardens. Bu. close at hand the motionless, colourless scene exudes a kin tangible silence, a visible silence all its own.

My entire universe now is a tiny cart track between tw cottages in France. The world beyond, the world only jus. beyond, with its slamming explosions and rattling machine-guns, has been registered by my mind as a constant factor to be ignored. All that matters is any sudden change on my still picture, the subtle intrusion of a shape that was not there before. To me the silence, the emptiness of this lane is more terrifying than a field full of explosions. It is an emptiness pregnant with promise of some horrifying apparition. It is a lost place beyond the normal habitat of humankind. It is where Columbus stood when his men thought they were nearing the edge of the world. It is where the spy stands blindfold as the bolts click and the bullets slide into the breeches of a dozen rifles. It is where the tiny jungle creature stands as the coiling anaconda stares with icy eyes. It is the moment in mid-air of the mountaineer who has lost his grip on the precipice lip or the parachutist whose release has failed to work. It is all of us standing at the graveside clutching a handful of earth or a red rose.

As I sit and watch my narrow lane, my mind insists on thinking ahead of my eyes. Begins imagining . . . it could be a sudden wave of SS infantry running into the lane . . . and, before I can press the foot button and fire enough bullets, one of them falls on his knees, aims a bazooka, the rocket springs straight at the turret, blinding us in the explosion, sending sharp shards of steel slicing through the turret, cutting, smashing, paining, screaming . . . or it could be the long muzzle of an 88mm appearing between trees in the orchard, a huge, self-propelled gun and, although I get in my shot first, the massive gun gushes fire. I glimpse the black shot in flight. It smashes through the tank, sparks the engine into an incinerating blast of flame, burning, searing, seething . . . or along that village street now could be crawling a fifty-ton Tiger tank, and in a moment its great bulk will fill the end of the cart track, and I shoot but my shot bounces off, and its great gun turns. I shoot again but it bounces. My 75 shot ricochets hopelessly as the great gun turns, turns, turns. A great flash with instant concussion: flesh, bones, flames, blood, screaming apart into unconsciousness . . .

. . . for a moment I sit shivering, resenting the imminence of death (for somebody here, if not for me), the years of youth

wasted, the years when I should be walking a pretty girl home from the youth club, taking her out cycling in the idyllic green Herefordshire lanes, rowing along the mirroring River Wye, rowing along sky mirrored in the river, and strolling by the Eden-coloured flowerbeds of the Castle Green. All that is lost. Sixteenth, seventeenth, eighteenth birthdays surrendered to war, black-out, civil defence duties, troop concerts, volunteer work in canteens. Nineteenth, twentieth birthdays surrendered to parade grounds, tank-training areas, shooting ranges, slummy barrack rooms, night guards . . . and now this! No pretty girl. No fairy lights. No flowers. No picnics. For the moment I feel bitter and resentful. And that gives me the defiance to sit here watching. They say that perfect love casteth out fear. Not down a little bedevilled Normandy cart track. Perfect resentment casteth out fear much more efficiently. In this doom-packed lane between grimacing cottages.

'Hello, Roger 4 Baker. Prisoners coming towards you. 4 Baker, over.'

'4 Baker. I see them, off.'

Stan: 'That's against the Geneva Convention.'

Keith: 'What is?'

Stan: 'To see prisoners off!'

Harvey: 'Gawd, put him out for the Tigers to eat.'

Silence. Each to his own thoughts. Lane still. Road clear. Orchards dead. I stare along my narrow province and begin to drift off into imaginings again. Movement! Movement imagined? Movement happening! Men. Khaki men. I consciously jerk my foot back from the fatal button. Khaki men. Jocks. Blessed Black Watch. More than one is bloody Black Watch. One man winding a field dressing around his own wrist. Coming along the strip of street across our front. Moving into the sullen orchard.

Keith: 'Driver, advance. To the end of this lane. That's it. Halt! Gunner, that gives you a better field of fire.'

We have squeezed along the narrow dirt track between the cottages, crushing the hay waggon into shattered sticks. We are at the street corner. A straggling village street with a few houses, yards, barns, orchards, totally chaotic and unplanned. Small groups of Black Watch, rifles at the ready, are moving along or across the street. In the street itself they march slowly and deliberately. In the orchards they crouch and run in short sprints. Another Sherman pokes its snout around the far corner of the street to our right. Two Germans, bareheaded and with

the usual baggy trousers over their high boots, walk across the road, their hands on their heads, looking shocked, grey, disconsolate. A Black Watch private guides them with gentle taps of his rifle (suggesting that he might have been a shepherd in civilian life on some Highland hillside), grinning and urging them on with a steady stream of Gaelic which is incomprehensible both to us and to the prisoners.

The trees in the orchards are merging from blacks and greys into greens. Daylight is superseding moonlight. Daybreak seems icy cold to me. But again that must be some kind of psychological reaction, for here in the tank we are all sweating.

**04.45 hours:** Numbers of Black Watch, perhaps up to a hundred, are standing along the street just waiting. There are no civilians. No Resistance fighters. This is a dead village, completely evacuated and militarized by the Germans. We roll along the street, grey cottages on our left hand, an orchard on our right. Once again we are moving out onto our exposed left flank. The light is already quite bright, and details of houses and orchards are clear. The cottages, which in moonlight and dawn mists looked ominous, now look only tragic and lonely. At the end of the street is a crossroads. And a church, a tall, solid church, very much like an English village church (Norman, of course). The sight is comforting, although beyond the churchyard the road dips into the plains which are still the hunting preserves of the Tigers. Over all that vast land the Nazi writ still runs. Those lanes are the freeways of the enemy's tanks and troop-carriers and self-propelled guns. Those woods are his assembly points and ammunition dumps.

We move across the junction, swinging right, and are behind a wall again, protected by farm buildings. I breathe deeply. As we continue into another narrow lane the rank, benevolent odour of farm manure oozes in through the openings of Stony Stratford. This smell is even more powerful than the slightly sweet stench of corrupting flesh with which we have lived for two months since landing. Through a gap in the buildings we glimpse a rather untidy, dirty farmyard.

Harvey: 'Gawd! Pull the chain! Home sweet home, Bookie?'

Bookie: 'They wants to rake out and get that place mucked out. Poor mucking pigs and poultry, having to scratch in that lot.'

Stan: 'I thought pigs liked scratching in muck?'

Bookie: 'Pigs are blinking sensitive animals with delicate

stomachs, worse than you or me. We always boils our pig food at
home before we feeds 'em.'
　　Harvey: 'Talking of pigs . . .'
　　I freeze as a German helmet appears within periscope vision.
A helmet on a Teutonic head. A Wehrmacht collar. A field-grey
tunic. Before I can stamp on the trigger, my brain flicks 'All
Clear!' It is only a German waxwork sprawled in a ditch beside
an upturned motor bike. He cannot be dead. There is no sign of
violence, no tomato sauce splashes of blood such as Hollywood
would inevitably infuse into such a scene. Just an undamaged
waxwork dummy, left out in the sun and tumbled into a ditch. It
cannot be alive. There is no movement of limbs. No heaving of
chest. No flicker of face muscles. Hands outstretched, clutching
at empty air in unnatural tension. Eyes staring. Face blank. It
drifts out of vision as we crunch past, a tiny horror tableau in a
ditch. I cannot imagine it as a hated Nazi, or as a mother's son, or
as a son's father. As a ploughman or a postman or a factory
hand. Or a member of a Lutheran congregation. Or a boozer in a
*Bierkeller* . . .
　　Just a sickening yellowing waxwork illustrating the futility of
human life. Would it not have been kinder of a loving God to
have created us all as human waxworks with easily replaceable
working parts instead of all the travail of mother, toil of father,
pains of growth, wild hopes and imaginings, affinity with
sunsets and sea breakers, the studying, wooing, loving, hating,
parading, fighting, starving, hiding, only to ride a motor bike
round a corner of some remote, stinking French farmyard, drive
headlong into a Black Watch bullet, fall grasping frantically at
the new sun, and fade into a clumsy waxwork in a ditch – a
dummy of less value than the spare parts on the motor bike it
rode? Now they will shovel him into a ditch as a present for the
worms, collect his badges as interesting souvenirs, appropriate
his watch and field-glasses as useful tools, and utilize his motor
bike as a valuable asset.
　　Loud click as Keith switches to A set, and a sudden blessed
silence from the unending radio static, signifying that he has
pressed the mike switch to transmit. 'Hullo, Roger 3 Baker.
Track clear as far as we can see. Roger 3 Baker, over.' '3 Baker,
OK. Keep watching. Off.' Click again as Keith switches back to
I/C. 'This is where we stay for now, lads.'
　　Once again we find ourselves in a little lane. Or, rather, this is
simply the beginning of a farm track running between an out-
building and the main *basse-cour* of a modest French farm. On

our right the buildings open up into a large and fairly tidy yard. A German lies at the precise centre of the yard. Several Black Watch run into the yard, weapons at the alert. One of them prods the German with a bayonet. No response. The Jock uses his boot to turn the German over. Another broken waxwork.

Ahead of us the cart track winds across a level cornfield towards a hedge where the track dips out of sight. Farther on, the track climbs back into sight up a slope between tall trees and disappears into a dense wood. There is no movement in the field or in the wood. The sun is now up. It is Tuesday.

**05.30 hours:** The story of Normandy, 1944. A cornfield. A hedgerow. A wood. Deserted. Nothing to see. No seventh Cavalry. No Light Brigade. No massed ranks of Brandenburgers. No Stukas.

Harvey: 'What are we waiting for, Corp? – apart from Christmas?'

Keith: 'Usual thing. Counter-attack positions.'

Harvey: 'What for? Jerry's gone home long ago. I reckon you could have a game of football on that field without Jerry taking any notice.'

Keith: 'Don't bank on it. He's probably down in that dip where the track disappears. Keep your sights trained that way. If Jerry's going to attack, he'll most likely do it sooner rather than later. No more idle chatter now.'

I wonder about Keith's abilities as a psychologist. While a tank is waiting like this, exposed to any unseen enemy guns, expecting an attack by larger and more powerful tanks, it is not wise to stop people talking. Firstly, if we do not chatter we shall be silently speculating over our fate and contemplating all the horrors of wounding or dying. Secondly, men who have been awake all night are quite liable to drop off to sleep if they are left with only an empty world to view from their tiny, isolated nooks.

Bookie: 'I can see a square thing. Right, three trees close together. Right again, a single tree, then . . .'

Stan: 'I've got it. A building. Not a tank turret.'

Bookie: 'Looks like a chicken coop to me.'

Stan: 'Too high for a chicken coop. You don't have chickens as tall as that.'

Bookie: 'It has to be tall for people to get in through the door, you stupid townie.'

Stan: 'Looks more like a loo to me.'

Harvey: 'What would a loo be doing out in the country there?'
Me: 'For passing pilgrims I expect. Looks like a tool shed through the telescope.'
Keith: 'Keep an eye on it. Some Fritz might think of using it for cover.'
Empty sheds in Normandy hedgerows hold little conversational potential for youthful tank crews. We relapse into silence. And all our own private agonies again.

**06.15 hours:** Hurried scraping on the back of the tank. Keith takes off his headset and climbs out. In a moment his head reappears and he picks up the mike. 'I'm off to a commanders' conference. Ken, come up top. Report if anything happens. Pull back under cover if you have to. Stan, move over and gun. Harvey, you can come up and load. Bookie, get in the driver's seat. Give you all a change of position. Keep awake whatever you do.'

I haul myself up into the cool, brisk morning air, a welcome change from the sweat-hole down below. Up here I can hear the constant noise of fierce battle from our right rear. But to our left and out front there is the undisturbed peace of nature. The Germans have failed to evacuate St-Aignan's birds, which chirp and whistle noisily. Somewhere an unmilked cow complains in anguished bellows. A small patter of human conversation filters through from the Black Watch just behind us who are digging deep into the rich Norman soil, dug over so often for more peaceful purposes these last two thousand years.

Stan: 'August flipping Week. What a way to go holidaying in France. Churchill's flaming Tours Limited. A right Cook's Tour this has turned out to be.'

Harvey: 'What do you expect at the price, mate? We *are* seeing life. When I was a kid, we only went away one day a year and that was the Sunday School outing to the seaside.'

Bookie: 'Our Sunday School outings never got to the seaside. Too far. We used to go out for a day in the country with the old "charabangs": remember the buses with the little door at the end of each row of seats and no roof when I was a kid?'

Stan: 'I thought they only had stage coaches when you were a kid, Bookie.'

Bookie: 'What a pain in the arse it must be to be brainy and belong to a turret crew!'

Me: 'Oily-fingered mechanic!'

Bookie: 'The backbone of the tank crew is in the driver's compartment. Hank says so.'

Stan: 'He meant the bit at the bottom of the backbone, but Hank is too much of a gentleman to mention the word.'

Bookie: 'Anyway, when the Regiment was first mobilized, we went back to one of those places where we went for Sunday School picnics. Same flooding field. We were on one of these schemes. We hadn't got any bloody tanks. So the crew went out walking, all holding on to a piece of string. The tank commander had three or four pieces of string, and every one of his crew held on to a piece of string. That meant you were sitting in a tank. Then you walked across the fields like that. Bloody silly, really. In a tank but not in one. Holding sodding pieces of string. And effing stupid you felt with some farmer standing watching you and shouting, "Is you lot all out for the day from the School for the Blind?"'

Clanging on the back of the tank. A Black Watch Lieutenant is hitting the armour plate with an entrenching tool.

'Can I come up?' he shouts.

'Be our guest!' I bawl back. He climbs up gingerly.

'Where's your commander?'

'He's off at a conference, sir.'

'Can I take a look at the Boche country?'

'Would you like to borrow our glasses? Not that there's much to see.'

'Thanks. It's a better view from up here . . . Bloody good glasses they issue to you tank chaps.'

'They're not WD. They are best Boche supply. Zeiss. We borrowed them from a Jerry for the duration.'

'Good idea. Must get myself a pair.'

He rests his elbows on the turret and scans the landscape slowly. 'Can I get my Sergeant up to have a look?'

'We don't charge for a look around the bay, sir.'

'I should think not, for all there is to see. Not like Dunoon.'

'Plenty of cover for Jerry, though?'

'Too damn much. Sergeant, come up here.'

The two Scots study the landscape. We point out conspicuous features and estimate possible points of enemy advance. Eventually they stand up and grin at me.

'Seems rather chilly at this altitude?'

'Yes, sir. We'll be ducking down quickly enough when the shooting starts. Do you think the gentle Hun will start something?'

'How should I know? You tank boys seem to know much more about what's going on than we do, regardless of rank.'

'That's being able to listen in to BBC news on our radios.'

'Let us know the cricket scores!'

'Didn't know Scots played cricket, sir?'

'Croquet, knitting, Happy Families – anything to forget this bloody war.'

The sun is now climbing higher in the sky on our left. And the shadows shorten, drawing back into the bases of their objects. Where the woods opposite have been an incomprehensible puzzle of trees and slanting shadows, now the stronger, higher sunlight penetrates and cleans up the lines of the woodland so that tiny glades and avenues become clearly lined. I turn my binoculars on each open space, green and glistening, and upon each clump of wood, sharp and black, searching for the odd squared shape or for the ominous hump or for the unaccountable movement.

Nothing!

**06.50 hours:**   Stan: 'I think our Keith has got a week-end pass.'

Me: 'Perhaps Hank has instituted morning prayers?'

Harvey: 'Or perhaps they've all been captured by Jerry and there's nobody left except us. Stan, is this set still working? No messages have come over it since I've been sitting beside it.'

Bookie: 'There's a ladybird just walked right across my periscope.'

Harvey: 'A what?'

Bookie: 'A ladybird. Red with white spots.'

Harvey: 'No good! I could go the lady or the bird but I'm a bit too old for ladybirds.'

Stan: 'Bookie, are you sure that wasn't an armoured troopcarrier crossing your front. It would look just like a ladybird.'

Bookie: 'Would it really?'

Stan: 'Yeah, and all the white spots would be the faces of the poor Fritzes looking white and scared when they saw you sitting there.'

Bookie: 'Frig off!'

Silence. If you can call bird-song silence. Stillness. If you can call the gentle ballet of breeze, leaves and grasses stillness. Peace. If you can call the perpetual menace of fanatical stormtroopers snaking through undergrowth peace.

Harvey: 'Hey, let's go home. There's nothing doing here. As boring as a jumble sale. Let's just sneak off. And then when dear

old Keith comes back, chewing his moustache and looking for his tank . . .'

**07.05 hours:** Me: 'Here's Keith coming back. Get ready to play musical chairs again.'

Keith trudges along the farm lane behind us with a tread closely resembling that of a farmer wearing boots heavy with sodden clay. He is carrying his map case under his arm and has both hands thrust deep into his pockets. He is staring down at the ground and does not see the Highland Lieutenant who has come across to speak to him. Suddenly Keith starts, retrieves his right hand from his pocket and salutes, his other hand still stuck incongruously in his pocket. The Highlander merely grins. They stand and chat in the empty lane. Empty lane, deserted farm buildings, silent land. All around us the suspicious silence. Whispering, muttering, gossiping silence.

In Fleet Street this morning the war artists will be drawing arrows out from Caen and will not know that Keith and the Highlander and I stand at a tiny blob well ahead of their wildest arrow on the map. Keith and the Lieutenant exchange friendly salutes, not the slammed emphatic motions of the parade ground but the gesture of two passing desert travellers, sharing a moment of companionship in a lonely place. Keith climbs casually up onto the tank. Pulls his left hand out of his pocket at last. The hand is clasping a pipe. He knocks the warm ash out against the turret, pockets the pipe and nods to me to drop back into my normal seat.

Click of microphone. Keith intones his briefing notes. According to Hank, either we have lighted upon a total vacuum in the German defensive system due to shortage of troops, or else any survivors from St-Aignan have simply gone to ground in Robertmesnil to wait for reinforcements. Nobody knows yet.

Stan: 'So why don't we go find out?'

'That's not the plan. The entire Polish Armoured Division is coming through on our left and a Canadian Armoured Divison on the right and they are going to smash right through to Falaise.'

Stan: 'I still think it's now or never. We could get over to that ridge now. In a couple of hours there'll be 88s over there and all the armoured divisions in the world will only be walking straight into another high-class cock-up.'

Keith: 'The Generals seem to think differently. Mind you, I don't know if they are right. I've got the feeling that Hank

doesn't agree with them either. Anyway we have our orders.'
Bookie: 'Bleeding Generals. If we did away with them, the war
would be over much quicker!'
We watch the continuing landscape. Stan recites, 'What is this
life if full of care we have no time to *sit* and stare . . .'

**08.30 hours:**   We reverse out of our cart track, between the farm
buildings. We poke our tail back towards the church, then roar
forward along the parallel minor track at the front edge of the
village. Farm buildings protect us from the enemy's view. Just
outside the village there is a small, dark wood with the density
of a forest. At the rear of the wood there is a glade, almost
totally secluded. The rest of 3 Troop tanks are already parked
there.
   Keith: 'Driver, halt. Switch off. Unload all guns. Operator, get
the earphones out and we'll keep wireless watch down at the
side of the tank. Crew, dismount and prepare breakfast.'
   We dismount slowly. After long periods in cramped positions
inside the tank, we emerge like talipeds, shambling, sloth-like
creatures whose limbs tend to bend in the most unexpected
directions. Harvey opens a tin of corned beef to fry, and we go
gathering some of the abundant dry wood to make a fire,
shielded by tall trees. One by one we take the spade from its
brackets on the side of the tank and make our little pilgrimage
into the trees, rendering unto Nature that which is Nature's. In
this little wooded nook of Normandy the performance of natural
functions is much more pleasant than in a crowded, stinking
camp latrine or even on an open hillside.
   Yet we are supposedly in a perilous place, an enclave behind
the enemy lines where one would expect to be hiding deep in
trenches, hounded by the enemy. The atmosphere here is more
reminiscent of a family picnic or a Boy Scout camp. The only
other people in sight belong to the other three tanks of the
Troop. Their crews are taking their leisure in the summer
morning. War still crackles, like a small undergrowth fire, in the
middle distance, but near at hand there is a solitude which belies
the presence of a thousand men, Yeomanry and Black Watch,
spread in and around a tiny village.
   Stan and I go foraging for kindling on the outskirts of this tiny
but intense forest, devoid of movement. Some lines come into
my mind about 'I know . . . a green grass path that leaves a field
. . . something . . . something . . . into a wood where is no song
of birds at noon.' I must look those lines up. The book is in my

small pack. Chilling words that fit this place. Delightful in the sun. Bedevilled in the shades. This is like another wood nearer the beaches. Strolling through the trees we smelled the smell and came suddenly on the German bodies. Piled, a dozen or more together. No evidence of battle. In the nearby village people refused to discuss or go near that part of the wood. The whisper was about a revenge killing by the Resistance . . .

Harvey has fried the corned beef in one tin, soaked hard biscuit in rancid butter in another tin, and in a third tin double-boiled some water to try to rid it of the appalling tang of chlorination. There is also half a bottle of white wine, a Camembert cheese and a hunk each of dry, rye-sawdust bread. Our bartering with the local peasants makes for luxurious camping. We sit down on the lank grass to eat. The battle noises are no louder than the anticipatory rumbles in our bellies. Perhaps everybody is dead, leaving us sitting here unaware in the woods. Finished breakfast, we can go home.

Stan: 'If it wasn't for the war, we would be on holiday now, August week.'

Bookie: 'I never had no holidays. Used to get a week off after harvest, in October. Spent it working on the vegetable patch.'

Harvey: 'Working on Lucy too, I bet.'

Bookie: 'You belt up. You're not old enough to know about things. Anyway, my Lucy's a ruddy good cook.'

Stan: 'Anyway, didn't you know that this Lucy he talks about isn't his wife? It's the cow.'

Bookie: 'I'll roll your face in that cow pat over there, if you don't shut it.'

Me: 'You should have brought one of your cows with you, Bookie. Tethered it to the back of the tank. Then you could get out in a lull in the battle and milk a pint or two for the lads.'

Harvey: 'He got shot in the pants digging potatoes at Noyers. Jerry couldn't miss him again if he was bending, arse-heavenwards, doing a spot of milking on his old three-legged stool.'

As we laugh merrily at our own imbecilities, Bookie swings his mess tin like a scythe. Stan ducks and the mess tin hits me. I overbalance from my crouching position, crash into the tank track and spill corned beef on the grass. Anxious for jollity, we all guffaw loudly. I scrape the corned beef out of the grass and spoon it back into the mess tin. I'm hungry!

Harvey: 'You've spilled some of your corned beef on the tank track, Ken.'

Bookie: 'That's not corned BEEF!!!'

There is a moment of icy silence. Bookie crawls over to the tank track, picks something from it, holds it up. A tatter of field-grey cloth.

Bookie: 'Harvey, you should look where you're driving. You've mashed up a Jerry.'

Harvey: 'You crude farm bugger!'

Harvey stares at the track pale-faced. Keith gets up and wanders away. Stan throws his mess tin away from him. Bookie drops the piece of cloth, wipes his fingers on his denim trousers and laughs weakly. Keith is leaning against a tree, bending over, convulsed – and not with laughter. I get up, go round the tank, lean against the other side, finish eating my corned beef.

I'm young, animal, hungry.

Troop Sergeant Jim Wells walks over from his tank, Stoke Bruerne, Roger 3 Able.

'You lot not talking to each other then? Bit of a tiff in the family?' Harvey points to the track. Jim inspects the remnants.

'Ugh! Tragic happening amid all this nice friendly warfare! Where's Keith then? What's he doing, banging his head against that tree? Playing at woodpeckers?'

Me: 'He's gone back to worshipping the old pagan gods of the woods, Thor and that lot.'

Bookie: 'It made him heave his stomach up.'

Jim: 'What did? Thor and that lot? Or the damage to his tank track? Tell him Hughie says to brush up the camouflage a bit. We may be moving in and out of trees and hedges later in the day.'

'So we pretend to be an apple tree instead of a haystack?'

'That's it, young Ken. I suggest you get some Jeyes Fluid on that track. Or else you'll be in trouble if the sanitary inspector comes by.' He robs a lump of Harvey's Camembert cheese, exchanges obscenities with him and returns to Stoke Bruerne.

I wipe around the inside of my mess tin with a rather grimy finger and lick the finger clean. At home we say Grace before meals. And I was never allowed to sit down at table without washing my hands and combing my hair. Wiping up gravy with new bread was a venial sin only to be indulged in if mother and father could be lured away from the table for a moment. My progress to my present state of aesthetic shipwreck owes not a little to the day north of Caen when we were ordered to bury a long-dead German who had been lying too long in the sun. Having dug a neat hole, we picked the German up by the limbs to swing him into the grave . . . The arm which I was holding

disintegrated and came away in my hands like crumbly cheese. We had to resort to shovelling that load of human Stilton hastily into the pit. Such an exercise in life education endowed me with the ability to eat corned beef under any circumstances. Keith returns to the tank. I give him Sergeant Jim's message. We set to work lopping a few live branches out of the wood to transform our tank into that scene from *Macbeth* where Birnam Wood comes to Dunsinane. I mention the concept to Stan.

'Yeah, a mixture of Macbeth and the Wooden Horse of Troy,' he laughs. 'Once we get within the walls of Robertmesnil, Captain Agamemnon Macgregor and his trusty gladiators leap out and decimate Sepp Dietrich and his Trojan SS. Come to think of it, our Night March might one day go down in history like the Trojan Horse?'

Me: 'Not a chance. Agamemnon wasn't in the Yeomanry. He was a Guards officer, and his brother-in-law was Editor of the *Athens Daily Times.*'

Harvey: 'And don't forget we're not even British now. We're Canadian Army. All you'll get in the Official History, Stanley boy, is "Canadian troops, displaying the spirit that won the West, captured St-Aignan-de-Cramesnil."'

Stan: 'Yeah, like they captured Caen, twelve hours after we were down there in the city in this bloody tank.'

Me: 'What we need is a Xenophon.'

Bookie (trying to break into the conversation): 'Why? Can you play one?'

Me: 'Idiot! Xenophon was a Persian soldier who went on a famous forced march in ancient history. He wrote about it afterwards. And what he says goes, because he was the only one to write about it.'

Bookie: 'Hank draws pictures.'

Keith: 'That should get us a mention in *Comic Cuts*. Let's get the Christmas decorations hung up on 3 Baker.'

We stick branches into various projections and holes around the Sherman until it looks like an immense but rather moth-eaten bush. The idea is not to build an imitation tree but simply to destroy the clean, square, metallic outline of the armoured vehicle.

'Have you ever seen a Bactrian camel?' asks Stan, 'Lots of humps! And all its wool hanging off, permanently moulting. That's Roger 3 Baker for you!'

'Come on, Roger 3 Bactrian camel,' yells Harvey, slapping Stony Stratford on the rump.

'Gidee-yup!' I add, 'with Corporal Keith McAlpine starring as Lawrence of Arabia.'

**09.50 hours:**  We have mounted Roger 3 Baker and rumbled the hundred yards or so from our tiny woodland dell to the minor lane which runs parallel to the village street. This minor road is now the base line from which A and C Squadrons are slowly probing forward. We halt along the lane at a spot where, flat and devoid of hedges, it runs past the cornfields and orchards. We wait in reserve. From where we are, the ground seems to dip away in all directions, here very gently, there more sharply, meaning that we are at the crest. Behind us now the little village of St-Aignan, in its orchards and with the church spire skewering up through one of the orchards, looks pretty in the bright sunlight. This is the same village which, six hours ago, looked bleak and perilous, seen from the other side by moonlight.

Harvey and Bookie are sitting in their front compartment, heads out of their individual flaps. Keith is sitting on the upper of the two commander's seats in the turret. Stan and I are outside, perched on the edge of the turret. The other three tanks of 3 Troop are spaced about twenty yards distant from each other along the unhedged lane. Half-a-dozen Black Watch squat on the lip of a slit trench which they have just dug at the corner of a narrow, connecting lane leading back past a wooden sheep-shearing shed into the village.

Stan: 'You know, we could be a lot worse off. Digging in, in Russian snows. Struggling through the mud in Italy. Riding guard on Arctic convoys. Chasing the bloody Japs through the jungle.'

Me: 'Even just being a civilian, ducking away from V1s and V2s. Then queueing up for rations.'

Bookie: 'But none of them buggers have got the 1st Adolf Hitler SS Panzer Grenadiers lined up in front of them, or the effing Hitler Youth.'

So we sit swinging our legs like kids on a lock-gate overlooking a canal. As we swing our legs, a large black shape leaps over the wood where we had breakfast, plunges at us, growing huge in size, filling the sky, shaping into an aeroplane, tiny bits falling from its wings. I think swiftly, but shout much more slowly, 'Messerschmitt!' Even before I can pronounce the entire word, the thing has flashed black and white crosses at us, darted along the lane and disappeared over the orchards. As it disappears, its thunderous engine noise seems to follow, chasing it as though

disembodied, and accompanied by a violent clattering sound. There are a couple of clanging noises like someone plucking a treble string of a giant piano.

Then there is silence. A silence which we can listen to. A silence that goes on and on. At last we realize that the silence is nothing more than our stunned eardrums, unable to cope again with hearing. Neither Stan nor I have moved, although Keith has dived down into the turret.

Me: 'The plane must have been hit. There were little bits falling from the wings.'

Stan: 'Little bits falling? Those little bits were empty cartridge cases, you twit. He was firing his machine-guns. At us!'

Me: 'Heck! I wouldn't have sat here and watched if I'd realized.'

Stan: 'And where would you have gone in the tenth of a second it took him to pass?'

Me: 'Hey! I wonder where the bullets went?'

Stan: 'Just don't shake your head too hard!'

Two other Shermans roll along the edge of the cornfield behind us and come to rest within hailing distance of our tanks. The Squadron Leader climbs out of the first one, the Second-in-Command from the other. They walk forward to Hughie Mac-gregor's tank and engage him in conversation. These Shermans belong to HQ(F) Troop. The Squadron has an administrative headquarters, HQ(A), including quartermasters, cooks, supplies. Then there is the 'Fighting Headquarters', HQ(F) Troop, tanks in which the Major, Second-in-Command, Squadron Captain and sometimes Squadron Sergeant-Major go into battle. They are normal Shermans fully operational. Only the Colonel has a Command Tank with a dummy gun giving space for extra radio equipment and command facilities.

Until just before D-Day I belonged to HQ(F), trained with them, ate, drank and slept with them, walked many long miles with them to Salisbury or Bury St Edmunds, sat with them in canteens, pubs and cinemas, listening to their good-humoured banter, spiced with crackling obscenities after 'Lights Out'. So the lads from HQ(F) are my old pals. I go over to chat with them. 'Any news? What goes on?' – HQ(F) crew members are very well placed for eavesdropping on the conversations of the great.

'Hank is expecting a counter-attack. Your Troop and HQ(F) are going to sit in the centre, plug any gaps and resist to the last man. Or at least that's the idea.'

'As long as I am not the last man, I don't mind.'

'How did the Night March go with you?'

'Boring really.'

'Hey, Ken, have you heard about Bill Fox's secret weapon?'

'It's not a dirty joke is it?'

'Aw, come off it, Ken. You know us . . .'

'That's why . . .'

'No, Gospel Truth! Cut me throat and let me die! Last night on the march we passed right over a German slit trench. Old Bill says he saw the whites of their eyes, looking up at us, just as though they was doing an Al Jolson number. All paralysed with fear. So Bill puts his hand inside the turret where we keep our Mills bombs in the pouch, takes out a bomb, pulls out the pin and lobs it over the side. Says they need their bowels moving. But no flash. No bang. This morning Bill gives young Bob hell over the bombs. "No bloody fuses in. Check the bloody things. Get your so-and-so finger out!" and all the rest. So, Bob takes out the bombs, counts them and, to his surprise, finds that they are still all there. None missing. Next Joe shouts, "Who's pinched my pissing apple out of this pouch? Who's eaten it? Come on, you jokers. I put a nice big red eating apple in that effing bomb pouch last night." Know what old Bill had done? In all the noise and confusion and darkness on the march? Took Joe's apple out of the bomb pouch, pulled out the stalk and flung the apple at the Huns.'

'Just imagine one frightened Jerry, with an effing great lump on his head, wounded by an apple for the Fatherland. Bob says it's against the Geneva Convention to throw apples in battle since William Tell was from Geneva and shot that apple off his son's head. And when old Bill told Hank what had happened, David-boy says he will have to look up in King's Regs to see if it's a court martial offence.'

With absolute precision the German guns weigh in with something much more substantial than apples. A row of black explosions runs, like spurts from the hooves of immense invisible horses, across the cornfield beyond Bill Fox's tank. A direct hit on a cottage a hundred yards away produces a pure white explosion, a cloud of ruptured stone and mortar. A whale of an explosion flares, gushes and batters the air between us and Hughie Macgregor's tank. I take the quick way into the turret, a standing leap, touch of foot on the track, push of the hand on the deck of the tank, twist of the body and I roll across the turret nine feet up in the billowing air. Only to find Keith ducked inside the hatch, blocking my way in. Stan tumbles on top of me from

behind. He, Keith and I sort ourselves out and drop into the turret. As I go, I get a field-wide vision of Bill Fox ascending his tank as though leaping Beecher's Brook without a horse, Hank disdainfully cocking one leg into his turret, Hughie Macgregor going down his turret like a Stuka dive-bomber. Several Black Watch privates roll over the lip of their machine-gun pit, mess tins in hand. One tall, solitary Black Watch officer stands at the edge of an orchard, watching the circus and sniffing the air as though aware of something burning.

'God, I'll have scorchmarks on my arse for weeks,' gulps Stan.

'Have you been hit?' asks Keith anxiously.

'No, it was the friction as I slid over the turret. I could smell my trousers singeing as I went.'

'At least I had some potatoes to show for it when I got shot in the arse,' chortles Bookie.

**10.20 hours:** We have moved only a few yards forward from the minor road into the field but the move has opened up for us a complete panorama of our front. We are at the highest point of the green pasture through which a cart track runs down into the wooded gully across our front. Then, half seen, the track climbs up the slope beyond, twisting on through cornfields to the hedgerows and tall roof of Robertmesnil. The wooded gully runs right across our view. To our right is a small orchard with a gap through which we can vaguely see the line of the Falaise road. Behind us is the thick wood where we had breakfast. To the left of the cart track is a rough vegetable field and, all along our left side about fifty yards away, a long finger of orchard. Beyond and behind that orchard are the first scattered cottages and farms of St-Aignan-de-Cramesnil, which forms our rear.

In the centre, 2 Troop are making their way down the track into the dip. The gully is deep enough to hide the lead tank before it emerges again and climbs up the track among the trees where 2 Troop are going to form up, watching Robertmesnil to their front and the gully behind them. 4 Troop are extended in the trees watching the gully further left. 1 Troop appears to have pushed over the gully even more to the left, using the other track through the large farm where we kept watch earlier this morning.

To our extreme left we can see a patch of open country which is still beyond our control. In the finger of orchard to our left the Black Watch are well dug in. Between us and them is one of the HQ(F) tanks, commanded by the Squadron Captain. On the

right A Squadron tanks are judiciously spaced amid the orchards. We are a considerable little army, but we are still out on our own in unknown territory with untold numbers of enemy reinforcements, tanks, guns, SS, somewhere up the road.

Stan: 'Sitting here like this, we might just as well be watching a cricket match. Nothing happening, nobody moving, bloody monotonous, soul-destroying waste of time. Might as well go home. Hey, Corp, what about it? Let's turn the tank round and go home. Maybe everybody would do the same. Jerry as well. We march on London and they march on Berlin.'

Me: 'Sounds like a more sensible way of ending the war.'

Keith: 'Sounds like kids' talk.'

We are now closed down for action so that the normal noise of warfare does not intrude into our consciousness. There has been an increase in the steady drumming of artillery shells from both sides. We only sit up and take notice when we hear the brief, abrupt, slam-crash dual impact of anti-tank weapons.

'Hullo William to William Able . . .' Someone starting to talk before they were ready. That was the Colonel's call-sign, calling his Second-in-Command. But it was not the Colonel's voice.

Stan: 'Probably wanting to borrow a spoonful of sugar from the 2-in-C.'

Harvey: 'More likely the Coleman's mustard to put on the ham, don't you know, old chap?'

'Hullo William to William Able. Medical half-track immediately for Big Sunray. Over.'

'William Able, coming immediately. Off.'

In spite of the artillery outside and the rising heat of the sun, a chill silence seems to have crept over the field. It is the silence, the telepathic intensity of fifty tank crews sitting listening. It is a silence which is in the mind rather than the ear. Sunray is the tank term for Commander. And Big Sunray on William tank is the Colonel himself. And the call for the medical half-track has only one possible meaning.

Harvey: 'Christ, Corp, that's the Colonel bought it, surely?'

Me: 'That's rotten luck. Coming right through the Night March, then getting wounded before the battle even starts in daylight.'

Bookie: 'It must be that bloody shelling. I hope the Old Man is OK.'

Far to the left in my periscope I see the front of the Squadron Leader's tank. A jeep pulls up. A tall figure vaults off the tank

into the jeep. The little vehicle spins in a tight circle and speeds away.

Harvey: 'What will they do if the Colonel is badly wounded?'

Keith: 'Take him back to base hospital.'

Bookie: 'Christ, if I could get my hands on a Hun now.'

Harvey: 'But how will they get him back? We're miles behind the German lines.'

Bookie: 'Square-headed bastards!'

Keith: 'The half-track will have to go back the way we came during the night. It should be easy to spot the track marks of so many vehicles.'

Harvey: 'I'd rather sit here and take my chance, rather than do that journey in daylight.'

Bookie (faintly heard, not on I/C, shouting): 'Shit on you, rotten buggers. Shooting our Colonel! Why don't you go back home and shoot bloody Hitler?'

Harvey: 'Get down, Bookie, you fool.'

Bookie: 'Bloody SS! If I get my hands on you, I'll wring your necks like Christmas turkeys.'

Keith: 'Get back in! Corporal Hooker, that's an order!'

Harvey: 'Get down, Bookie, or I'll bash your head. Stay down, you lunatic. Don't do it again.'

Stan: 'What's happening down there?'

Harvey: 'He opened his hatch and was standing up, climbing out, going to attack them single-handed, shouting insults at the Boche.'

Me: 'So what? It's not very dangerous out there at the moment. I don't see any Jerries around.'

Keith: 'That's not the point. It's not a habit to be encouraged. We are in the front line, in action, closed down, under orders. Don't do that again, co-driver. Just don't do it!'

Our fears and worries are subsumed in Bookie's outburst. His gesture gives vent to our own tensions. It will be the same in all the tanks throughout the Regiment. Shock! Big Sunray seriously wounded. The Colonel. That shy gent. The Old Man. A rather lovable big Teddy Bear. Suddenly our steel ring of armour and guns seems a little less solid. We had wanted to weep or to scream, but British troops do not behave like that. Only the odd eccentric like Bookie can do a thing like that. And when he opened his hatch to climb out, he let out much of our distress too. When he flung taunts at the invisible, untouchable Germans, he expressed our own anger. And when we turned our ire and contempt on him, we were holding ourselves in contempt

for our own weakness and sensitivity.

Harvey: 'Good old Bookie, anyway! You told the buggers.'

Me: 'You ought to learn to swear in German, Bookie, then you can really insult them and know they understand the insults.'

Harvey: 'Well, I suppose Major Wykeham will step up to Colonel. And Hank will be Second-in-Command of the Regiment?'

I pull out a sheet of paper from my pocket and make a note of the time when the Colonel was wounded. My notes are made on odd sheets of paper rather than in the more formal type of diary. We are given specific orders that we may not keep personal diaries during the present campaign. There seems to be a theory that the personal musings of one 147 Tout K. J. might materially affect the outcome of the war should it fall into the hands of one of Adolf Hitler's secret service chiefs. Graham Harris tells an interminable story about a German spy finding a personal camera on a burnt-out British tank, after which the developed film passes through numerous adventures before reaching Hitler's bunker. Hitler then studies the prints avidly and after some time of private meditation emerges from his study waving the photos and shouting. '*Ach so!* It is ze *British* we are fighting against. Why haf never anybody told me zis before?'

'Hullo Victor. Hullo Victor. Sunray hit by HE. Urgent medical orderly please. Urgent! Urgent! Victor, over.'

'Hullo Victor. OK. Off.'

Stan: 'Who's Victor then? That's B Squadron, must be!'

Keith: 'Yes, B Squadron and their Squadron Leader hit.'

Harvey 'God! Jerry's working down the Army List. What the hell's going on? The Colonel and the Honourable Peter both bought it and the battle not started yet?'

Bookie: 'They're hitting the ones at the back before they hit the ones at the front.'

Keith: 'Today, we're all at the front. There isn't any back at St-Aignan.'

I jot a few more notes, in between staring out through the 'scopes. If one sits and stares, like the W. H. Davies poem, one does really finish up with cow's eyes, seeing everything out of proportion. It is essential to keep looking away from the periscope in order to retain maximum vision efficiency and judgement balance. As it happens, there is nothing to see. And when there *is* something to see, we have three Troops out in front to see it before we get the chance.

So I stare out over a patch of virtually undamaged French

agriculture and compare it with the scenes of 1914–18, blasted, destroyed, when the static trenches ran eternally across the same piece of land. My patch of Normandy looks almost cosy in the ascendant sun, except for the one menacing roof at Robertmesnil in the distance. For some reason, buildings behind the enemy's front line always look hostile and malevolent. It must be a case of the mind projecting its own fears and suspicions onto the only human creations visible. In fact, in 1944, hedges, bushes and small woods are much more treacherous than buildings for they give much less obvious cover for tanks, SPs and mobile infantry.

Down the track in front of us and into the wooded gully hops a large brown bobtail rabbit, looking much bigger than its English cousins. It seems entirely at ease and unperplexed by the constant explosion of shells and mortar bombs among and behind us. Its white tail disappears in the tall grass towards 2 Troop as I watch.

Stan: 'Hey, Ken, did you see that? A rabbit.'

Me: 'Yes, I saw it. Out for a morning walk.'

Stan: 'Then why didn't you shoot it for dinner, you idiot?'

Me: 'I thought maybe it has rabies and will bite a Hun.'

Stan: 'Do rabbits get rabies?'

Me: 'I suppose so. Ask Bookie, the Brackley Poacher King.'

Bookie: 'If I'd had my old double-bore with me, that rabbit wouldn't have had nothing but a bit of salt and pepper and a few onions.'

Harvey: 'Live and let live, that's me. I don't believe in all this shooting business. I'm just a glorified bus-driver, a noncombatant. They wouldn't let me be a Conchie so I drive a tank as the next best thing. Live and let live. That's the tank drivers' union rule, and even the Boche sticks to it.'

Me: 'As long as you don't call on the gunners' union for support when the Jerry gunners come back from strike.'

**11.15 hours:** I have stared at my oblong patch of landscape until I can shut my eyes and still see it detailed before me. It is a fairly simple lay-out today. It is easily demarcated by that deep gully or ravine running right across the middle of it from right to left, approximately west to east. As we have troops forward of the gully, there should not be need to worry about the trees on this side of the dip. Over to the extreme right, between wood and orchards, I can see a patch of cornfield and the Falaise road empty beyond it. There again A Squadron stand between

us and the road. They should spot any movement in that direction.

I make mental inventories of the trees and bushes. Above the point where the track finally disappears: three bushy-top trees in a solid hedgerow with light between the tree stumps; then a patch of solid woods with no light showing; an open horizon with no hedgerow; four tall trees; two large bushes; part of a gate or shed showing through a gap before two more medium bushy-top trees. If that light or gap or bush moves or disappears, it means danger, action, deeds before words, and words before thought. Fire! Report! Review! Adjust! Fire!

'Hullo, Roger 2 Baker.' (Hitler-mimic, Corporal Astley.)
'Alert! I seem to see movement half-left, a hundred yards left of roofs, but cannot yet identify. 2 Baker, over.'
'2 Baker, keep looking. Report as soon as you are sure of movement, even if you can't see what moves. Over.'
'2 Baker, OK. Off.'

I screw my eye up close to the gun sight and slowly traverse along the 2 Troop area, taking advantage of the considerable magnification to explore the intimacies of that little wilderness of trees and shadows in front of an even darker hedge. Nothing moves there . . . except green fear. The continuous sporadic traffic of shells overhead and the fitful jazz beat of explosions behind us have merged into our consciousness until we disregard them. They become like a shading of woodwind, strings and percussion, inconsequential continuing music waiting for the soloist to enter with his first clarion note.

The SLAM-CRASH of an aimed shot – direct, violent, massive – smashes across the humdrum background of barrage. Where? What? '2 Baker. I'm bloody hit! Bale out! Hornet at . . . Gawd . . .' ( . . . ? . . .) (God, that's Astley gone!)

Hornet – enemy tank or SP. Where? Where? where, where, where . . . I squeeze the grip right . . . left . . . traversing quickly, staring into the camel-shaped trees. Hornet at . . . where, where, where, the hedge, solid-topped, fairly level . . . has a gap, a gap. A gap? Why? What? 'Charlie, left of roof, hornet in hedge over . . .' I adjust left, down, crosswires on! Stamp! Flame at muzzle. Frustrating smoke. Smoke. Smoke. Clearing to show spark of tracer leaping high into gap but another tracer from near gully flies into gap ahead of my tracer as Stan slaps my leg, loaded, down a bit, fire! Stan slaps. Stamp. Fire. Traverse. Sight. Slap. Stamp. Fire. Other flashes than mine festoon the far hedge with artificial flowers, blooming, dying,

red as Flanders poppies. And as quick to wither. Normandy has poppies too.

A feather of smoke, more permanent than the transient clouds exhaled by shell bursts, wavers up to the left of the roof. I put my foot on the other pedal as solidly as on the accelerator of a car. The co-axial Browning rattles away, every fifth bullet trailing tiny tracer sparks. The first sparks dig into the roots of the hedge. I move the gun control gently up and down in a hosing motion with my left hand whilst traversing the turret slowly with my right hand. The Browning sends out fiery arrows at the hedge, perhaps half a mile away. Other tanks are brassing up the hedge in similar fashion. I keep my foot down, mentally ticking off the tens of bullets fired. A sharp click announces the end of the belt of bullets. My tiny hose of fire quenches. Beyond the hedge the single column of smoke still rises, much thicker now. Around the Robertmesnil roof a wider cloud of smoke indicates a building on fire. Whether farmhouse or barn we have no means of telling.

Keith: 'Gunner, cease fire. Operator, load AP again.'

Stan: 'Co-ax reloaded . . . 75 loaded AP.'

Me: 'I feel better for that little bit of anger.'

Bookie: 'I hope Corporal Astley feels better too.'

Me: 'What do you mean?'

Bookie: 'I mean look over to the right of the track. More smoke.'

There is indeed more smoke, over 2 Troop's position. But it is not the column of flame or pall of hideous, thick, black smoke which marks the total conflagration of a Sherman. This is a thinner, less dense spiral.

Stan: '2 Baker didn't brew up altogether. Maybe they all got out.'

Harvey: 'Astley broke off in mid-message. I reckon he's had it, poor bugger.'

Me: 'He could have snapped the plug of his mike, bailing out.'

Harvey: 'I hope nothing has happened to Astley. He's such a bloody funny bloke. Who's going to make us laugh if he's bought it? Who's going to impersonate Adolf? Who's going to shout "Ve haf goot torture for you. Ve vill pull your nails out and your balls off"? You can't win wars without the Corporal Astleys.'

Bookie: 'We're going to have to win it without the Colonel and the B Squadron Leader and Sergeant Pearce and Corporal Astley and any other poor sod that gets in the way of a Jerry shell.'

Keith: 'Wait a mo'. We still don't know what happened. At least I think we got the Jerry gun, whatever it was, judging by the smoke.'

Stan: 'Big Chief Sioux, him read smoke signals.'

Keith: 'Yes, well, that's enough then. We're fighting a war, not running a children's party, thank you.'

We sit and watch the columns of smoke, each with its own meaning. Two narrow and faint. One wider and dense. And we wait for 2 Baker's survivors to appear over the gully, so that we can count them . . . and know the worst. For the hundredth time I mentally measure the distance from my own seat to the top of the turret. If the worst comes to the worst, if we are hit, if (within seven seconds, they say, if you are lucky) Stony Stratford bursts into a volcano of fire, then I may get out. A gunner's chance is about fifty-fifty. The operator's chance is less because he has to get past the gun. The driver and co-driver have a better chance in some respects because they are farther from the engine where the volcano blast will take place. Also they are not sitting on top of, and in between rows of, large shells packed with high explosives. On the other hand the driver and co-driver stand more chance of getting trapped inside the tank in an accident.

The commander has by far the quickest exit route. If he is agile, he can, with one vault, soar out of the turret top and land on the ground without touching the deck of the tank. But he risks the highest fatality rate in warfare from head injuries when, as most frequently happens, he goes into battle with his head sticking out of the turret in mid-air.

So I secretly rehearse my exit: a push of the hands on the inner turret rim, knees doubled, feet kicking against the turret wall, I spring backwards and up, arms flinging upwards, fingers hooking onto the turret hatch, touching the flat turret top to continue the vault into mid-air and out wide towards the safe ground . . . hoping to avoid the blazing hell which the back of the tank has become even whilst I am making my leap. It has happened to two of my friends who were gunners. One made his jump and hit the ground with his clothing aflame but otherwise uninjured. He said that it all happened so quickly that he did not have time to be afraid. The other gunner did not move quickly enough. He was caught inside the tank. The explosions of the ammunition, sufficient to knock out fifty tanks, served as a humane killer before the furnace began to grill him where he sat. Something in my being revolts more against the slow grilling of my flesh after

death than against the sudden swift shattering of mind and body in a massive explosion.

My periscope picks up movement down the track in the gully. A black beret appears. Another. A third . . . Four! The figures trudge up the track into sight.

Stan: 'Only four. Can you see who they are, Ken?'

I swing my gun to cover the four figures. Squint through the magnifying sight. Grey, waxen faces come into focus. One with blood on his forehead. Blood on his chest. Four well-known faces. Sad but relieved. Hurt but unbowed. I count them again. Recognize them. Try to make four into five. Press the mike switch, 'Corporal Astley is not with them.'

Harvey: 'Who's going to take the piss out of bloody Hitler now then?'

The little procession heads to the Squadron Captain's tank. Halts a moment.

'Hullo, Roger Baker.' (The Squadron Captain.) '2 Baker Sunray will not be joining us for supper. Roger Baker, over.'

'Roger Baker, sorry about that. Off.'

So Corporal Astley, the orphan, will never again twiddle his moustache, shout *'Hoch, Hoch, mein Gott'* and give his impersonation of Hitler. Hitler has gained his revenge. Something evil has again entered the high summer's day. Only a thin curl of smoke now rises as a memorial to Astley where his knocked-out tank snuggles into the forest beyond our sight.

Harvey: 'Who started this rotten war, anyway?'

# ACT IV

# 'View Hallo, Tiger!'

**12.35 hours:**   Full noon. August heat. Smoke and dust. A static skyline. Crowded with green shadows. Empty of people. One distant, menacing roof. Hidden fires. Ourselves watching. Intense. Silent. Sweat-soaked. Poised between tiredness and fear. Crackle of static. Voices of distant battles. Crash and shatter of shells. Ours. Theirs. Brilliant blue skies. Torrid sun. I wipe my eyes with sweat-soiled cotton waste. Wipe the periscope rubber. Wipe telescope. Eye to periscope again. Empty oblong world. Smoke bursts. Crash and shatter of shells. Mainly theirs. Birds sing in sudden silence.

'Hullo, Oboe 3 Charlie. Hullo, Oboe 3 Charlie. View Hallo! Three Tigers, moving north, line ahead on road. Twelve hundred yards at one o'clock. Oboe 3 Charlie, over.'

'Hullo Oboe Able to 3 Charlie. Hold your fire if you can till I join you.' (That's Tom Boardman.) 'Able to 3 Charlie, over.'

'3 Charlie, holding fire. Off.'

Harvey: 'God, man! Tigers!'

Now the moment of true fear has come. Tigers! They say each Tiger will take out three Shermans before it succumbs, if then. They say one Tiger took out twenty of our tanks way back. Now the huge steel hand of fear clutches and squeezes my lungs, heart, throat. Like molten metal pouring down the throat and behind the eyes.

Keith: 'Driver, start up. Loader, check loaded with AP. Gunner, traverse right. See what you can see. Co-driver, keep watch ahead.'

Oboe Able is making his way to the right flank to take direct control of the shoot-out with the Tigers. The German 56-ton tanks (almost twice as big as the Sherman) are heading down the Falaise road towards Caen, oblivious to our presence. I swing my gun onto the short stretch of road which I can see across the distant cornfield. No Tigers there. Yet. In any case at this range my 75mm would be like a pea-shooter against a concrete wall.

'Hullo, Oboe Able to 3 Charlie. I see them now. Keep under

cover and hold fire until about eight hundred yards. Then fire at
the last one while I pepper the others. Over.'
'3 Charlie. Will do. Off.'
(Stan: 'If Oboe Able is going to take on the first two Tigers with
his 75, he needs to be ready to duck.' Harvey: 'Or jump. Or say
his prayers.')
'Oboe Able to 3 Charlie. Near enough. Fire! Over.'
'Charlie, OK. Gunner, fire!' (In his excitement Charlie has
forgotten to switch back to I/C, but his gunner can hear A set
clearly.) 'Gunner, on! Fire! . . . Got him, you golden boy. Got
him. Charlie, got him. Over.'
'Able to Charlie. Get the middle one. I'm hitting the first in line
to keep his head down. And use your I/C. Off.' I see a thick
sprouting of smoke over trees beyond my range. 'Oboe Able to 3
Sunray. Charlie's Sunray hit. Get over there and keep Charlie
shooting. 3 Over.'
'3. On my way. Off.'
I traverse gently back and forward but can see no more of
the road. The growing cloud of smoke shows where one of the
Tigers is blazing.
SLAM-CRASH of an 88mm! Almost simultaneous crashes.
Flat trajectory. Tremendous muzzle velocity. An anti-aircraft
gun used point-blank against tanks. Firing and impact ex-
plosions coming almost together. No smoke in A Squadron
positions. SLAM-CRAASH! Another Tiger fires unseen. A
Squadron's 3 Troop Leader will be dodging through the orchard
trees. Lifting the commander from the turret. Giving orders.
Bearing on the middle Tiger. One Tiger blazing and the other
two swinging round to look for shelter and still not sure where
the pesky Shermans are. We see it clearly in our mind's eye.
BLAM-CRASH – slightly different sound, equally imperious,
of the seventeen-pounder.
'Oboe Able to Oboe. Second Tiger brewing. Am keeping third
busy while Charlie brings to bear. Over.'
'Oboe, bloody good show. Off.'
Black gush of smoke over trees hiding road. Another Tiger
burning. SLAM-CRASH of 88 almost together with BLAM-
CRASH of seventeen-pounder. One . . . two . . . three crashes
nearby. An answering roar of sound. New spouts of flame
beyond the distant trees. I shout, 'They've got him! They've hit
Tiger three!'
'Hullo 3 Sunray in 3 Charlie. Got the second Tiger first shot.
Hit the third with three shots. Charlie Sunray hit by falling flap,

result of near miss. Send van for Charlie Sunray. Charlie other-
wise OK. Over.'
    'Oboe Able to 3. Good shooting. Off to you. Able to Oboe. Can
see first two Tigers smoking and abandoned. Third Tiger blew
up. Beautiful fireworks. Over.'
    'Oboe to Able and 3. You earn a Tiger's tail each. Off.'
    (Stan: 'Hear that? Three bloody Tigers gone up in smoke for
none of ours!')
    I chew a boiled sweet and fold the paper. The chewing of the
sweet is incidental. The folding of the paper is critical. The brief,
unseen but uncomfortably close clash with the Tigers has been
exciting, stimulating but also terrifying. A split second's delay or
a yard's error of judgement by Oboe 3 Charlie and the Tigers
could have been in among us by now, smelting some of us into
writhing ash. The brief delays and errors of judgement were on
the enemy's side and he paid the price. But where the three
Tigers led, others must follow – Panthers, SPs, Mark IVs. The
hedgerows ahead may be thick with enemy tanks, gingerly
pressing their guns through hedges, ranging on us already,
ready to fire. Smash us in the turret, driving compartment,
gunshield, engine. Tear us limb from limb. Seal us within our
own crematorium tomb. Spark the conflagration that nothing
can douse.
    So I suck a boiled sweet and fold the paper. And the folding of
the paper is therapeutic. My crying need is for an occupation for
the surplus part of my mind which is not concentrating on the
periscope view and the earphone chatter. Now I apply the rest of
my mind to the ritual of folding a sweet paper. The first fold,
apparently simple, is in fact crucial because the slightest error in
alignment affects later folds. The second fold is indeed fairly
simple. The third fold finds the paper already wanting to slip out
of the exact square pattern. On folding the paper for the fourth
time I find considerable complications because of the thickness
of the little wad related to its surface area. Invariably I try a fifth
fold and inevitably all my efforts to fold, straighten and com-
press the paper end in utter failure. Sometimes during the calm
which lies at the centre of the tornado-like battle raging about us,
I sit for ages struggling with the problem of folding a sweet paper
for the fifth time, compressing my own fears and anxieties into
the stubborn paper as I work towards the unattainable and my
eyes continue to scan the empty world outside.
    When Stan first saw me concentrating on folding a sweet
paper, he thought it a tremendous joke and accused me of

tottering on the verge of lunacy. Now he sits at the other side of the gun intent on the same scientific experiment with a used toffee paper. And that corner of the mind which is still free to roam asks whether perhaps we have seen the last of the Germans for today? Or are there more Tigers in that jungle?

**12.55 hours:**   'Hullo Roger 1. I can see our little strange telegraph friends on the left. Dozens of them. In a cavalry charge across country. Roger 1, over.'

'Roger 1. Good to know they've arrived. Keep our left secure. Leave them to get on with it. Over.'

'Roger 1. OK. Off.'

Harvey: 'What the hell is Roger 1 talking about? Telegraph friends?'

Keith: 'Poles, of course. Telegraph poles!'

Harvey: 'Then why can't he say Poles? Surely Jerry can see them by now.'

Keith: 'Jerry isn't supposed to know that there is a Polish Armour . . .'

'Hullo Oboe 3. Number of nasty hornets straight ahead. Crossing from right to left. Some turning towards us. Ten . . . twelve . . . fifteen or twenty I can see. Over.'

'Oboe 3, OK. All Stations Oboe. Did you hear? Fifteen to twenty hornets ahead. Oboe 1, 2 and 4 over.'

Keith: 'All crew watch half right. Nasties should be moving behind hedgerows either side of gully.'

Bookie: 'Christ! Twenty of the buggers!'

And now SLAM-CRASH, again and again, unseen but near. Ours and theirs intermingling whilst we watch and wait and shudder.

'Roger 2 Charlie. Have brewed one Mark IV. Two more in sight, right of me, three o'clock. 2 Charlie, Over.'

'2 Charlie, good shooting. Off.'

(Harvey: 'Hey, that's little Sonny Bellamy. Bloody good shooting, Sonny. That's paying them one back for Corporal Astley.')

'Roger 2 Charlie. Tally Ho! Number two brewing. Watch for it. Here goes number three. Third Mark IV flaming. That's all we can see. 2 Charlie over.'

(Bookie: 'Good old Sonny boy. Bash 'em for the Colonel. Bash 'em for Astley. Bash 'em for the V bombs.' Keith: 'Cool it then. Watch out. That's only three gone.')

'2 Charlie! Behind you! Behind you, I say! 2 Able, traverse right! Charlie! Charlie! Oh my God, 2 Charlie is brewing. 2 Able,

can't you traverse, right? Right! Traverse . . . Oh my God . . . bale out . . . bale!'

Fire shoots skywards across the gully, not where the Germans should be. Where 2 Troop should be. The slam-crash double explosions overlay each other, and the day degenerates into chaos, noise, flame, smoke, grilling sunshine, sweat, fear; and our tank shuddering and juddering even as it stands still on the exposed, oh so exposed ridge crest.

Stan: 'That was a Sherman.'

A second fire blasts even higher a few yards to the right of the first. Not where the Germans should be. Where 2 Troop should be. Two towers of flame gushing into the sky, spilling out foul black smoke.

'2 Able. Both Sunray and Charlie gone . . . Hullo, Roger 2 Able. May I do . . . God, I'm hit . . . baling . . .'

(Me: 'Sonny's had it then.' Bookie: 'You never know. There's always a chance . . .')

'Hullo Roger 3.' (Hank calling Hughie.) 'Move up to cover Roger 2's front. 3, over.' 'Roger 3, OK. Off to you. All Stations Roger 3 move up in line with me. Off.'

Keith: 'Driver, advance slowly. Gunner, I think all 2 Troop tanks have brewed. Any vehicle you see moving will be enemy. Shoot first. Ask after. Co-driver, do not, repeat, not fire on walking men. They may be 2 Troop survivors. Have you got that?'

I work my gun along the known hedgerows and woods. From this new angle I can see more of the woods across the gully. Trees. Undergrowth. Branches. Intricate, twisting tracery of branches, twigs and leaves. Those twisted variegated shapes are safe. I count them. Assess them. Trees and branches. Twigs and leaves. A box shape. A box . . . BOX! Jab gun elevator, twist grip, crosswires ON! STAMP! (Keith: 'Hornet! Hornet! Front!')

Suddenly everything seems to slow to a thousandth of normal speed, like a film running down. A single second is packed with so many thoughts, so many sensations, so many occurrences, each one fully comprehended and savoured to the full. The bulbous gush of fire from our own gun muzzle, dazzling the telescopic sight. The huge recoil of the 75 gun by my left cheek. The clang of the breech block springing open and belching out heat and sulphurous fumes into the turret. The entire tank lurching back in the agony of the firing act as the great gun gives birth to the heavy shot jammed tight within it. The agonizing drive of the shot up the rifled gun barrel, the curving grooves

grasping the shot as it gathers speed, acceleration fighting against deceleration, the shot twisting into a spin which hurls it from the gun at tremendous velocity. The spark of tracer racing across space.

Whilst the tracer is still in mid-air, a brilliant flash lashing from the box shape in the hedgerow, identifying it as a gun turret. A shot fired at us or ours. Then our tracer dipping in slightly towards the enemy tank and, in the last moment of its flight, another twin tracer speeding in from another angle, merging with it so that both tracers hit almost in the same instant and within inches of each other.

There is a tiny puff of smoke from the box shape. It jerks back into the wood out of my sight. Even as it does, thick black smoke spouts around it, black smoke tinged with crimson. Stan slaps my leg and I stamp again, holding the gun on the base of the ascending smoke pillar. Slap. Stamp. Fire again.

'Hullo 3 Able. Have brewed a Mark IV in the area of Roger 2. Roger 3 Able, over.'

'Roger 3 Able, well done. Keep your eyes open, Off.'

Stan: 'What the Hell! Ken got that one. The two shots landed together. But ours hit first. What is 3 Able talking about, just because he is a Sergeant and we are only a Corporal?'

Keith: 'What does it matter, as long as it burns?'

Bookie: 'Go on, burn, you buggers, burn!'

'Hullo, Roger 3.' (Hank to Hughie again.) 'Can you get one of your people forward to cover exit of Roger 2's people? Also to check on possible move across gully to 2's position. 3, over.' (Stan: 'Uh-huh. Bloody glory calls. And who do we think little Hughie will be sending up to do that little job?' Keith: 'Shut up! They're transmitting.') '. . . 3, Off to you. Hullo, Roger 3 Baker. Did you hear? Go do it. Take no risks. Get back here if in doubt. 3 Baker, over.'

'3 Baker. Understood, on my way. Off.'

We roll gently down the green slope towards the thick belt of trees which seems to rise up to the sky as we near it, obliterating the view across towards Robertmesnil. A jungle of trees and uncut hedges. An orchard appears to have collided with a copse, and a mortal battle has been taking place between opposing species of trees. The space beneath is rank with the casualties of broken branches, rambling undergrowth, groping thorns and last year's leaves. Harvey picks his way carefully through the trees. The thirty-ton tank could easily smash down these lanky trees but in the process we could damage one of our guns or the

gun-sight. We might also pick up loose wire and other litter in our tracks, and that might temporarily halt us. In a place where quick retreat might be all-important.

Keith: 'Bookie, come up and load. Stan, gun. Ken, come up. I'm getting out for a look-see. It's impossible from up here. My head is stuck up among the branches. And bring me up a sten gun.'

I wriggle up beside Keith. The turret is pressing back a large branch of one of the trees so that the top of the turret is swathed with twigs and leaves. Keith drops over the side of the tank and treads softly towards the gully, which is now about fifteen yards in front of us. I get out of the turret and crouch low to get a better view through the trees. Keith pushes his way through a mess of overgrown hedge. He disappears from view.

Me: 'Harvey, switch off for a few seconds. Ready to switch on again. I want to listen . . . Right, switch on! Stan, pass me the Tommy gun.'

In the momentary lull as Harvey switched off, I could clearly hear other engines through the clamour of the barrage. But the air is so battered and blasted by explosions that, had I listened for half an hour, it would have been impossible to discern the direction or number or type of engines. Suffice to say there are tanks out there!

Furtive movement on our right. Keith? Furtive movement on our RIGHT! . . . that's not the way Keith went. No way could he be coming that way. Nor 2 Troop on our RIGHT! Only Jerry . . . the turret will not traverse right. The gun is jammed against the tree and can only traverse left – cannot traverse right – movement right can only be . . . I fall flat on the engine covers and from the lower vantage point see a patch of uniform holding a bassoon – a patch of grey uniform holding a large bassoon, a contra-bassoon, that cannot be a bassoon . . . who would come playing bassoons in this uninhabited ghost world . . . not a bassoon but a bazooka to blast tanks with, but I am still holding the Tommy gun, sub-machine-gun, that spatters lead ripping the tiny patches of silence amid the general din, and I think it spatters lead. Even before I think, before I consciously pull the trigger, pointing at the bassoon bazooka blast machine, and I drag the gun down because Tommy guns leap up, their muzzles leap in the air scattering bullets wildly, so pull the gun down scattering leaves twigs bassoons till the bazooka is there no more, scatter more bullets leaves twigs fears and the bazooka isn't there, I hope it isn't there . . .

Me: 'Driver, reverse. Gunner, traverse right, co-ax point blank range. Just baste those trees. Driver, halt! Gunner, on! Hose those trees. There was a bazooka man there. Keep it blasting away. Loader, reload HE . . . Gunner, fire HE.' I pause for breath. The 75 flashes, crashes, and the shell smashes into trees almost under our noses so that the vast explosion throws back howling, screaming torrents of shrapnel and shredded wood which scratch and spatter our own tank.

Then I realize that Keith has come up over the back of the tank.

Keith: 'What goes?'

Me: 'Bazooka man. Think I got him with the Tommy gun, or else he took fright and skipped.'

Keith: 'He certainly won't be there any longer. Get in and get ready to skip. I saw at least three tank shapes across the gully. No go there. As soon as 2 . . .'

Me: 'There they are. 2 Troop.'

Out of the gully, well to our left: berets, heads, shoulders, four five six Yeomen, forlorn, running, stumbling tiredly. Six of them when there should be eight or nine. Their officer is with them, arms linked with two bloodied Troopers. He seems unwilling to walk, his body and legs not co-ordinating. They wave to us. No Sonny! They head up the slope for home.

Keith: 'OK, driver, let's go. Back where we came from. In reverse, but *fast*!'

**13.00 hours:** Amid the reverberations of guns and mortars a new sound distinguishes itself, a high screaming whine. Then an immense earthquaking explosion that sends the tank swaying from side to side.

Harvey: 'That's a bomb. It's an air raid.'

Keith: 'Pass the yellow smoke. They're American.'

Harvey: 'Flaming Yanks!'

Another almighty concussion. Stan passes a yellow smoke-bomb to Keith. On the flat decks of our tanks are painted large white stars which are supposed to be visible to bomber pilots. If, as sometimes seems to happen, we are attacked by short-sighted pilots who have not been provided by the RAF with spectacles, or by illiterate Yankee pilots who cannot distinguish between allied stars and Nazi crosses, then we let off yellow smoke as a further identification sign. As another minor earthquake denotes the fall of another block-buster bomb from a Flying Fortress high above us, I see a row of yellow smoke-bombs burst into autumnal glory among the orchards as annoyed

commanders take simultaneous action.

Harvey: 'That won't stop them. I'm sure Air Force pilots believe that Jerry has clicked onto the idea of yellow smoke. And so when we eject yellow smoke, they imagine we are Jerries trying to deceive them. So they bomb us all the more violently.'

Stan: 'Or maybe if they are Yanks above, they're descendants of Custer and they think we are Sioux down here making smoke signals. White man, him heap big god flying on metal cloud up sky and dropping thousand-pounder turds on Big Chief Sitting Bullshit.'

A funnel of dense smoke and flame rushes up out of the ground fifty yards ahead of us, mushrooms high above the trees and then cascades dirt, smoke, jagged iron in all directions. The invisible express train of blast howls and smashes into Stony Stratford. It is like being in a crash with a ghost vehicle. My head jerks back from the rubber pad, recoils forward and whiplashes against the crunching iron turret wall. I feel as though I have run into Joe Louis's fist. Too late I grab at levers to steady myself. A sound like hail patters on the outside of the tank as the lethal cloud of rubble begins to fall. I feel Keith duck into the turret behind me. As usual his knees jab into my back. A lump of shrapnel as big as a golf ball, but not so smooth, bounches on my left shoulder, ricochets against the breech of the gun with a pinging sound and tumbles to the turret floor. Descending dust, ever-present smoke and charred dirt drift into and around the confined turret, causing us all to cough and retch.

Harvey: 'Go home, you sods. Go back to the States. You've pinched our girls and drunk all the beer. What more do you want?'

'Hullo, Oboe 1 Able. Two Mark IVs on main road. Eighteen hundred yards. Am engaging. Oboe 1 Able, over.'

'Oboe 1 Able, will cover you. Off.'

Keith: 'Gunner, can you still see the Falaise road?'

Me: 'No, it's out of sight for me since we last advanced.'

'Hullo, Oboe 1 Able. One Nasty down. The other hit . . . and whackho! there she blows!'

'Oboe 1 Able. Give your gunner a pat on the back. Eighteen hundred yards is good shooting any day. Off.'

Stan: 'That still leaves twelve to seventeen.'

Bookie: 'Twelve to seventeen what?'

Stan: 'Jerry tanks in those woods, according to what somebody reported just now.'

For a few moments there comes one of those strange lulls which descend on battlefields from time to time. Maybe ten German tanks are sitting in those woods watching us. What are they thinking? Why are they not acting? When will they act? They do not refrain from nastiness unless there is a much bigger piece of nastiness being planned. Fritz is not a lazy soldier.

This silence makes me feel naked. I have a couple of inches of armoured steel in front of my face, thicker steel in front of my legs. Yet I sit out in the open, high above the ground, imagining that a 75mm from a Mark IV is lining up on my gunner's seat. And a Mark IV from two hundred yards is as lethal as a Tiger from half a mile. Some enemy gunners go for your tank track in order to disable the Sherman. Some go for the engine, if visible, to produce an instant inferno. A few sophisticated shots go for the commander's head protruding from the turret. But the majority go for the gun and gunner. My own aim, if I get an enemy tank in my sights with open options, is to put his gun out of action first. No sensible German will give me a chance to shoot back by aiming at anybody else, anywhere else in the tank, but me!

Discipline, learned through foot drill on parade or through endless shining of brasses and peeling of spuds, does produce an instinctive reaction to commands in the heat of battle. It does *not* affect the dreams that come in the night, or the drift of thought in the idle moments of days behind the line, or in the long hours of inactivity in the line. All the horrors of war resurrect from time to time and pass across the mind's colourful stage like a procession of ghosts from *Macbeth*. Some tank crews gain relief by discussing their fears and, in the process, exacerbate the agitation of wildly imaginative people like me. Would I prefer a smashed leg, or a tearing stomach wound, or an arm ripped off, or a shaming gelding in sensitive places, or a chest wound that could vary from trivial to critical within a fraction of an inch, a fractured skull, an eye plucked out, a scarring of the face for life? (It's happening now! All around me!) Is it really true, as they say, that the shock of wounding prevents one feeling the pain at first? The worse the wound, the lesser the feeling?

Rarely is screaming heard in a battle in the way that it is related in fiction. But I may be the odd one who screams! And what shall I be feeling then? And if a shot hits us at a certain angle, it can knock the turret flaps shut, weld them tight and leave us

trapped. If the shot hits the engine, there are two chances. In the case of the tank brewing totally in a twenty-foot torch of flame, we shall grill alive, medium to well done, in two seconds flat – that is, just as we are being blown apart by dozens of our own 75mm shells. Alternatively, if the shot misses the petrol system, we may emerge into oxygen-rich air as human torches soaked in oil.

These messages lie coiled, compressed within the brain, like snakes dozing in the sun. Then, like the unseen, striking snake, they unwhip and flash across the mind in their entirety within a fraction of a second, biting their poison into the mind – bleak, glaring ideas against a lurid background of remembered incidents and unremembered dreams and present events. At that point fear emerges in all its symptoms. The clutching feeling at the heart, piercing sensation in the throat, ice-cold prickles up the nape of the neck and under the ears, burning fire behind the eyes, within the cheeks and across the eyebrows.

But fear is not to be equated with panic. Fear is a thing which one sits with, converses with, tolerates and resents. Panic may be devoid of fear and is a sudden, unpremeditated and often totally illogical reaction to a sudden, unexpected occurrence – the puma springing from the tree. Fear is all too often only too logical, and related to the well-expected. This silence is the worst time. No sound or movement to detract the mind from the hurrying, busybody whispers of doubt and apprehension. Silence is a time for loving, for two people in the moonlight, for the shepherd on the hill, for the poet in the pine wood, for the student in the library. Not for the front line with its thoughts that lurk in legions under every bush. Especially here straight out front where thin smoke marks the spot at which Sonny Bellamy and Astley lie dead.

Pray for noise! It comes! Our own artillery stonk. Correct to the yard. Right on top of us! Keith's knees hammer my vertebrae as though playing a descending scale on a xylophone. More grit and filings shower on us – from behind. Stony Stratford lurches forward – battered from behind. I see another Sherman disappear in an explosion which looks like a great ball of coal dust blown from under the earth. When the dust subsides, the tank is still there.

Stan: 'Flipping hell. That's our own artillery. Let 'em all come. Let 'em all have a go. If Jerry can't hit us, perhaps the Yanks can. If not the Yanks, then the Royal Artillery. Who's next? Penny a shy!'

Harvey: 'Jerry must be pissing himself with laughter. There'll
be more Huns carried off to hospital with cracked ribs from
laughing than are wounded by this lot. If I were a Jerry, I would
pack up and go home and leave us to it. We don't need them to
be in a war.'

Me: 'There's always the Navy!'

Stan: 'If Nelson could see this, he'd do his nut. "England
expectorates . . ." Heads down! Here they come again. Housey
Housey!'

Black shell-bursts play among the bushes and trees precisely
along the edge of the gully in front of us. If the first artillery stonk
was extraordinarily bad, the second one is extraordinarily good.
Shells in rapid, drum-roll succession flicker and puff along the
entire length of the nearest woods. A tree catches fire, the flames
running up it like red-shirted sailors swarming up a ship's mast.
Another tree totters and falls. A third tree lifts off, like a rocket
zooming upwards, then loses momentum and topples over
upside down. In a brief pause in the artillery barrage I hear a new
outbreak of the distinctive double-impact noise which indicates
tank or anti-tank guns. And this noise comes from behind me.
As I am now traversed right, that means the noise is from the
left. Where there is nobody. Except maybe the Poles.

'Hullo, Roger 1. It looks as though our telegraph friends are
coming back from their picnic and will not be travelling further
today. Roger 1, over.'

'Hullo, Roger 1. Can you give more detail? Over.'

'Roger 1. I would say fifty or more doing a Ronson. Over.'

Stan: 'That's it then, ain't it? That's bloody IT! "At 13.00 hours
the Poles will pass through us" but what they forgot to say was
that at 13.01 hours the Poles would be going back where they
came from – some of them.'

Me: 'Oh, skip it, Stan. They did more than you should expect
from any human beings. Anybody else but the Poles would have
beat a retreat half a mile sooner. It's the Generals to blame again.
If I can see these ridges on the map, why can't they? And why do
they think Jerry will have forgotten to put his 88s up there? It's
Balaclava all over again, waxed moustaches, blood, glory and
sheer catastrophe.'

Stan: 'The Charge of the Light Brigade was a Boy Scout
Jamboree compared to this.'

Bookie: 'Some of those bloody Generals couldn't milk a cow.'

As frequently happens, Bookie's convoluted logic silences us
all.

**13.25 hours:** The barrage comes and goes like violent gusts of rain on an equinoctial day. There are moments of silence, when I can hear Bookie scratching himself, down there in front of my knees. Moments of sound of distant battle, seeping through the earphones and accompanied by far, anguished voices within the earphones. Moments when the concussions around us rise beyond the audible level and become a physical assault upon the ears even through the padded protection of the headsets. Through it all I traverse gently back and forward, stopping to inspect a suspicious clump of leaves or a freak straight branch, waiting for the next move of those enemy tanks, as near to me as the other goalkeeper on the football field when I am playing in goal for the Troop. Too near.

At the extreme left of my traverse arc I can see the Squadron Captain's tank level with us. His crew are all my bunk-room pals from HQ(F). As I reach the end of a left traverse, I see the Squadron Captain's tank standing stark and immune. Then one horrific pulsation of the mind records a ball of flame and smoke shooting from the side of that tank, the fearsome crash of an 88mm gun after the flash, the even more terrible crash of the explosion on the Sherman. People eject from the tank, two of them with clothing smouldering. They fling themselves to the ground as a gusher of fire spews skywards from the turret. Another mind-numbing explosion out of that turret. A fire so intense that it sears into the retina of my eye to the exclusion of all else momentarily.

That tank is twenty or thirty yards away. If the 88 can see them, it can probably see us. Rip the turret grip right! Think! Lines of fire. Lines of fire. Not from the left because the impact was slightly right. Not from the extreme right because we would have been in the way. Robertmesnil! Straight line in hedgerow! Brake turret. Up gun. Stamp. Consciously look at the crosswires on the gun sight *after* I have fired. But a part of the mind was registering the crosswires accurately and unasked – as one drives a car without thinking. Smoke and flame die from the muzzle, and I see our tracer stab into the area under that straight-lined shape. The tracer bounces off solid mass at the centre of a bright explosion. Another 88 fires from the same hedgerow. Fires at us and somehow misses. The second 88 is so well hidden that I can see no trace of it. I shoot at the approximate spot where I glimpsed a muzzle flash. Fire again! (Much faster than they can fire.) Adjust, slap, stamp. No response there . . . but another . . . and another 88 fire towards us. Brief vision

of muzzle flashes in far hedgerows, blur of something flying angrily towards me, furied howl of displaced air alongside us. No explosion. Yet. (I think: 'They're not very good gunners. Four, five shots at all our tanks. All missed. Unless they're hitting someone else out of my sight.')

The invisible 88s are probably SPs firing hull down from behind the Robertmesnil ridge. Only inches of their flat steel turrets need to protrude above the ridge, a thousand yards and more away. And behind the hedges their shapes merge so that only the flashes of their guns will betray them. I fire again and again at remembered flash points. Other guns alongside and behind me are sending tracer arrows into that same area of confused hedgerows.

Keith: 'Gunner, cease fire!' He switches to A set. 'Hullo. Roger 3 Baker. Can our Charlie move over and lend some weight? Scare the nasties if they are still there. 3 Baker, over.'

'Hullo 3 Baker. Good idea. Off to you. Hullo, Roger 3 Charlie. You heard. Take your line from Baker. 3 Charlie, over.'

'Charlie. Understood, on my way. Off.'

Keith: 'Gunner, use co-ax and brass up those hedges to give Charlie his target.'

I fire short bursts into the skyline. A shock blast sends Stony Stratford keeling over to the left, a breath of torrid air, a deafening detonation. Icy fingers of death claw at my veins. I start my escape leap. Then I realize that we have not been hit, except for the killer blast from our own Charlie's seventeen-pounder muzzle. He has fetched up too near to us and is almost as much of a danger to us as are the Germans. With the sensations of his first shot still rocking and terrorizing us, his AP shot smashes into the hedgerow, or something behind it, and opens up a great ragged hole of fire. He goes on firing as quickly as his loader can load. Half-a-dozen shots spaced along the offending skyline. Nothing fires back.

'Roger 3 Charlie. Cease fire. Resume your normal position. 3 Charlie, over.'

'3 Charlie, OK. Off.'

Hughie and Hank do not mind *us* standing out in the open field as tempting morsels for the 88s. But they will not expose Charlie any more than necessary. The seventeen-pounder is too precious. Charlie crawls cumbersomely back to his hiding-place behind a small orchard on the right. Silence. The Robertmesnil ridge is still again. At this end.

'Hullo, Roger 1 Sunray. Roger 1 Sunray reporting Roger 1 was

brewed by SPs from the farm. Roger 1 Able is now Roger 1. Over.'
'Roger 1. Understood. Off.'
'Hullo, Roger 4. Hullo, Roger 4. Sunray wounded. Urgent half-track, please. Roger 4 still functioning. 4 over.'
'4, OK, will arrange, off to you. Hullo, Roger 4 Able. Did you hear? Take Command of Roger 4. 4 Able, over.'
'4 Able, I heard. Will do. Off.' (Harvey: 'What the hell's . . .')
'Roger 4. Hit again. Gunner wounded. Can you send half-track back? 4 over.' (The temporary commander calling.)
'Roger 4. Will do. Off to you. 4 Able, your 4 needs another pair of hands. Over.'
'4 Able, will see to it. Off.'
Harvey: 'I say again, what the hell's happening? That's one Troop Leader unhorsed and another has pissed off looking for a more comfortable neck of the woods. And the third has already gone home.'
Stan: 'And that leaves just us and Hughie between fifty-five SS Panzer divisions and the thousands of English virgins who escaped the Yanks.'
Me: 'And they are in more danger from Harvey than from the SS.'
Harvey: 'No, honest! Who IS left in the battle except us?'
Stan: 'Well, there's Hank and Bill Fox and Roger 4 Able and . . .'
Keith: 'Gunner, traverse right. On! Mark IV hull down on strip of bare skyline.'
My eye is attracted by a tracer from one of our tanks shooting towards the point indicated by Keith. What idiot Jerry commander is poking his head over a bare skyline? Hands adjust controls. Pity the poor crew in that Mark IV. Target so small that the fine crosswires almost blot it out. Pity the poor Jerry gunner. Stamp on button! The smoke. The noise. Germans must be getting short of commanders too. My own tracer emerging from its cloudy birth and striking at the skyline just low of target. Near enough to splash earth and steel splinters in the idiot commander's eyes. Perhaps near enough to ricochet into the Mark IV's turret. In the eternal split-second of supercharged thought I wonder how Keith can have identified that tiny square bulge as a Mark IV. It is no more than a squared-off dirty fingernail paring showing over the crest, a thousand yards away. It does not look large enough to receive one of our 75mm shells. Its own gun is not showing. Possibly the commander did not realize that a

scrap of his turret is protruding above the skyline as he surveys us through his periscope.

Stan slaps my leg. Even as I stamp the floor button, in the eye glance before our own flame and smoke obscure my vision, I see the tracer from a neighbouring Sherman heading out in the same direction. My tracer almost collides with the other shot, right on the same spot of the target. A modest puff of smoke arises from the point of impact. The tiny line of turret disappears. But immediately a larger puff, plume, gusher of smoke broadens and blackens the skyline at the same spot.

Stan: 'Poor sods, with a bird-brained commander like that. Didn't stand a chance.'

**13.50 hours:** 'Hullo, Oboe 3. Masses of enemy infantry advancing through cornfields, nine o'clock. Oboe 3, over.'

'Oboe 3, act accordingly. Off to you. All stations Oboe watch for infantry observed by Oboe 3, nine o'clock from him. All Stations Oboe, over.'

With the abrupt impact of a true August storm, thunder rolls out of the sky and transforms itself into steel rain. Clouds of smoke cumulus roll across the fields. Lightning flashes out of the ground at a hundred different places. After the feeble response of last night and this morning, the huge German barrage comes as a double shock. I am mesmerized by the frantic succession of explosions, the separate puffs appearing faster than a steam-engine could produce with the throttle wide open. Sudden dirt storms, miniature tornados, erupt out of the ground all along our front. Again and again we are showered with dirt. The air is black with smoke from outside, brown with dirt haze and blue with the smoke of our own firing as well as our petrol fumes. And the sun strikes on steel in full summer intensity.

'Hullo, Roger 3 Able, Roger 3 Baker.' (Hughie sounds an immense distance away.) 'Move forward to nearest hedge to brass up advancing infantry. Roger 3 Able and Baker, over.'

'3 Able, OK. Off.'

'Baker, OK. Off.'

Keith: 'You heard that! Driver, advance. Left stick. Straight. Tuck in behind that hedge as you go. Gunner and co-driver. Enemy infantry should be coming into your sights in the big cornfield straight ahead. Fire when on!'

The first movement across the pleasant golden cornfield is of tiny dark spots appearing and disappearing in the more distant corn. The spots grow into helmets, and under the helmets are

faces. Two, five, ten, a dozen, a score, a platoon, a company surely. More and more. Flame and smoke obscure my view. I realize that I have fired the 75mm, and my foot is now jammed on the Browning button. The multiple tiny blips of tracer from the machine-gun chase the larger, fizzing tracer of the 75. Into the cornfield. A raw, red cabbage of flame blooms amid the corn, and the dotted line of Browning tracer whips to each side of the main explosion as I go into the hosing routine. I see a German soldier standing perplexed in the corn. The telescope magnifies the detail and reveals him in his sloppy tunic, baggy trousers and large tin hat, a pathetic little man hardly typical of the elite SS whom we have come to fear. My Browning has exhausted its belt of ammunition. I can see the tracer from Bookie's gun spraying in short bursts farther left. But my German stands for a full second wondering what to do, which way to go. Then he drops as a 75mm HE shell from another Sherman explodes in front of him. I am not sure whether he took cover before the burst or whether he was blown to the ground. He does not reappear.

Stan slaps my leg. I fire both guns. Lines of tracer are sweeping the field from other tanks and from various directions. HE flashes spurt from points right across the field. The German infantry move forward in rushes, still mainly discerned as movements in the corn rather than as recognizable human bodies. When no explosions or tracer are to be seen in one part of the field, it comes alive with stealthily moving enemy. When we switch to that point, they go to ground. The movement there ceases. But other groups rise and rush forward. I quickly decide to fire short bursts at moving groups, then switch to other places to catch other groups as they rise. As quickly as Stan slaps my leg, I stamp out more HE hell for the men in the field.

Germans in the cornfield. Our own Browning thudding away. Stan reloading and slapping my leg. Stamping on firing buttons. Adjusting crosswire sights. Our own flame and smoke. Alien flame and smoke. Enemy barrage rocking our tank. Bookie firing away downstairs. Keith reporting. Frantic radio traffic. Thunder such as no Norman summer has known, their thunder, our thunder. Lightning of shell bursts, briefer, brighter, more angry and more frequent than God's lightning. Our tracer sweeping cornfields and miraculously colliding with someone else's tracer in mid-air. A dozen lines of tracer. 75mm flashes amid the corn. Men stumbling, crawling, hesitating, falling, flaming, running.

'Oboe 3. My Baker has brewed. Oboe 3 ov . . . I'm hit . . . I'm bloody hit . . .'

'Hullo Oboe. Can anyone tell me what is hitting Oboe 3? Oboe, over.'

'Oboe 4 Able. Now 4 Charlie has brewed. I think there is a nasty about ten o'clock. Can't see . . . all gone dark . . . all gone cold . . . somebody please, please, ple . . .'

'Hullo 4 Able. Are you there? 4 Able, over.'

'Come in somebody, we're on fire . . .' (. . . ? . . .)

'All Stations Oboe follow procedure. Identify yourself even if you're dying. Otherwise we can't help. All Oboe, off.'

'Oboe 1 Baker. Our Sunray killed by exploding shell. Otherwise OK. 1 Baker, over.'

'1 Baker, carry on if you can, off to you. Hullo, Oboe 4 Able, are you there? 4 Able over.'

Our tank rocks and shudders at another near miss. Dirt patters in through the openings again. Something hits me between the eyes. Pain. Stinging pain. BETWEEN THE EYES! I should be dead. I shouldn't feel pain between the eyes. But I do. I take my frozen hand from the pistol grip and clap it to my forehead. Something squirms. I squeeze it. Kill it. Crush it. A wasp. Crack-shot wasp. Right between the eyes. Stinging pain.

I fire both guns again. Hit an area of furtive movement in the corn. Movement stops. Two other HE shells explode within feet of mine. A triple flailing death. Winnowing the grain. Harvesting the hate of years. And the corn begins to burn. And my Browning stops. Remains silent.

Stan: 'Misfire, co-ax!'

Keith: 'Get it going again then. Use your drill!'

Stan: 'I'm using bloody drill, aren't I? It won't move. It's the heat. Gun is red hot. Jammed. Useless.'

Keith: 'You *must* get it going. Must! Must!'

Me: 'Let me have a look.'

I pull off my headset, squeeze out of my seat, double myself up into my own leg space, crawl under the breech of the 75, scalding myself on the blazing empty 75mm cases under the gun, come up close against Stan. He is wrestling with the jammed cocking lever of the Browning, a small horizontal lever jutting out from the right side of the breech. It won't move. Stan and I tug at it together. Solid. I shout in Stan's ear: 'Get the oil. And a hammer.'

Stan: 'You'll burst the bloody thing.'

Me: 'No good as is, is it?'

Stan: 'Here's the oil.'

I drop down on the floor and scream at Harvey: 'Hammer!' He leans and yells back, 'What?' 'Hammer! Give me the hammer!' He grins 'Oh, hammer?' I struggle back up to Stan.

Stan passes me the jerrycan of water out of the storage sponson. (Stan: 'That's a court martial offence, you know!') I pour tepid water over the Browning breech. Not done! But that should cool it somewhat. I pour a thick stream of oil over the same area. Not done! But if oil won't loosen it, what will? I grab the hammer. Bash at the cocking handle. Not done! The handle bends slightly but remains frozen. Panic now. (Stan: 'I'll visit you in clink.') I slash away with the hammer like a frantic murderer at work. The handle moves. I hit it again. It jerks back. (Stan bellows 'Yippee-ay-eh!') I drop the hammer. Work the cocking handle with my hand. Back and forward sluggishly. More quickly. More oil. I put my finger under the ordinary manual trigger on the gun. Pull trigger. It fires, a rapid burst. It works. (Stan: 'Crazy bugger. That could have been your hand and my face!')

The corn is burning. The entire cornfield is burning. It is burning where the triple explosions occurred. It is burning hundreds of yards right where A Squadron tanks have been aiming. ('Hullo, Oboe 4 Able. Are you there? Oboe 4 Able, over.') There are also other fires, towering Ronson funeral pyres: two of them I can see to the right as I traverse – A Squadron tanks. The entire cornfield is now surrounded by fires. There are still Germans in the middle of the field, some still advancing, some firing wildly, some running towards the rear, some waving and shouting, some frying where they stand.

'Hullo, Oboe 1 Able.' (A Squadron Leader calling direct to 1 Troop Sergeant.) 'We're not going to let this bastard in the Mark IV brew up the entire Squadron. You go right. I'll go left. One of us will get him. Oboe 1 Able, over.'

'Oboe 1 Able, going right. Off.'

While the infantry attack disintegrates in the burning cornfield and a new smell of charred flesh permeates the tank, the German barrage still tears viciously at the woods around, scattering plumes of blazing earth across the fields and into the orchards. Now our own artillery comes down in a series of red-eyed, smoke-aureoled explosions at the far edge of the cornfield, cutting off the retreat of the infantry. Those little grey men run in all directions now, their fear of our guns superseded by the nearer, more urgent and atavistic terror of total

incineration. The Black Watch guns, from their tiny pits behind us, add to the chaos. A few Germans stop to shoot back, the very intensity of the inferno about them at least providing smoke cover for those who have not become flaming human torches or been butchered by our bullets or fallen suffocated by the fumes of burning grain.

'Hullo, Oboe 1 Able. Mark IV at two o'clock from you, aiming in my direction. Get him fast. I will. . . we're hit! Bale, lads, bale! Oboe 1 Able closing down. Off.'

'Hullo, Oboe 1 Able, if you're still there. Dismount at leisure. He won't hit anyone else. I got him up the backside. A severe case of metal piles for one Fritz. Off.'

'Hullo . . . squawk . . . squawk . . . see 1 Able's full crew coming back safely. Over.'

'Oboe to unknown station. Thanks. Look after them. Off.'

Harvey: 'Stan, have you got an empty Browning tin?'

Stan: 'Coming down. Don't forget to pull the chain when you've finished.'

Me: 'In the next war they'll build tanks with chemical loos.'

Harvey: 'Stan, pass me my hammer back at the same time.'

Stan: 'If you've got constipation bad enough to need a hammer . . . ?'

Two opposing barrages, and the sound of our own guns as I continue to fire shorter bursts into smaller spaces in the growing cornfield conflagration, cover the delicious sounds of Harvey relieving himself into the ammunition box. The auditory sense is not necessary to inform us of his progress, which is manifest to another of our senses in an overpowering manner.

Keith: 'Gunner, hold your fire. I can't see anything for smoke.'

Me: 'Me neither. I'm firing by sense of smell.'

Stan: 'Then how come you didn't hit Harvey where Oboe hit the Mark IV just now?'

The August sun beats down. The tank engine is running. Our own guns are reeking hot to the touch. Each of us is sweating from fear and exertion. We can fairly feel the heat from the burning fields and brewing tanks. Combined with the mounting heat there is the smell of roasting flesh from outside as well as the animal smells and cordite fumes within Stony Stratford's own grimy bowels. The total effect is stupefying. Almost anaesthetic. In spite of the frantic, mortal battle activity, I am finding it difficult again, in the oxygen-deprived oven, to keep my eyes open.

Traversing right, I see movement. One man. Khaki. One of ours. An officer walking. Towards us. Out of a small orchard. Something intrigues me about him. I look through the telescope for a closer view. Recognize him. A Squadron. His face is set in a fixed, shocked grin. I realize what is wrong. His arm is swinging loose. His hand is hanging the wrong way round. A patch of red shows beneath his shoulder. A pang of pain, sympathetic, compulsive, shoots through my own shoulder. The cloth of the upper sleeve is ripped away. He walks like a sleep-walker in a hurry. And grins. At nobody in particular. Someone leaps off a nearby tank and walks beside him, catches him even as he stumbles. Out of my vision.

Stan: 'Poor bugger!'

Harvey: 'Even though he's an officer. Anyway, who's to say? Would he be better off dead like Sonny? Or waiting like us for a worse one in the guts or cobbles? He's got a Blighty one, mate, and that's not the worst thing happening around here!'

Me: 'He might have been Oberleutnant Fritz frizzling out in that cornfield.'

Harvey: 'Corn on the cob!'

Stan: 'Oh, can it, Harvey! Isn't it enough to brass up the poor bleeding Jerries and leave 'em to roast without insulting them afterwards?'

**14.10 hours:**    'Hullo, Roger 3. Move your people left and forward to cover gaps, and watch for infiltration. 3, over.'

Keith: 'Driver, that means we go through the hedge there, swing slightly right and come up to another hedge which angles into this one. This hedge is set on quite a high bank, in case you can't see. So go steady. Advance now.'

Harvey: 'I can't see a thing but hedge from here. Hold tight!'

Stony Stratford digs its tracks into the high bank and begins to climb into the dense hedge. This is the moment we have all feared in Normandy. Whoever designed the Sherman had never heard of the Bocage! These thick, impenetrable hedges are planted on high banks defended by deep ditches. Moving from one field to another, the tank presents to the enemy its underside of thin plate, tempting to whatever iron beast or demon be lurking. So Harvey balances the tank on the ridge of the bank, balances and then allows it to topple gently over until the tracks hit the lower ground, still with a nerve-jarring bump, and we are through, in the corner of an extensive vegetable field. Another hedge comes diagonally to meet our hedge in a tangle of bushes,

a miniature jungle of lush greenery. Beyond this jungle will be the infamous gully through which enemy tanks have been slinking.

Keith: 'Driver, right. Move into that corner where the hedges meet. Gunner, you should be able to see where the track goes down into the gully once we reach that corner.'

I sit still, and the tiny wilderness at the junction of the hedges moves towards me. The gun barrel presses aside smaller branches and leaves. My vision is full of immense, magnified leaves, convulsing and distorted. Then the telescope clears. Then I see it. Away, to one side, mid-distance, down bank, amid trees, the sinister square shape that is not of nature.

Keith: 'Driver, halt. Gunner, hornet, half right. Fire when on.'

I rip at the pistol grip, and the turret hisses round. On! He hasn't seen us. And everything happens at once as though triggered by my foot on the firing button. Muzzle flashes. Gun roars and slams back. We are falling, falling to our left, tipping over. I grab at handles to keep balance. A knee crashes into my back. A wild scream rends through the general noise.

I bounce up out of my seat. Keith is lying on the turret floor under the gun. His face death grey. One arm twisted completely under him. We are all hanging over to one side. I scramble up and look out of the turret.

We have toppled sideways, sliding into an invisible ditch, under the bushes. The slide has taken us out of sight of the Mark IV. But he must surely know we are here. I grab the commander's microphone. 'Driver, reverse! Reverse! Try straight back. Hurry! Hurry!'

Stan: 'Keith fell as the tank toppled – tipped him right off his perch – just as you fired – caught his arm inside the gun guard – it's all smashed up – his arm.'

The Sherman heaves itself out of the ditch like a punch-drunk heavyweight struggling to get up at the count of nine. It slides and skews again to the left. The engine booms. Tracks squeal. Rectifies itself. Levels up. Churns backwards. I climb out of the turret to get a view over the hedge. The Mark IV is no longer where it was. In the time available it can only have gone one way – back into the gully. I drop down into the turret again. Switch to A set.

'Hullo, Roger 3 Baker. Sunray injured. Moving back. Have fired on Mark IV fifty yards west of track, and it has now retreated along gully west. Roger 3 Baker, over.'

'Hullo, 3 Baker. Will meet you. Off.'

Because Harvey is reversing, he is unable to see where he is going and must rely entirely on directions from above. 'Coming to hedge. Up you go! Steady. Hold it. Down. Now roll a bit, full speed . . . slow down . . . halt.'

Hughie's tank is coming to meet us as we arrive back near our original position. I duck into tank. Keith's hand is bleeding badly. Stan wraps a field dressing roughly and quickly round the hand. Keith is in shock and seems to feel nothing. I judge the wrist is broken and probably the forearm or elbow. I grab Keith under the arms. He makes no response. Stan holds him by the knees and pushes while I pull from above. Harvey has opened up, climbed up the outside of the turret and unceremoniously grasps Keith's collar and hauls from above me. We struggle upward through the tight hatch, pulling, lifting and pushing. Suddenly, forcefully, we all emerge into the light like a cork popping from a wine bottle.

Hughie Macgregor comes up the side of Stony Stratford.

Me: 'The tank slid into a ditch, sir; almost turned turtle just as I fired at the Mark IV. Keith fell and got his arm jammed behind the recoil.'

Hughie: 'That's bad. Damn bad. We'll get him down straight away.'

Hughie, Harvey and I leap to the ground. More German mortar bombs explode in the general area. I begin to dive for cover. Then notice Hughie is not diving. Cancel my own dive. Stan eases the semi-conscious Keith down into our arms. Behind us the medical half-track drives up and the Corporal jumps out. Runs to help us. Without further words we carry Keith to the half-track, an ungainly but useful hybrid vehicle, the mule of armoured service, with two ordinary wheels and two small tracks – half lorry, half tractor. We lift Keith in, and immediately the half-track beetles away through yet another group of bursting mortar bombs.

Harvey and Stan gallop back to Stony Stratford's solid comforts. Hughie is not going to squat or lie down, so I stand beside him, conscious that it's all right for him because I tower six inches above him. And it's usually the top six inches that get shot off first!

Hughie: 'Right, take over 3 Baker.'

Me: 'What about a gunner, sir? Corporal Hooker is useless on the 75.'

Hughie: 'Aye, ye're right. Ye can have Briggs out of my own

crew. I'll send him over. Move back and cover that damn gully. Keep Fritz away from the front door. Good luck!' He turns away, then pauses and stares. 'What's that damn bump on your forehead?'

'Stung by a wasp. Scars of war!'

'Another damn secret weapon of Hitler's?'

Hughie trots back to his own tank, climbs up the front, knocks at the co-driver's hatch. Briggs opens up. Listens to Hughie. Ducks down. Emerges carrying water-bottle and Sten gun. Runs over to Stony Stratford encouraged by the eldritch shrieks of another batch of Moaning Minnies descending like invisible but all too audible witches.

Me: 'Welcome to the party, Andy!'

Andy Briggs: 'I'm gunning, am I? Handy Andy, that's me. Show me where your leak is, lady. I'm the plumber.'

Tank crews are interchangeable. If one of us is wounded we know who takes his place and we make the switch automatically. I am the only one with previous command experience so it's my head which goes out of the turret. The co-driver would normally come up and 'gun'. But Bookie closes his eyes and shudders before firing the massive 75mm gun. Which means the shell may land nearer our own tanks than the enemy's. Even fear of being shot at dawn could not make Bookie keep his eyes open during that horrifying muzzle flash and recoil. Even less would he be capable of looking out of the turret hatch. And although he is the senior rank among us, it is the individual's training and 'trade test', rather than his rank, which decides who does what job in the tank.

We bustle up the side of the tank. I pick up the mike as Andy drops into the turret. I follow him in. Andy is a popular chap. Not very tall and inclined to be tubby. Wears glasses. About a year older than me. Comes from somewhere near Carlisle and is working up to be an auctioneer in civilian life.

'Right, driver, advance. Back through the same hole you made in the hedge.'

As we again balance on the bank and topple through the hedge, my heart skips a beat. I am now perched with my head out of the turret and a complete view all round. And right at the spot to which we are heading is an absolutely horrific death machine – a bomb or an aerial torpedo or a huge rocket, a gigantic unexploded egg: so huge that I rub my eyes, look again! Probably dropped by the US bombers just now. I have no idea what size bomb it is but I have never seen one so big. I estimate it

is as long as our Sherman tank! We must have missed it by inches on our previous sally.

Me: 'Driver, halt! Gunner, can you see that bomb right ahead?'

Andy: 'That can't be a bomb. That's a ferking battleship.'

Stan: 'We can't go rumbling past that thing.'

Me: 'We just did. Twice! Right, lads, plug your ears and close your eyes. Gunner, one round HE. Fire!'

Andy: 'What? At that bloody great monstrosity?'

Me: 'Where do you think? Fire!'

Andy: 'Oh, well . . . Holy Mary, Mother of God, pardon . . .'

It happens too fast. Here, looking from above and only a few feet away, the muzzle flash is a sky-splitting, eye-gouging flame. Almost before the muzzle flash has fully burgeoned, the answering flame from the shell's impact flares against the bomb, more angry and more diffused. A heart's beat pause and then a full-size version of hell races from the ground up into the sky, flame wrapped around flame like the petals of a fiery artichoke enfolding one another. A tree in the hedge explodes in sympathetic reaction. And comes the almighty triple concussion: muzzle roar, shell burst, bomb blast! A noise so intense it darkens our vision as it hammers at our brains. I feel my head snapped back on my shoulders. An umbrella of sods, filth, shrapnel, smoke, fire opens over my head. I duck into the turret, jamming *my* knees into Andy's back, punching the flap-release bolts, wrenching the heavy turret flaps down after me, whipping my fingers away from the clashing, axe-edged flaps as they slam down. A hail of lethal rubbish rattles down over my head. Four distinct versions of ultimate blasphemy from within the tank in the sudden, stunned silence.

'Hullo, Roger 3 Baker.' (I had better report what that was all about.) 'Just blowing an unexploded bomb, a gift from on high. No damage. Roger 3 Baker, over.'

'3 Baker, you had us worried. Off.'

'Roger 3,' (Hank calling Hughie) 'tell your Baker there's enough noise going on without him advancing the date of Guy Fawkes Day. Off.'

(Stan: 'OK, Hank, take the micky. You're not deafened, blinded and shitting yourself.')

Turret hatches open again. Head out. Lovely August afternoon. Peaceful, verdant world, innocent of danger, bathed in the high noon sun. Ping-eeh! A stray bullet (stray, I *hope!*) smacks against the turret and cartwheels away over my head. I shrug deep into my collar.

'Driver, move back into our corner. Mind the ditch. Slowly does it. Gently. Whoah! Halt! Gunner, can you see?'

Andy: 'Yep, more than I want to! Nice, juicy slices of No Man's Land with thousands of invisible Jerries hiding in invisible holes.'

From this high viewpoint I have a comprehensive view of the partial views which I was earlier studying. Through the woods into the bare gully. The cart track. Copses, hedges, orchards. Behind us cornfields and orchards with Shermans tucked in among the trees. The finger of orchard in which the forward section of Black Watch is dug in. I am high above the world, seeing but able to be seen. I feel indecently exposed. I can see no enemy but know they must be there. Snipers, machine-gunners, bazooka operators, artillery observers, anti-tank gunners, fanatical SS Panzer Grenadiers and Hitler Youth, Mark IVs, Panthers, Tigers, SPs.

More moments of silence, of stillness, of endless waiting, of drugged monotony. The mind struggles with the repetitious messages of an eye which must continue traversing back and forward over a wide panorama of nothingness, the classic conditions for hypnosis. The more agile part of the mind again tends to wander, even up here on the exposed commander's eyrie. I have my own devices to keep that section of the mind occupied, apart from folding sweet papers. Sometimes I calculate the number of minutes and seconds we shall be in action from daybreak to sunset. Then I reduce that period to percentages. Calculate at what time fifty per cent of our duty will have transpired. At what time ten per cent. At what time one per cent. Looking at my watch, what percentage of the day has now expired?

Stan: 'Hey, Ken, you shouldn't be commanding this tank if you're not a blinking Corporal. It's not good Trade Union practice.'

Harvey: 'Serious, it's not right! If you're good enough to stick your head out, twelve feet up in the air in the middle of a bloody big battle, you should be paid the rate for the job. Plus overtime! Think of all the ruddy Staff Captains at HQ who would be scared to show an eyebrow within a mile of the front line. But still win MCs.'

Andy: 'That goes for the whole effing crew, too. I can't see why in the RAF you can have a Flight Lieutenant who is not even the commander or pilot of his plane. You can have two or three officers to one bomber. Just to fly in the ass-end of a plane you

have to be a Sergeant. But we, Fred Karno's Army, have to sit right out in a field within yards of Jerry's 88s (the same anti-aircraft guns that they can fly thousands of feet above) – and what are we?'

Bookie: 'Cannon fodder.'

Andy: 'No, we're not! That's the point. We are highly skilled and trained crew. But we're only Troopers.'

Harvey: 'Except my playmate, Lance-Corporal Hooker, who gets a stripe for proficiency in milking cows.'

Bookie: 'Piss off. Anyway, Andy's right. I think we should be the same as the RAF. All tank crew should be Sergeants.'

Stan: 'Especially the poor sod who has to stick his head out as a target for every Boche in sight.'

Me: 'Trooper Barber, are you calling your commander a "poor sod". That's a court martial offence.'

Stan: 'Sorry, mate. This is Trooper Uriah Heep down here wringing 'is 'ands and asking 'umble hapologies.'

I look at my watch again. Shakespeare wrote that famous passage about time moving at different speeds for different people in different situations. I know for whom time crawls along at its slowest. For the tank commander with his head stuck out high above an alien battlefield, desiring but not endowed with X-ray eyes to penetrate the scowling woods, waiting for the sudden flash of agony, and seeing all the time the thinning smoke palls rising over other tanks which have brewed up and cooked their crews alive.

Stan begins to sing his favourite song. 'I love coffee, I love tea. I love the Java Jive and it loves me . . .' Senseless! Like war!

**14.30 hours:** Still only 14.30? 2.30 p.m. Gunfire nearby. Sudden, spaced, buffeting.

'Hullo, Victor 4 Able. Have brewed one hornet. Another in sight. Over.'

'4 Able. Good show. Charlie coming to Help. Off.'

Me: 'Gunner, traverse left. Can you see anything, skyline, left of farm?'

Andy: 'Traversing past farm. Nothing yet . . . I can see smoke on skyline but not . . . Bloody hell! See that? Talk about Ronsons. That was a Jerry turret blown right up in the air.'

A gusher of fire has catapulted the unmistakable outline of a tank turret, twisting and spinning fifty feet above the ridge, before plunging down again into the vortex of flame. And as though the falling turret had been a lid slammed down on a

furnace, the fire goes out. In its place a spreading chestnut-tree pattern of oily black smoke oozes upwards into the sky.

'Hullo, 4 Able. Second hornet brewed. No others in sight. 4 Able, over.'

'4 Able. Good sport. Off.'

I focus most attention on the 90° arc immediately front, surveying it back and forward with our field glasses. Every third or fourth turn I extend my field to 180°. Now and again I take in the full 360° around the tank. (Jerries have been known to creep up from behind at the most unexpected times.) On one of my all-round sweeps I spot another Sherman moving up behind us. The tank coming up astern is topped by an officer's cap, jammed square on a stolid, pushed-forward head, and can only belong to our Squadron Second-in-Command, Captain Bill Fox. He halts about ten yards away and signals me to go over.

Me: 'Andy, come up for a moment. Bill Fox is here and I have to go over for a chat.'

I take a quick, cautious look along our front. Nothing. Vault out of the turret. Slide off the back deck. Climb up the front of the 2-in-C's tank. He grins his usual sardonic grin, which seems to imply that grown-up men cannot really be taking soldiering seriously. It is all something of a pleasant make-believe and an interruption to the sterner realities of fox-hunting and rodeo riding.

'I have a job for you. Dammit, lad, what's wrong with your eyes?'

'Stung by a wasp, sir. In the line of battle.'

'A kamikazi wasp, no doubt. But no medals for that, you know. I have a job for you. Take your tank across the gully. You will find our knocked-out tanks there. Survivors got back safely. Three people are missing. There could be one of them still alive. Corporal Astley, young Bellamy and Trooper Judge. Be a good lad and go check. Absolutely sure. I don't want any of our lads left to the bloody mercy of some SS butcher on holiday from the concentration camps. Be quick. Take bloody good care. If it moves, bloody shoot it. Off you go.'

I salute, jump to the ground and walk back to Stony Stratford on wobbly legs, in a condition for which Stan has an apt description. As Stan and Harvey say, what about the wages for the job? If I were a mere aircraftsman in the RAF, they wouldn't be saying 'Take this Spitfire and do a low-level suicide attack on an enemy position.' Those woods scare me frozen. And I have a pathological horror of dead human bodies close up. I would

rather face a live bull than a dead human. And I faced a few bulls in Hereford. So what do I do? Ask Bill Fox for the day off? Report sick with a wasp sting?

'Driver, start up.' (How did I get up here on the turret?) 'We are going across the gully. Straight down the track and across the gully fast.'

Harvey: 'Whose bloody idea is this?'

'Bill says there's just a chance Sonny is still alive.'

Harvey: 'Why didn't you say? Let's go!'

'Go fast. But ready to slam into reverse if we must.'

'OK, boss. Berlin, here we come.'

We crash out of our hiding-place like a berserk elephant, and bounce onto the cart track. Turn, skidding, left. One or two Shermans in sight, back up the field. Harvey steers down the steep, twisting track into the unknown gully which has become sinister. The prowling ground of Tigers. The sides of the gully are jungles of tall trees connected by thick undergrowth – hunting grounds for tanks which lurk like angry rhinos; breeding grounds for infantry which slither through the jungle like silent snakes.

We plunge wildly and blindly into the depths of the gully. Unexpectedly it widens out into a broad, flat, green bottom – not unlike a race-track, about the same width, winding gently into a green distance, with the steep banks like stands and the thronging trees like crowds of cheering race-goers. Stony Stratford roars in the travail of crunching up the far bank (Stan: 'They'll hear us in Paris') and the trees enclose us again.

Me: 'Driver, slow down. Take it gently into the corner. Give me time to see round it.' That is a pious hope, son! Our 75mm pokes out in front of us like an elephant's trunk, and the sloping front of the tank also precedes my eyes by several feet. An enemy round the corner always has time to spare, to get off a shot before the commander's head clears the corner.

The track bends to the right. Always upward. Nothing in sight as the track reels slowly into view. Up over the lip of the gully. An open space about half the size of a football field but not clearly defined. The usual confusion of hedgerows thick enough to be called woods, or woods straggling enough to be called hedgerows. A waste, a wilderness with space between the tall trees. To the left beyond a patch of thinner hedge is part of the cornfield which we set on fire as the enemy infantry tried to cross it. To the right, beyond thicker trees, is another cornfield blackened by fire. Nosed into the trees at nine o'clock, eleven o'clock

and three o'clock are Shermans, two of them still oozing trickles of smoke. Behind, at five o'clock, is a narrow gap in the woods from which a Mark IV must have shot up the Troop. Nothing moves. Here or beyond.

Anti-climax! We are alone. No 88s. No SS.

Me: 'Bookie, come up. Driver, I'm getting out to have a look. If anything happens, skedaddle! Don't hang about. I'll find my own way home.'

Harvey: 'I'll wait for you.'

Me: 'Don't! Get the tank out at full speed. Safer for all of us. Me as well. I'll go to ground. Got it?'

Harvey: 'Under protest. OK.'

Me: 'Gunner, keep that cornfield on right under survey. Operator, the cornfield on the left. Driver, watch straight ahead. Switch off and listen every two or three minutes. But be ready to move.'

Bookie has crawled through from the driving compartment into the turret, not an easy task at the best of times. Now he climbs up from under the gun, squeezes past Andy and looks up at me as I sit on top of the turret.

Bookie: 'I'm not sticking my effing head out up there. I'm a co-driver, not a bloody commander.'

Me: 'Listen, Bookie. You've got a stripe. Now is the time to earn it. Just sit here and scream if you see anything move. Andy and Stan will do the rest.'

Bookie: 'Well, make it fast!'

I drop to the ground and run to the gap behind us. A narrow, dark alley through the trees. A Mark IV could have sneaked up there. No movement now. No square shapes. From this angle I can see Corporal Astley sprawled in the turret of the nearest Sherman. I stop myself from shouting to him. It is a long, long, weary way to his tank. Corporal Astley watches me all the way. His eyes are like one of those Rembrandt paintings in the National Gallery – the eyes follow you wherever you go. Corporal Astley watches me climb onto his tank but says nothing. His right arm, caught in the turret flap, is extended in one last parody of the Hitler salute that he himself would have enjoyed. Hesitantly I touch the hand. Cold already. Unfamiliar. No sign of blood. Just shock. Shock to the body. Shock in the eyes.

Hurry, hurry, hurry on, then, to the next tank watching forward, the nearest tank to Paris and Berlin, the tip of the arrow point. This one still sends up thin trails of smoke from the blackened engine. I look into the turret. Nobody. But through

the turret I can vaguely distinguish someone . . . sitting in the driver's seat. This tank did not explode. A shot has hit the gun and twisted it in the mounting.

I open the driver's hatch. And wish I hadn't. Trooper Judge is sitting there. All of him. Except his head. What has happened to his head is explained by the stipples of mincemeat on the walls of his compartment. From the shoulders down he sits upright. Holding the sticks firmly. Feet in place. Ready to drive to Berlin. One of the smart Hussars Regiments, the 'Cherry Pickers', wears cherry-coloured cap and trousers. Trooper Judge's blouse is smart with the same colour. the mess on the floor is black. Flies have already found it. I hold my handkerchief to my nose and close the hatch quickly.

That leaves Sonny Bellamy's tank, which *did* brew up. No hope for Sonny if he was inside, although Shermans do not always brew instantly. Sometimes there are seconds of panic-stricken agony before . . . Tucked away in its own corner of the woodland glade is the Sherman which was Sonny's. For a few moments this morning he wreaked havoc among the enemy. Now the tank stands lifeless and filthy with smoke. I approach it reluctantly from the side, climb onto the turret and look inside. There is nobody there. The turret reeks of soot and burnt explosives. A desecrated temple. Uninhabited. I reach down and lift the flap into the driver's compartment. A movement in front of the tank catches my eye. I freeze. Then relax. A movement only of shadows on the grass. Shadows cast by trees in the bright sun and persuaded into gentle motion by a hesitant, unmartial breeze. On the grass someone is lying, stretched out in the sun as though sunbathing in this summer afternoon. I lean on the useless gun and swing down the front of the tank.

Sonny Bellamy is lying asleep, engulfed in peace, his hands folded over his chest, a pleasant look of satisfaction on his face. I bend over him. His denim blouse is warm in the sun. The delicate shadows give movement to his breast. Only his cheek is chill in the ultimate hypothermia. I look for his pay-book but his pockets are already empty.

The last time I saw him, a few hours ago, he was pretending that all the noise of battle was his fault, playing drum rolls on an imaginary set of drums. He is twenty, a few weeks younger or older than me. (He *is* twenty? He *was* twenty. He will always be twenty.) A little old to be playing at drums. A little young to be playing with guns. Far too young to be lying here, where he will ever more lie in a 'corner of a foreign field'.

I glance at my watch. Only three minutes since I parted from Bookie on the turret. I have aged many years. I must move on. And why should I want to wake Sonny up? Why want to interfere with the inscrutable and infinitely intricate patterns of destiny? Finer than gossamer. More treacherous than uninsulated high-power cables. Perhaps Sonny's present destiny is not the worst of options mooted for him on the spinning roulette wheel of his own fate. If I could wake him, for what more horrid fate might he be reserved? I bend closer, looking for hurts, damage, bruises. I can see none. A small, fatal bullet, or a tiny needle of shrapnel, or simple shock? Time to go. Four minutes of the time bondage which we continuing mortals must obey. Cheerio, Sonny. The clock does not matter for you now. 'I will write you a poem all to yourself one day, Sonny!' I leave his physical semblance sunbathing in the glade and wonder where his spirit has gone, playing imaginary drums.

I walk forward, waving to Bookie's eyes, almost invisible between tin hat and turret. Trooper Judge's tank is still jammed into the hedgerow, as when its gun and periscopes probed through to challenge the enemy. I squeeze through a narrow gap in the bushes. A German officer grins at me from the turret of a Mark IV tank, its great gun pointing at me five yards away. Sheer fright sends me charging across that five yards and up the front of the tank, waving my puny pistol idiotically. The mind has already registered the familiar blackening of the tank, gun askew, tracks broken, staring eyes of the commander with his set grin. But panic operated more swiftly.

Desolation reigns here as in Sonny's Sherman. And the grinning commander ceases at the waist. What happened to the top of Trooper Judge happened to the bottom of the German. His elbow, vice tight on the turret, holds his trunk in place. Blackened, shrivelled creatures squat and stink inside the tank. The flies exercise their loathsome neutrality. There are untidy lumps scattered over the burned cornfield, like sacks of manure dumped by the farmer. Only the sacks are of field-grey cloth, their contents Panzer Grenadiers.

Nothing moves, nothing hisses, nothing pings. I go ten yards forward into the field and take a look at the badges on the nearest field-grey lump. The badges mean little to me. By a strange freak our months and years of training have failed to include identification of German ranks and units. So I memorize the badges, which may mean something to Hughie or Bill Fox. Standing here in this deserted French field, I remember Siegfried Sassoon, as

so often in Normandy. I remember his story about standing in a trench opposite Mametz Wood at a crisis hour of the Somme battle. Nobody moving. No enemy in sight. The armed millions vanished like ghosts. For a moment Sassoon possessed the entire battlefield single-handed. A few days later he found thousands of men still disputing the same killing-ground which he had occupied alone.

I squeeze back into the little glade of sunny doom. Run up the front of Stony Stratford. Bookie ducks into the turret. Swing after him, shoe hitting his tin hat. Pick up microphone. Harvey has the engine idling, purring contentedly.

Me: 'Driver, home in reverse. Go, go, go!'

Harvey backs circumspectly across the open space. Or at least *we* do, for Harvey can only see about 90° of the 'circum'. I watch the remainder, talking him back, down into the gully. Still no square shapes. (They wouldn't want any tears, those lads. Sonny for ever beating drum rolls and grinning. Astley for ever giving the Hitler salute, po-faced.) Stony Stratford roars in anger of acceleration, streaks back across the wide, open race-track of the gully bottom. Off the track, smashing through bushes, our tail rising.

I cross to the 2-in-C's tank and fill old Bill in on the details. Describe the badges of the Germans seen. 'As though he was sleeping, did you say?' His normally jolly face is tight with grief and his eyes fill with water. He looks away across the gully, still a No Man's Land. 'Thanks,' he says. 'Thanks for going. It's as I expected.' I salute. He nods back as though not really seeing me. He orders his driver to reverse, and I depart over the side in some peril as the tracks start churning the bushes.

We snuggle back into our corner of hedge and continue to watch the tiny patch of woodland on either side of the gully which is now familiar ground. We have inserted ourselves again into the static tableau of battle; infantry dug into holes in the ground, tank commanders peeping out of motionless tanks, Fritz over yonder, the artillerymen way back, piling more shells ready to hand. All waiting for the silence to rip apart. All wondering whose name is on the next bullet or shard of shrapnel, Britisher and German alike. All in the infinite lottery of war.

**15.00 hours:**  'Hullo, Mother. Where's my sugar? Over.'

'Mother, we're trying to get some sugar for you . . .'

'. . . My batteries are as flat as a snake's belly. And still no sugar . . .'

The voices are faint, increasing and fading away across the ether. Completely blotted out when one of our regimental stations speaks. These voices have been in the background all day but, over the last hour, have become clearer, perhaps as the unit draws nearer to us.

Stan: 'What silly ass is asking for bloody sugar in the middle of a battle?'

Harvey: 'Sounds like a Yank. It's a wonder he's not asking for ice-cream as well.'

Me: 'Your Yank is probably a Canadian, Harvey. One of their columns working up on our right.'

Bookie: 'Why is he asking for his mother?'

Stan: 'That's his call-sign, you clod.'

'Hullo, Oboe Able. Message for Oboe 1 Able. Am moving towards you. Time to go hunting again. Don't pot me by mistake. Over.'

'1 Able to Able, OK. Over.'

Me: 'That's Tom Boardman off swanning again. Gunner, traverse half-right. Operator keep look-out ahead and left.'

Stan: 'Looking left is like what the fairy on the Christmas tree saw, all leaves, spikes and branches.'

Me: 'Happy Christmas then. Look where you can see. Or else see where you can look.'

Stan: 'Incomprehensible but understood.'

'Hullo. Oboe Able to 1 Able. View Hello Tiger! Move right a bit. You'll see him. Over.'

'1 Able, wait . . . I see him. Only inches of turret visible. Over.'

'Able to 1 Able. Pepper his head. I'll salt his tail. Keep him ducking. Over.'

'1 Able, will do. Off.'

Bursts of rapid cannon fire. A dull flat 'boom!' A succession of huge crackles. The usual cloud of dirty smoke billowing up out of the trees well left of where I had been searching.

'Able to 1 Able. Cease fire. We have a kill.'

'1 Able. Thanks for inviting me to the hunt. There seems to be only one fox in that neck of the woods. Over.'

'Able to 1 Able. One fox too many when that fox is a tiger. Off.'

In one way the odd single enemy is sometimes more worrying than the mass. Whilst the mass attack is frightening, it is usually only too obvious. The single, unobserved attacker can move stealthily through the undergrowth to loose off a bazooka bomb from close at hand. Even, in all this rank grass, to climb up the

back of the tank without being seen. So I sit up in the top of the turret and worry most about the unseen clumps of bushes and long grass right there behind us. We have been in action now for about fifteen hours, and it will be dark in another seven hours. But the last seven hours will be a long, long time as the summer day swelters on in all its thirstiness. Up here it is broiling hot, with heat radiating off the burning steel all around, yet tempered by a slight breeze at times. Down inside the tank it will be like the stoke-hole of an old coal-burning ship.

'Hullo, Mother. Any news of my sugar? Mother, over.'

'Hullo Mother. We're sending you some sugar as soon as we possibly can. Off.'

'Mother. Bloody lazy square wheels! Off.'

Stan: 'That blinking Canadian again, bothering about his sugar. We're lucky to get tea, never mind sugar in it. If I was his Colonel, I'd court martial him for wasting wireless time.'

I swing my field-glasses quickly through a 180° arc once more. Then glance over to our rear. The German who wasn't there before still isn't there! I think that, if I were creeping up behind a tank, I would wait until the commander had given his occasional glance to the rear and then . . . I whip round unexpectedly and stare at the rear. The German still isn't there. Why don't they bring the Black Watch up level with us?

Harvey: 'Look, there's a bloody bird landed on the end of our gun.'

Stan: 'Don't believe you.'

Harvey: 'That's jonnuk. Scout's honour. Look for yourself.'

Andy: 'Hey, Stan, look up the barrel and see if it has nested.'

Harvey: 'God, if I was a bird, I wouldn't be buggering about here. I'd be off migrating three months early to Africa where there ain't no wars no mo'.'

Me: 'May I remind you gentlemen that we are not bird-watching but Jerry-watching.'

Stan: 'Show me a nice big, juicy Jerry and I'll watch him all day.'

**15.15 hours:**   In the hot, dreary sunshine and the long, dreary silence I am losing touch again, drifting, back to the little glade across the gully, so like that painting by Constable: a small field mainly in shadow but patched with golden sun; tall, thick spreading trees; cornfields beyond, wide and brilliant for harvest; and a boy lying there drinking at a pond; a boy with the face of Sonny Bellamy drinking at a deep, cool fountain of peace . . .

Whoosh! Crump! Whoosh! Crump! Whoosh-oosh-oosh! Crrrump-p-p!!! Our tank has become part of the hedge. The branches stuck into our camouflage net merge into the wilderness in which we are ensconced. For long enough this morning we stood out on a bare hillside, looking like a bushy-top tree without a trunk. Now we belong in the scene, and whilst we remain motionless, Jerry can hardly find us. So his artillery explores all likely hiding-places, hoping to find the odd tank, artillery pit or machine-gun post.

'Hullo . . . Able . . . and Sunray indisposed. Transport . . . can you . . . Able over.'

'Four Able, OK. Off to you. Hullo, 4. Did you hear? Can you send doc? 4 over.'

'4, help on way. Off.'

(Harvey: 'Oh I say. My sunray is indisposed, what? My bleeding sunray won't be taking tea, don't you know.')

It could be an 88 lancing horizontally across his turret, smashing the hatches down on his head. A howitzer HE splashing all things in sight with speeding splinters of jagged, white-hot shrapnel. It could be a Moaning Minnie dropping vertically down into his turret. It could be a stream of machine-gun bullets stitching a pattern across his face. It could be a simple accident. It could be shock which leaves the body unscarred or blast which tears the lungs. It could be a heart attack brought on by extremes of fear and frenzy. It could be heat stroke. Or it could be that he has gone 'bomb happy' and is dancing naked on the turret top.

FIRE immense, infernal, thundering! . . . light searing the eyeballs . . . noise of the universe splitting apart . . . heat of a belching volcano . . . flame and pelting steel raging out of the turret wall three feet from my face . . . crackle of fire taking hold . . . stench of cordite and burning material . . . thick, choking smoke spattered with blood-red flame on the turret, in the turret . . . God, we're going up . . . three seconds to get out . . . if . . . 'Bale out! Bale out!'

I jack-knife up onto the turret top, crouch there as Andy catapults past me, grab Stan's elbow, haul him choking out of the carnage. Bookie launches himself into the air to the right. Harvey? I jump clear across the back deck, down into the undergrowth in one leap, collide with Bookie sprinting for home.

Me: 'Where's Harvey? Seen Harvey?'

Bookie: 'Fiddling with the escape hatch. Underneath.'

I run on all fours, along the left-hand side of the tank.

'Harvey! Harvey! Where are you?'

'I'm here, trying to be a bloody rabbit down a warren.' Harvey crawls out from under the rear of the tank. I scramble back to join him.

Me: 'Silly sod, coming that way! Andy?'

Andy: 'OK. Behind this bush, doing my bit for king and country. I'll never need Epsom salts again.'

Me: 'What about Stan? Where are you?'

Stan: 'Halfway to flooding Australia, mate.' He lifts a filthy face out of the ditch and grins.

I look up cautiously at the tank. The turret is still hidden in smoke, but none of the gushing, horrific flame that so often marks the death of a Sherman. This fire seems to be more smoke than flame. Strange!

Run back along the side of Stony Stratford. Sundry bangs and crashes in the trees, but all rather irrelevant. I crawl under the front of the tank in between the tracks. There is a square hole where Harvey has released the escape hatch. Squirm through into driver's compartment. Smoke, but no fire! Grab a fire-extinguisher. Peer into the turret. Clogging, stinking, eye-caking smoke – but no flames! Slide back out through the escape hatch. Crawl forward into the bushes. Haul myself up into the smoke. Pump the fire-extinguisher across the front of the turret. Pull my beret off and wave furiously at the smoke. Wood smoke. Nice smoke. Lovely smoke.

I laugh and pump the extinguisher again. Climb like a mountaineer through the mists, only through smoke, to the summit of the tank. Sit and laugh. At moments like this, laugh or cry! Stan appears beside me, a puzzled look on his face. He sniffs the air and peers suspiciously into the smoky turret.

Stan: 'What the hell goes on?'

Me: 'Our camouflage caught fire.'

Stan: 'Well, strike me! We could have stayed up here and grilled a steak.'

Me: 'It must have been an HE. Look, gouge marks!'

Stan and Andy drop into the turret which now smells rather enchantingly of wood smoke. Stan checks the remaining 75mm shells for damage.

Harvey: 'Escape hatch on! I've just come up the front of the tank, and she looks like a grey-haired old lady that's had her hair singed and frizzed.'

Our fresh green camouflage has been reduced to a few twisted

branches charred black and sprinkled with white ash and fire-extinguisher foam – quite conspicuous amid the prevalent green.

'Bookie, will you get the axe and chop a few more fresh branches for camouflage, please?' I switch to A set and explain: 'Hullo, Roger 3 Baker. Camouflage set on fire by direct hit. Fire out. No damage. No casualties. 3 Baker, over.'

The wireless waves continue chattering away. Messages from our own Regiment loud and clear. Distant messages identifiable only as human, but lost in the ether, their language, nationality or service arm indistinguishable. Nearer voices, mainly Canadian, messages largely comprehensible but audible only when our own stations are silent. Occasionally swift bursts of crackling Morse. And then, in the silences, always the whisper of atmospherics, alive, varying, almost having a meaning – like the incessant traffic of the dead in battle trying feverishly to maintain contact as they drift farther and farther into the empty wastes of eternity.

'Hello, Mother. Where is my sugar? Mother over.' (That Canadian voice again, terse, rude, exasperating.)

'Hello, Mother. You should have some sugar by now. Over.'

'Hello, Mother. If I had bloody sugar, would I still be asking for it? If I don't get some soon, I'm going home. Over.'

'Hello, Mother. Keep your hot air where it belongs. Up your ass. Off to you.'

'Ah-hallo, Roger Able. Can't somebody tell that Mother idiot to keep off the air?' (Bill Fox getting het up.) 'We're fighting a damn battle while he's chattering about sugar for his tea. Able, over.'

'Hullo, Roger Able. I've had a word. Sugar is not sugar but what cockles live in. Over.'

Harvey: 'Still don't get it. Cockles live in the sea, don't they?'

Stan: 'Shells, boy. Cockles live in shells. Obviously the Canadian crank is wanting more shells. "Sugar" is his code-word for shells. Yum, yum, cockles, winkles and mussels!'

Bookie: 'Cockles, winkles and what? Never heard of them.'

Stan: 'God, what do you eat on farms?'

**15.43 hours:**   Silence. Stillness. Heat. Stench. Fear. Weariness.

Stan: 'What are the buggers doing?'

Me: 'To whom do you refer by that obscene epithet, Trooper Barber? To our respected enemy? Or our not-so-respected General Staff?'

Stan: 'Both! The Staff should have reinforcements up by now. But probably they are having a bridge tournament this afternoon. First things first.'

The woods seem to burst apart with a thundercrack fifty yards to our right. A tree rises into the air, poised on a bright, expanding finger of flame. Noise hits Stony Stratford with a series of sledgehammer smashes as explosions erupt with the velocity of a Bach fugue. I duck instinctively but come back up to my vision point. The shot that has my name on it will arrive before its sound. And from any angle to the vertical. Ducking won't help. More important to see if infantry or tanks are following the barrage. The constant repetition of concussions drives the breath from my lungs and claws at my chest. The ferocious flashes dazzle my eyes, and smoke clouds obscure the landscape.

Time for a joke? Or an attempt at a joke. Me: 'There's your answer, Stan. That's what Fritz has been cooking up.'

Stan: 'Couldn't we send Fritz the map reference of GHQ? Let him paste them for a change?'

Normally we would have close infantry support as an added early-warning system of enemy intentions. But our handful of Black Watch are spread out around our long, brittle perimeter, still isolated in the alien land. More than ever our position seems precarious. The summer afternoon again becomes torrid as shells of every calibre and mortar bombs of vertical descent plaster everything in sight. I check our escape route. Then permit myself a sickly grin. If we do reverse, where to? A few seconds of reversing would take us back into the village and back-to-back with B Squadron. Nowhere else to go. Reinforced, numerically superior German panzers encircling us, (as they already may do) closing in for the kill. A Squadron and C Squadron both down to almost half strength . . . Best not to think!

More fire leaps off the front of Stony Stratford. A hot tornado tears at my beret. Shrapnel screams old woman's curses at me. No burning camouflage this time. No panic. Only a frantically beating heart. Stunned ears. Stuffed nostrils. Sullied tongue.

Me: 'All safe? Harvey? Bookie?'

Harvey: 'It effing-well woke me up. I was having a whizzo dream. Betty Grable!'

Bookie: 'It was his snoring woke him up. Do you think Betty Grable would sleep with THAT?'

They are joking when, six inches away, death has just

knocked at their little doors. There in the gruesome bottom of the tank it is a heroic effort just to maintain consciousness. Fumes from two direct hits, from a wood fire, from fire-extinguisher foam; pints of human sweat, frequent urination, battle weariness, lack of sleep. I must keep them alert.

Me: 'Gunner, is the 75 functioning OK after the various bangs?'

Andy: 'Seems OK to me. If she blows me to heaven next shot, ask me again on my way down.'

Me: 'Operator, how goes the ammunition?'

Stan: 'Yes, mate, I'm awake too! Actually, kiddoh, we're down to four belts of Browning.'

Me: 'More in the bin outside. Check the 75 ammo, will you?'

Stan: 'Sure, boss. Then Crazy Horse him count up big heap German scalps he got hung on him belt. Sharpen him tomahawk. Make more arrows.'

As they bumble through their jokes and just stay awake, more mortar bombs bracket the tank, keeping me more than awake. Get down inside the tank! Cosy safety of thick steel walls. My eyes are heavy when I need to be able to pierce every leafy bush and hedgerow, to spot tanks, men, guns. I am weary to the point of despair. And then I see Major Bevan taking an afternoon stroll. Am I seeing mirages? Have I gone round the bend? Hank out for a stroll? In a thunderstorm of battle, whose rain is jagged iron splinters, whose lightning strikes again and again at the same places, whose thunder continues, peal overlaid on peal.

Tall, lean, languid, he ambles along the verge of the vegetable field, swishing his riding crop at tall weeds. He pauses and waves his riding crop at a thicket about fifty yards away from us. Presumably another of our Shermans is nestled there, invisible to us. For miles around everyone has gone to ground, German Grenadiers and Black Watch in their fox-holes, Yeomanry inside their tanks, Artillery in their gun-pits. But Major Bevan chooses to walk above the earth. He is wearing the normal officer's cap, as opposed to the beret which most of us wear, a khaki shirt – a cloth crown on each epaulet – and an old loose pair of corduroys. More Minnies fall a hundred yards behind him but he continues his stroll towards us without haste.

At the gap in the hedge to our rear, which is our escape route, he pauses again. Then changes direction and walks across to Stony Stratford. He looks critically at the burnt camouflage branches still adorning the tank beneath Bookie's green, fresh decorations. Flicks away a dead branch with his riding crop. I

give him a rather sketchy salute. He touches his cap with his riding crop in a familiar gesture. Gives Stony Stratford a friendly wallop across the rump as though she were a horse. Screws his face into a combination of a grin and a wink. Then continues his ramble back through the hedge. I see his cap beyond thinner patches of hedge as he strolls across the cart track which is the focus of our world war at this moment. Sporadic explosions continue as he turns and heads back up the slope, still at the same Sunday afternoon pace, towards where HQ(F) must be.

I no longer contemplate diving for refuge inside the turret. If David Bevan can saunter coolly across the fields under fire, then I can stand up in my tank and keep a clear watch. Whilst I am still squaring my shoulders and feeling slightly braver, the most appalling crash yet, the most frightening flash yet, shatters my new-found resolution. They happen at tree-top height, with the effect of an aeroplane blowing up, where there was no aeroplane, or a tank brewing up, where there was no tank. Like the fusion of firing flash, impact explosion and follow-up blast, all in one sizzling flame and overwhelming concussion. All flash. Very little smoke. Flash and noise. In mid-air. After some moments of pondering, as less offensive shells and mortars continue to pound, it occurs to me that I have seen a head-on crash between a German HE shell and a British HE shell travelling in opposite directions! I may be wrong. But there is no other reasonable explanation.

Stan: 'We don't have any infantry in front of us, do we? There's a man's face staring at me from ten o'clock, fifty yards, face just above ground level.'

Me: 'There's nobody there. At least there should be nobody there. I can't see from here.'

Stan: 'It's ghostly. It's just a head. Staring at me. I've been staring back. But it hasn't moved in ten minutes.'

Andy: 'Where, mate? I can't see a thing.'

Stan: 'Ten o'clock. In front of that huge clump of grass.'

Andy: 'You're seeing things, mate.'

Stan: 'That's right. A head. Without a body.'

Harvey: 'So what? We've seen lots of things flying around today. Tank turrets, trees, unexploded bombs. Why not a few spare heads? There's probably a body somewhere belongs to it.'

Stan: ''Struth! It bloody gives me the creeps.'

**16.30 hours:** 'Hullo, Victor 4 Able. There appears to be move-

ment in the cornfields beyond the gully again. Not yet able to say what or how many. Victor 4 Able, over.'

Me: 'Gunner, operator. Can you see? Cornfields beyond gully and right of the wood?'

Stan: 'It puzzles me. I can't spot any special details. Just a feeling of movement. In the corn. Like a breeze. Only low down.'

Me: 'Maybe infantry crawling . . .'

Andy: 'Hello . . . wait . . . definitely – a Jerry helmet, five hundred yards, one o'clock of woods.'

I report: 'Hullo, Roger 3 Baker. One o'clock of woods beside track. Furtive movement, probably men crawling. Roger 3 Baker, over.'

'3 Baker, OK. Hold fire. Off to you. Roger 3, did you hear? Over.'

'3. Yes. Hold fire. Let them come on a bit. Get a good view. Off.'

Me: 'Gunner, did you get that?'

Andy: 'If they come nearer, we should see them in the woods along the gully.'

Me: 'Keep your sights on that area.'

I climb out of the turret seat and squat on the turret, giving myself two or three feet more of height. The taut microphone cable will not allow me further scope. I steady my German binoculars and scan the gully.

Stan; 'Another Jerry in the cornfield. Gone again. Crouching or crawling. There could be hundreds.'

Andy: 'Nobody above the gully yet.'

Harvey down in front is actually shoved deep within the immense hedge. He can see nothing. Andy will have a perspective of waving leaves and will be traversing delicately to get a clear view through his telescopic sights, which are level with the gun barrel. Stan's periscope protrudes through the top of the turret, so he will have almost as clear a view as me.

Stan: 'More movement. Same place. No way of counting them.'

Andy: 'No sighting yet.'

Me: 'I think we . . . I see them. Little men coming out of the bushes above the gully. Six. Ten. A dozen. Gunner, right, gently . . . on. Hold fire a moment. Then both co-ax and HE when I say.' Press mike and switch to A set. 'Hullo, Roger 3 Baker. Little men emerging above gully. A hundred yards right of track. About to fire. Roger 3 Baker, over.'

'3 Baker. Fire and I will take my aim from you. Off.'

More little men in a staggered line, moving cautiously through the bushes. Andy's first shell hits high in the trees above the gully. Strictly inaccurate but deadly for anyone beneath it. He hoses the co-ax tracer down into the bushes and the advancing men. Another line of tracer leaps from our right rear. Hughie Macgregor lining up blind on our target. Tracer from the left, B Squadron, into the cornfield. Andy's second shot smashes into the bushes. Little men fall, disappear, crawl in several directions.

Our little private argument with the enemy grows into a general confrontation. Other tanks have either spotted movement farther to our right or taken presumptive action. The little grey figures in the woods, formerly moving towards a common goal, are now split into smaller groups or single individuals. These make short, quick rushes in conflicting directions. Some rush right, some sprint left, some crawl to the rear, others slide down the bank forward. Not easy to shoot at.

Me: 'Gunner, aim for the foremost, the front runners. Don't let them get down in the dip.'

Into the intense din there bursts a higher, louder, compressed screaming and slamming as a Typhoon rocket plane (I see it indistinctly through the trees) hurls itself at the woods, the rockets fizzing out from it like smaller planes given birth, diving into the sea of flame and smoke which must mark the residence of German tanks invisible to us. Then another plane. I hurl a yellow smoke-bomb to leeward of us – a belated signal.

The movements of the grey men on the gully slopes become even more confused, without apparent logical purpose except perhaps to find some shelter. There is still a downward movement. The bottom of the gully could be welcome shelter, and they could crawl through the undergrowth right under our noses. Some figures hurl themselves down the slope. Others fall in unco-ordinated movement. Many lie still. A few approach the bottom limit of our vision.

Me: 'Driver, we'll advance through the hedge. Hang on for ditches. Gunner, rake the lower banks of the gully as soon as you can see. Driver, advance.'

Stony Stratford lifts her nose up in the air. Tracks grapple at the hedgerow bank. Our thin underside is exposed for a moment. We balance, topple, crash nose-down into the rank undergrowth beneath the hedge.

Me: 'Driver, left stick . . . halt.'

We have driven forward to where the track dips into the gully. Now we can see much farther down the opposite bank. The two machine-guns send threatening tracer along the lower slopes where a number of grey figures are emerging onto clearer ground. They pause, one or two of them staggering, collapsing. The others turn and run. The distance is too great for any of them to rush us directly.

A shadow across the sun. More screaming. The rocket planes race along the treetops again. A fresh burst of artillery fire from behind us lands shells all along the gully bottom. Near enough to throw dirt onto our tanks. But nearer to the grey figures, throwing some of them . . . screaming anger hurtles out of the skies and explodes under our nose . . . Stony Stratford bucks back . . . rocks forward . . . panic: no yellow smoke left! . . . something blunt thumps my shoulder . . . branches peeling off trees . . . grey ants scattering, convulsing, scurrying . . . sun turned to smoke . . . grey ants scurrying left, right, rear, not forward . . . barrages washing towards each other . . . overlapping . . . shells – ours, theirs – overlapping, fraternizing, combining in a double density of smoke flame their flashes our flashes our guns firing flashing blinding smoke obscuring grey men crawling back, hiding, lying still, hiding behind bushes, bushes ripped away by huge fire blasts showing naked grey worms slithering, disappearing, lying, gun flame blinding smoke obscuring double barrage drumming God-awful crash on rear deck! . . . mortar bomb . . . where's my head? – blood on fingers – not much . . . must report . . .

'Hullo, 3 Baker. Little men moving back through woods. None in gully bottom. 3 Baker over.'

'3 Baker. Good show. Move back a bit and let the hounds see the foxes . . .'

Switch to I/C. 'Driver, did you get that? We're obscuring other people's targets. Reverse slowly.'

Stan: 'What was bang?'

Me: 'Mortar bomb, rear deck. No damage.'

Bookie: 'Have a look, Andy, and see if he's still got a head on his shoulders.'

Andy: 'He's not talking through his effing navel yet. If he is, his lips are not moving!'

Hardly any motion on the gully slope. Little motion among trees in woods. Attention now on cornfield already partially burned out once today. Black patches and gaps amid the yellow standing grain serve Andy and Bookie as markers. They fire

short bursts wherever movement takes place. Sometimes the movement is so subtle it might be the breeze rustling through the ears of corn. They fire anyway. It won't injure the breeze. Sometimes a field-grey figure launches itself desperately across an open space. A split second of terror. We sympathize because we too on occasion have suffered the eternity of sensations packed into a split second during which one crosses an open space under fire. An eternity for the fugitive running. A split second for the watching gunner.

Once again the most violent shock and flash of all, although the friendliest – our own muzzle flash and explosion which I must have observed again and again in these hectic moments without actually noticing. The curving, beautifully scientific flight of puttering tracer flame. The responding gay flash, ball of flame, cloud of smoke and detritus in a skyline hedgerow. Pause. Reload. Sinister through the perpetual noise of battle and tank engines comes a dull, metallic click. The day freezes into arctic ice with a black sun in a copper sky. I know what the message is before Andy presses the mike switch.

'Misfire, 75!' 'Operator, recock 75.' '75 ready to fire.' 'Gunner, one round 75 . . . fire!' No flash. No crash. No leaping, raging recoil. No plumes of muzzle smoke. Just that devilish metallic click of the firing pin. 'Misfire, 75!'

The overheated breech of our 75mm now contains, from front to rear; 1) a lethal, iron warhead, filled with high explosive, which will disintegrate into shrapnel and kill up to fifty yards away from the point of burst, this warhead fitting tightly into 2) a large brass case, itself filled with enough explosive to drive the shell up the tight, rifled barrel and emerge at a thousand feet per second. And in the rear end of that brass case is fitted 3) a percussion cap which should fire the large charge within the brass case. The percussion cap has now been struck twice by the firing pin, triggered by Andy's foot. Stan will now have to extract the entire shell from the breech and pass it to me so that I can throw it overboard. It may explode as the breech opens, filling our tiny iron cell with incinerating flame, flailing iron shards and asphyxiating gases. It may blow up in our arms. It may wait until I throw it, and that last jerk may cause it to shatter, together with my head, mixing my skull-shrapnel with its iron-shrapnel.

Nobody has moved inside Stony Stratford. There is a tangible frozen silence, undisturbed by the lesser terrors from outside. It is like waking up and finding a cobra twisted around your

throat. 'Right, driver. Take us back behind the hedge. Left hand down a bit.' We bounce over and through the second hedge which gives us fair shelter from observation. 'Driver, halt. Driver, co-driver and gunner, dismount. Get your heads down to the left of the tank while we unload to the right. You three, bale out!'

As Andy goes past me, he offers to stay and help. He knows there is really nothing he can do to help. He shrugs, climbs down the left of the tank and joins the other two. They grin – green, horror grins. Give the thumbs up sign. Duck down out of sight. 'OK, Stan. I'm coming down. Take it easy. We'll discard some empties first.' Under the breech of the 75 is a huge fireproof bag which catches the empty, scalding-hot brass cases ejected as the gun recoils and opens its breech for reloading. Now the bag is full of these empty cases, obstructing the space under the gun. Stan unhooks the bag from the recoil fixtures, and we haul the heavy, clanking load out onto the roof of the turret.

I dive back down under the gun, grab the large, clumsy breech release and swing with all my might. Stan crouches like a goalkeeper, ready to stop the round from bouncing right out of the breech at the first swing. But my pull only succeeds in half-opening the breech, revealing the mocking brass rim with the tiny percussion cap, like a small brass coin, in the base of the case. And very clearly dented. I swing, ponderously but gently; the breech opens fully and I handle the large shell clear of the opening in one sweet, continuous movement. No jolts. These things can explode even without jolts.

I am now sitting on the edge of Stan's tiny, round seat, nursing a complete 75mm round which is so long that it extends to much wider than my body, protruding beyond my cradling arms. I adjust it into a diagonal position to avoid knocking the detonator nose at the front end. It can explode from there too! I crouch under the gun and roll the round into Stan's arms. Crawl under the gun. Squeeze past Stan, who is now standing up nursing the shell.

Stan: 'Poor little orphan. Nobody loves it.'

Me: 'It'll "poor little orphan" *you*, if its tummy begins to work.'

This conversation has taken me past Stan and up into the turret hatch. I reach down and our two pairs of hands jockey the thing into a vertical position in an embarrassing location just below my belt.

Stan: 'Watch it! There could be a population explosion.'

Me: 'If I drop it now, it will be straight down your gullet, so keep your big mouth closed.'

Stan can reach no higher. I balance the shell on a bent knee, then gently launch it and myself upwards. Hardly room for two of us – killer fish and me – to get through the hatch. Lay the thing flat on turret top.

Hullo, there is a war going on out here. Shells exploding. Guns banging. Bullets zipping. Cautiously lift the misfired shell again, knee high, lunge, send it spinning sideways. Fling myself flat on turret. Nothing! Still nothing! More and more nothing!

I shout down to the other three to mount up. 'Driver, reverse. Back a few yards. Gunner, can you see the misfire in the grass? See if you can blow it with co-ax. Fire!' The misfired round could be fatal to infantry. Andy fires his co-ax briefly. The brass case belches into brilliant double roses of flame, magnificent, bloated, expanding roses. As the shattering report hits us harmlessly, Stan, from his periscope, and I, from my perch, contemplate the raging progeny which we nursed so gently in our arms. 'Driver, take us through the gap in the hedge. Back to our original position.'

As we peep out of our former nook at the junction of the hedges, all the action seems to be concentrating on the skyline. No action in the gully. No action in the woods above the gully.

Stan: 'Did you notice that tank in the hedge next on our left? It's old Sergeant Dawlish. I had my periscope on the old sod, and if I had had a gun on the end of it, I could have gone rat-tat-tat. And nobody would have known. I would even have paid for a headstone, saying nice things about him like, ''He wasn't such a damn, pea-brained, shit-arsed sod as we all thought!'' '

Bookie: 'He put me on a charge for peeing off the doorstep of the hut at Bury St Edmunds.'

Harvey: 'Well, that *is* a crime, chum. Not quite treason but definitely worse than desertion.'

Bookie: 'Yes, but it was two o'clock in the morning in mid-January with two feet of snow and ten-foot icicles hanging off the trees, remember? And he was prowling around knowing that we had been out on the booze and had all had a bladder-full.'

Andy: 'Hold it! Movement in the gully, on this side. Little man. Hands up. Kamerad. Waving white flag.'

Stan: 'His underpants. Don't let Sergeant Dawlish see him. He'll put him on a charge for ''improperly dressed when surrendering''.'

Bookie: 'He wasn't even on duty that night. He was just prowling, waiting for our bladders to burst.'

Andy: 'Three of them. Hands on heads.'

Me: 'I see them. Watch behind them and to flanks in case it's a trick.'

Three German soldiers advance slowly and nervously through the undergrowth, climbing up between the trees on this side of the gully. Baggy trousers, battered high boots, tunics swinging loose, helmets pushed back or discarded, no visible weapons, hair tousled, faces grey and unshaven. Two have their hands on their heads. The third is waving a white flag. I stand up on the turret and wave. The Germans look suspiciously in our direction. All point at the white rag. They are about twenty yards away. I motion them to halt. They do. Motion them to lift their arms. They do. Motion them to extend their fingers. They do. (The hands-on-head posture, beloved of film directors, can be fatal if one of the prisoners is clasping a grenade on top of his head. It has been known. Especially with the SS.)

Jump off the tank, scramble through the hole in front hedge. Wave my revolver. Beckon one of them to come on. He comes. Motion him to turn round like a mannequin. Motion him to walk up the hill alone. He is scared. Shakes his head. Wants to take his pals. I wave my revolver furiously. Scowl like the Ghost of Christmas Past. Point at our gun sticking immensely through the hedge. The first man shrugs his shoulders hopelessly. Plods up the hill towards Hughie's Sherman. Same drill with the second man. Up the hill alone. As the third man approaches, I beckon him nearer. I feel more confident with only one real live enemy – he unarmed, and I armed, backed by a Sherman tank!

Me: 'Do you speak English?'

German: '*Nein.*'

'French? *Français?*'

'*Ja. Ein peu.*'

'*Vos amis? Deiner Kameraden?* Where? *Ou? Wo? Et combien?* How many?'

'Not. *Nein. Non soldats. Zwanzig* [he counts twenty on his fingers] *morts. Blessés. Non soldats. Poof-poof. Alles kaput!*'

'Tanks? *Panzerkampfwagen?* Tigers?'

'*Nein. Marché. Marché.* Falaise. Paris. [He flaps a hand vaguely at unknown destinations beyond Robertmesnil.] *Deutschland.*'

'Right, on your way then. *Heraus!*' But he stands firm. Rooted. Imbecilic.

Impatiently I wave my revolver and accidentally pull the

trigger. A tiny pinprick of sound. A puny bullet spitting at the sky.

'*Nein. Nein. Vous non tirez. Je ne suis SS. Non tirez pas. Je suis gut soldat. Non SS. Je suis Heinrich Gruber, Kamerad! Kamerad!*'

I yell at him in frustration, exerting all the force of my lungs. Waving my revolver more furiously, finger off the trigger. Pointing up the hill. Heinrich Gruber, *Kamerad*, stands firm.

What can I do? I can't shoot him, assault him, kick him up the backside even. The Geneva Convention restricts my options. Andy's face grins at me like a full moon over the hedge. I beckon to him.

'Andy. Meet Heinrich Gruber. Andy – Heinrich. Heinrich – Andy. He has frozen at the joints. He's probably been told he'll be shot if he surrenders. Have you got a cigarette? Light it and give it to him. I'll pay you back.'

Andy: 'There you are, *mein Kamerad Heinrix*. Smoken *Sie* that! *Gut Englischer* tobacco, *hein?*'

Heinrich: '*Sehr gut. Hitler tobacco schlecht. Churchill gut.*'

Me: 'So far, so good. Now to get him walking. His gears have seized up. Come on, *Kamerad. Marchons! Eins – zwei – drei.*'

Andy: 'Poor bugger's shitting himself with fright.'

Me: 'So would you if you were surrendering to the wild and woolly Black Watch, with pig-stickers on the ends of their rifles.'

I tap Heinrich gently on the shoulder. 'Come along, *Kamerad. Marchons*, please! What about a song to keep your spirits up? *Voulez-vous chanter?* Sing?'

Heinrich: '*Singen? Ja?*'

Me: 'Lili Marlene. You know that one?'

German: 'Lili Marlene. *Ja!*'

Me: 'Right, then. All together! Andy!! *Eins, zwei, drei!!!* Oh-underneath the lamp post, By-uh the barrack square, Ta-da-diddly-om-pom . . .'

Andy and I begin in different keys. Rather unwillingly Heinrich takes one pace. Then another. Grunts a low, unmelodic version of Lili, a kind of funereal Lili at the pace of a hearse moving across the barrack square. I keep a pace behind, revolver in hand, however great friends, *amis, Kameraden*, we may be.

Heinrich Gruber plods up the cart track, grumbling away to Lili Marlene and puffing away at a stub of very *gut* English tobacco. A few yards from Hughie's tank he stops, turns round, looks for me, lifts the fag-end, sniffs it, nods appreciatively . . . Hughie waves him on towards the rather less tender mercies of the men from Perthshire in the orchard beyond. I turn and find

Andy, holding on to a stout bush in the hedge and suffering from griping gusts of uncontrollable laughter. 'Oh, mother! Flooding Lili Marlene's funeral!'

**17.10 hours:** The barrage has decreased considerably. The enemy fire far less frequent. Occasionally searching back and forward in the village behind us. The day as hot as ever. The sun moving perceptibly towards the west. Skies clear. Little breeze. Turret top now painfully hot to the touch. Resting one's bare flesh on the exposed metal for ten seconds produces burn marks. My elbows, even with denim protection, are sore from contact with the heated iron. My mouth and lips are dry and swollen. My eyes ringed with dust. The wasp sting throbbing.

Me: 'Driver and co-driver, if you want to open up for a few minutes, do so. But be ready to slam your hatches shut at half-a-second's notice.'

Stan: 'Just think of those poor buggers in England playing cricket on an afternoon like this. No tank to sit in. No guns to clean. No hard biscuit to eat. No chlorinated water to drink. They must be dying of sheer boredom.'

Andy: 'Reporting . . . movement – cornfield, behind trees extreme right. Too big for a man. Not a tank. Looks like a bloody elephant.'

Stan: 'Hannibal's army reinforcing Rommel.'

Andy: 'I've got the 'scope on now . . . Oh, good grief! What a sell. It's only a cow.'

Stan: 'Bookie, Daisy's come looking for you.'

Bookie: 'What sort is it? Does it need milking?'

Andy: 'Don't know what sort! Sort of brown colour. But I can tell you it's hurt. Limping. Dragging a leg. Walking on three.'

Me: 'We'll have to shoot it.'

Bookie: 'God damn and bugger wars and armies and Hitlers and generals, colonels, majors, sergeants, sodding troopers, yeomen and SS that hurt a poor bloody dumb animal as can't answer back.'

Me: 'Andy, a burst of Browning, please.'

Andy: 'You're not asking me to shoot a cow? I can't shoot a dumb beast. I've never hurt an animal in my life.'

The cow has moved into a clear patch of cornfield and is standing crookedly, one leg shattered and, though inaudible from here, is obviously bellowing in pain.

Me: 'Andy, shoot it.'

Andy: 'I can't, I tell you. Men, yes! Animals, no!'

'Gunner! Co-ax! Fire!!'

I feel Andy tremble in front of my knees as he presses foot on co-ax button. Keeps it there. Tracer zipps across the gully. The cow staggers, splits apart, collapses shuddering, rolls over and lies completely still. Andy keeps firing madly at nothing, trying to hurt the insensitive sky – shooting God up the skirts for a hell of a mess-up with the creation frolic. An entire belt of bullets churns through the machine-gun, blasts from the spout and hurls into the blue. Click. Silence.

Me: 'Bookie. Why don't you get out and go round the back of the tank and brew up some tea. The barrage seems to have died down. You should be safe. I'll cover you. And I could do with a cuppa.'

Bookie: 'Fair enough. Pass me a can of water. But them bloody generals. I'd like to give *them* the cow treatment.'

Bookie de-busses. Jerry now shows his genius for telepathy. After leaving us alone for ages, he drops a cluster of Minnies neatly between us and Sergeant Dawlish's tank. Six bombs come down. Seven dark spurts leap up. Six spurts are bomb blasts. The seventh is Bookie heading for safety at faster than the speed of sound. Almost before the flashes dull, Bookie has gone to earth in his noisome little iron den, like a badger in daytime. Leaving his utensils outside.

Bookie: 'Milk that for a game! You knew Jerry was going to do that just then, didn't you?'

Me: 'Do you want to call off the tea-making for a while?'

'Yes. Blame Jerry. He's just blown my guts right up through my nostrils.'

Telepathy it must be. Fritz on the skyline thereupon lays down his mortar tubes and returns to brewing his own ersatz coffee from burnt acorns.

# ACT V

# Summer Evening

**8 AUGUST 1944:**

**17.55 hours:** 'Hullo, Roger 3 Baker.' (Hank's voice.) 'Can you see movement in woods beyond gully? Roger 3 Baker, over.'

'Hullo, Roger 3 Baker.' (I reply.) 'No movement visible from here. Over.'

'Roger 3 Baker. I'm sure something is happening. Keep watching. Over.'

'3 Baker, OK, off.'

Andy: 'I think he might be right. I think there is someone there. Will just get the 'scope on it.'

Me: 'You're right. Got it. Don't fire yet.'

There are one, two or possibly three field-grey figures, working their way from tree to tree and from bush to bush, extremely slowly and apparently unconcerned about being seen. Why only three men? And looking as though they are searching for something they have lost?

'Hullo, Roger 3 Baker.' (Hank again.) 'I see something moving. Open fire on that general area. We don't want people walking about freely over there. 3 Baker, over.'

'3 Baker, OK. Off.'

Andy: 'Wait a mo', skipper. I've got them in focus now. They're stretcher-bearers. Red Cross bands on their arms.'

'Roger 3 Baker. What delays you? Why haven't you opened fire yet? 3 Baker, over.'

'Roger 3 Baker. Stretcher-bearers. Wearing Red Crosses. 3 Baker, over.'

'3 Baker. I don't want movement so near us. If they are SS, the Red Crosses may be a trick. Chase them away. Over.'

'3 Baker. May I open fire on a Red Cross? Over.'

'Damn it, 3 Baker. Use your discretion. Off.'

The three men are half way down the slope. At this moment I spot another man about twenty yards to the left. He is the tallest soldier I have ever seen. Huge. Six foot eight at least. And as wide as he is tall. SS uniform, tin hat, rifle slung carelessly from his shoulder. Strutting slowly along the bank as though on sentry go. The prototype Nazi.

Me: 'Andy, come left about twenty yards. Can you see him?'

Andy: 'God, yes. Wonderman! Mr Atlas!'

Stan: 'I see him too. *Gefreiter* King Kong. Ten foot tall at least.'
Andy: 'He ain't got no Red Cross at all, at all.'
The Red Cross men further right have loaded something on a stretcher and are scrambling up the steep bank. 'Right, gunner. Chase that big fellow away. Co-ax, fire!' Andy directs the machine-gun tracer towards the Hun. But the trees are so thick that most of the tracer ricochets off in all directions. The huge SS trooper is unperturbed. At the same steady pace he turns and begins to head back towards the top of the gully.
Stan: 'Run, you ruddy great Hun! Knock him over, Andy, man!'
Me: 'Gunner, cease co-ax. Give him one round HE. Fire!'
A pause. Muzzle flash. The 75 was loaded with an armour-piercing round instead of HE, and this does not explode but – at tremendous velocity and relatively short range – hits the ground just below the big sentry and goes spinning into the trees, flinging up an inordinate mess of dirt, branches, leaves and smoke. And leaving an incredible swathe of broken trees in its wake. Slowly the whirling mess descends. The big man is no longer there. Has he retreated at the double? Has he taken cover? Has he disintegrated?
Harvey: 'Gawd Almighty, Andy. If he survived that lot, he'll be picking splinters out of his ass for the next fifty years.'
'Hullo, Roger 3 Baker. Spotted a non-Red Cross prowler, seven feet tall, so opened fire. All movement now ceased. Roger 3 Baker.'
'Hullo, Roger 3 Baker.' (The Squadron Leader again answering direct.) 'Seven feet tall or ten feet tall, chase 'em. I don't want the enemy to establish a claim to those slopes. Over.'
'3 Baker. Understood. Off.' (Switch to I/C.) 'Let's give it ten minutes, lads. No further stonks. No further giant storm-troopers. No further gold-prospectors staking out claims in the gully. No further courting couples: then we'll try making tea again.'

**18.10 hours:** Andy: 'The three stretcher-bearers are back'.
Me: 'What about *Standartenführer* Hercules?'
Andy: 'No sign of him.'
Stan: 'I reckon we'll find him hanging up in the top of one of those elms, like the fairy on the Christmas tree.'
I report in: 'Hullo, 3 Baker. The three stretcher-bearers are back. Looking for wounded. But *Standartenführer* Hercules has not returned. Roger 3 Baker, over.'

'Hullo, Roger 3 Baker.' (Hughie replying.) 'Who the hell is *Standartenführer* Hercules? Over.'

'Roger 3 Baker. A non-Red Cross type about seven feet tall. We blew him up to the top of that Christmas tree, 250 yards, two o'clock, over.'

'Ah-hallo, 3.' (Bill Fox standing in for the Squadron Leader.) 'We can't go around bloody shooting up the Red Cross. Keep 'em in sight. Chase 'em off if they misbehave. 3 over.'

'3, will do. Off to you. Hullo, 3 Baker. Did you hear? Over.'

'3 Baker. Will do. Entirely concordant with my moral scruples. Over.'

'3 Baker. The moral scruples of this Troop are more of a menace to society than Hitler himself. Off.'

Stan: ''Ello, 'ello, 'ello. Somebody in this Regiment has a sense of humour. I thought we were supposed to conserve wireless time?'

Me: 'There's plenty of it to spare at the moment. Nothing much happening. Good for the troops to hear a bit of banter.'

Stan: 'Too true, oh Great Paleface Chief.'

The day is now definitely in a state of decline. A cooler breeze is springing up to take the worst heat out of what has been a very hot afternoon. The sun is still high but westering. Shells and mortars burst with no more frequency than a fit of hiccups. For the first time in – what? . . . twelve . . . fourteen . . . sixteen hours? – I can hear no machine-gun or rifle fire. Not even distantly. Most of our remaining tanks seem to have switched off their engines. Birds chirp anxiously, exchanging news about what has been happening down earth, and making feathered assumptions about whether it is now safe to go hunting. Our tank is silent except for the constant atmospherics and the hum of the wireless set itself. When I remove the earphones, I can hear Stan softly singing . . . 'There's a small hotel, with a wishing well; I wish that we were there together.'

Andy: 'The Red Cross Fritzes have found themselves a customer.'

The three Germans in the wood have been crouching in the same spot for some minutes. Now they load something heavy on a stretcher. The two bearers lift their burden and head slowly up into the woods, stepping over huddled bundles beyond their care. The third man, presumably an MO or trained orderly, stands up holding a bag. He turns very deliberately in our direction, shades his eyes with one hand. Then waves at us. Turns. Plods off towards Berlin.

**18.25 hours:**  Although the front has gone quiet, we maintain our vigil over the gully, the woods beyond, the cornfield even more distant and the wooded skyline. The German medical orderly has appeared again, without his stretcher-bearers, and is probing through the dense upper slopes beyond the gully.

Me: 'Our friend is back across the gully, Andy.'

No reply. I glance down. My knees are level with Andy's neck. Andy's body is strangely inert. I chill at the thought. I touch his shoulder anxiously. He doesn't move. His neck. Warm! I bang his shoulder hard. He snorts and wakes up, startled, not knowing where he is. He looks up at me fearfully. I grin. Make a 'keep your eyes open' motion.

Sleeping in the face of the enemy is, I suppose, a court martial offence. But Andy, who was on the Troop Leader's tank yesterday and last night, will not have slept since 8 a.m. yesterday. I work out a quick sum. 8 a.m. yesterday to 6.30 p.m. today. That's 24 plus 4 plus 6½ hours, equals . . . Lord! – 34½ hours without sleep. And at least another 6 to go yet. Bookie appears at the side of the tank, placing five mugs of appetizing-looking tea on the rear deck. Unfortunately the reek of the chlorinated water already assaults my nostrils. Bookie climbs up and passes the mugs around.

Harvey: 'When did we last have a cuppa?'

Me: 'About ten hours ago.'

Andy: 'Hey, Bookie, have you been washing your socks in this?'

Harvey: 'If he had done, chum, we'd be drinking chocolate, not tea.'

Bookie: 'OK. I'll take the lot back and throw it on the grass.'

Stan: 'No, mate, don't do that. The French Government would sue you for sterilizing the soil for ever. Reminds me – when my old Granp' went senile, he was living with us and one morning he brought down his old tin chamber pot to empty. He lit the gas to make a cup of tea but instead of putting the kettle on, he put the old chamber pot on. It was boiling nicely before anybody noticed. *And* it was soup. Gawd, the kitchen stank for weeks. And that's exactly what this tank smells like.'

Me: 'Except that we have *four* Granpas inside.'

Chorus: 'Oi-oi! Ay up! Watch it, mate!'

Stan: 'You'll make Sergeant-Major yet, if you keep up wise-cracks like that.'

Me: 'Seriously, it's fairly quiet. Let's get a breath of air each. Andy – first Granpa out for a blow of air. Quick.'

Andy: 'On my way. Pass me my crutch.'

He climbs out of the turret. I catch a glimpse of his face. The face of a man of seventy, grey, dry, creased, gaunt and wasted. I suppose all of us look the same. And our premature ageing is exaggerated by the filth of five miles of battle and the weariness of two days and a night of fear. Shall we ever be young again? Andy drops to the ground, stumbles with cramp, massages his legs. Hops up and down. Runs back and forth like a footballer warming up before a match.

Idle chatter continues until Andy ends his five minutes of fresh airing. Harvey gets out for a breather. I stare across the gully to where the occasional grey sack, lying behind a bush or crumpled across an open space, shows where the German medical orderly's visits have been . . . have been . . . what's the word? . . . superfluous . . . that is, if he could have performed miracles at Lisieux (just up the road) . . . was he taking the wounded to Lisieux (just up the road)? . . . which is where St Teresa . . . could even St Teresa perform such miracles? . . . superfluous visits . . . or was it a superfluous medical orderly? . . . or St Teresa in disguise? . . . no he wasn't either a saint or superfluous . . . he was a walking bush . . . he wasn't really there, like the German who hasn't been there behind the tank all day . . . a bush . . . no, a crumpled sack . . . no . . .

Harvey slaps me on the back, and I jerk wide AWAKE!

Harvey: 'Wakey, wakey! I think I've had more than my time looking for dames out in that field.'

Me: 'No hurry. Nothing happening. Did you find any?'

Harvey: 'What? Dames or field? Plenty of field. But not a flicker of knicker! Shall I let Stan out of his cage now?'

Me: 'Yes, he wants to advance on Paris. Tell him to start walking and we'll catch him up in a day or two.'

Harvey wriggles down under the gun, and Stan slides down the back of the tank. I wipe the sweat from my forehead, and from under my eyes, and from around my neck. When Harvey slapped me on the back, I was on the point of falling asleep, propped up on the turret with my binoculars pressed to my eyes. In our present state it is fatal to stare at a tree which is swaying gently in the breeze. And whilst I am breathing this fresher air, I am still perched in the main ventilation outlet of the tank where the hot, reeking air from within is soporific. The SSM always says that commanding a tank on a hot day is like standing at the door of an overheated brothel.

'Hullo, William 3 Able. Crew member with suspected appen-

dicitis. Griping pains. Hard, swollen abdomen. High tempera-
ture. Do I jig? 3 Able over.'
    '3 Able. You jig. Will get a robber to your little house im-
mediately. Off.'
    That fine service, the Royal Army Medical Corps, has, from its
initials RAMC, derived the unfortunate nickname 'Rob All My
Comrades'. Hence 'a robber'.
    Harvey: 'I don't believe it. It must be against King's Regu-
lations to catch appendicitis in the face of the enemy.'
    I dare not lean on the turret. I stand beside it, scanning the
landscape. Again the invincible silence. The pure, mysterious
silence. Unknown insects buzzing. Here at the extreme point
(still!) of allied advance the silence is too good to be true. It could
be evidence of sinister intentions on the part of the persistent
Boche. So I resume the routine of searching the skyline, the
cornfields, the woods, the gully, the skyline the cornfields the
woods the gully the skylinethecornfieldsthewoodsthe . . .

**19.22 hours:**  One moment an empty cornfield, scarred by
blackened patches. Next moment – one, two enemy half-tracks,
crowded with troops wearing the big coal-scuttle helmet . . .
    'Gunner, cornfield, right . . . right . . . on! Both guns. Fire!'
Andy's first hurried snatch shot lands to the right and well up in
the woods beyond the targets. The half-tracks have appeared
across the cornfield from our right and are speeding to the
enemy's rear and the woods on the skyline. Ten, maybe twelve
infantrymen are sitting huddled and crouched in each vehicle.
They are hurriedly retreating, probably at 30 m.p.h. at 500 yards
range and increasing.
    The tracer from Andy's Browning loops down to the level of
the half-tracks as he depresses his guns. One of the Germans in
the rear vehicle jerks visibly. Our 75mm flashes, roars, smokes,
and the single tracer, apparently sliding along the dotted line of
co-ax tracer, hits low on the rear half-track. It leaps in the air,
with men falling, diving, leaping, rolling. The vehicle lands right
way up. Bounces. Spins in a circle. Goes on spinning. One
German still miraculously sitting in it! Possibly the driver, he
looks over the side, jumps out, runs and crawls towards a patch
of standing corn.
    The first half-track is now bucking and bouncing towards a
gap in the most distant hedges. It scuttles into the gap. At the
same instant Andy fires the 75 again. The tracer seems to take a
tremendous time to loop across the cornfield and into the gap in

the hedge. The half-track has disappeared but the tracer pursues it, cleanly through the gap in the hedge. A billow of flame! A rush of smoke! We shall not know any more about that explosion until we catch up with that shell tomorrow, or in a week's time. Meanwhile the rearmost vehicle is still spinning round in circles, like a decapitated chicken. From our left another tracer streaks out and impacts in a huge, orange balloon of fire. The half-track, now a lump of tortured metal, bounces across the cornfield, rolls over and, mimicking a human death, somehow shudders and lies still.

Harvey: 'Gawd, the fug down here is so bad that when we fired those last shells the fumes gave me a fit of coughing.'

Stan: 'Talking of coughing, did you hear that one about the bloke on the bus?'

Harvey: 'Yeah – where there was a woman conductor and this little Jew said, "Are you 48 bus?" and she hit him over the head with her ticket board and said, "No, I'm only 38 bust"?'

Stan: 'No, that's an old one. Listen . . .

'There was this bloke sitting on the bus who had a terrible cough. He was coughing and spitting and just couldn't stop. He was really pissed off because everybody kept looking at him and frowning and scowling and muttering insults. Well this goes on for a while, with this bloke getting redder and redder, both from coughing and from embarrassment, and everybody cussing audibly now. Then a kind-hearted type sitting in front of him remembers he has some cough lozenges in his pocket. So he pulls out the tin, turns round to this bloke who is coughing fit to bust and says, "F'r cough!" And the coughing bloke growls, "Ferk off yourself!"'

Andy: 'Oh no! Oh ruddy no! No wonder people start wars, to escape from jokes like that. It was probably a joke like that, cracked in the front line in 1918, that turned Hitler into the world's first Nazi.'

Me: 'Look, lads, we're all drooping. I suggest each of you gets into the co-driver's seat in turn and settles down for a quarter of an hour's snooze. We'll be here for hours yet. And we haven't enough ammo left for Bookie to fire his gun. Andy, you go first.'

Andy: 'Is that allowed?'

Me: 'Nobody has told me otherwise. And if Monty disagrees, he's not likely to pop his head in the turret just yet. Anyway I'm ordering it, and they can't demote me from Trooper if it's wrong.'

Stan: 'They could make you a Boy Scout Runner or an Air Raid Warden.'

Harvey: 'Or even a Squadron Sergeant-Major.'

Me: 'Nasty! Off you go, Andy.'

Andy: 'Thanks, mate. Tea in bed at 8 a.m., please.'

**19.50 hours:** For twenty minutes nothing has happened on our front. No movement across the gully. No shells or mortars on our side or the other side. No messages over the wireless. Nothing. Only indistinct rumblings and cracklings of a far-away war. Or perhaps it is still the echo in our ears of earlier wars. Whispers out of an unknown planet. Even the conversation within the tank has now languished. We have come to the end of our script of imbecilities. I realize that a mug is still standing on the turret. It is the tea which Bookie made, maybe an hour ago. I pick up the mug and look inside. Half full. Cold tea. My thirst overcomes my nausea. I take a swig of the liquid. Pure rat slime. Another swig. It is liquid. It is wet. It is obnoxious. But, like many bitter things, it has a thirst-quenching quality. I drink it all.

'Stan, have we any food left at all?'

Stan: 'Yes, one lousy tin of sardines and six biscuits.'

Bookie: 'No rotten sardines for me!'

Me: 'Then give Bookie two biscuits and, for the rest of us, a biscuit and 1½ inches of sardine each.'

Bookie: 'Dry flooding biscuits!'

Me: 'Apart from being a contradiction in terms, that is downright ungrateful to a kind government which supplies you with such luxuries. What do you want me to do? Send Stan down to the corner shop for a quarter of cheese?'

Bookie: 'Sorry! Didn' mean it like that, son.' Stan's hand passes me a hard biscuit, liberally topped with sardine – poor man's caviar, but more nourishing.

'Hullo, Roger 3 Able and 3 Charlie. Nasty hornet ten to twenty yards right of farm. Fire to my command. One round AP, one round HE, and bursts of co-ax. Report when on. 3 Able and Charlie, over.'

'What did the bugger say?'

'He said ten to twenty yards right of farm.'

'Does the Heeland Laddie expect me to pace it out?'

'Hullo, 3 Charlie. Switch to I/C. Over.'

'3 Charlie, OK. Sorry! Off.'

Harvey: 'He, he, he! Charlie will be for the high jump! – leaving his set switched to A like that.'

Me: 'Oh, I expect Hughie will put it down to battle panic. The Heeland Laddie's very sweet.'

Stan: 'Remember that time on Salisbury Plain when we were all listening to BBC – Glenn Miller concert – and Hank came up on BBC and almost everybody responded, and he put all the silly sods on a fizzer and . . .'

The three crashes from behind us are almost simultaneous. Three Brownings hurl sparks to our right, through the gap and out of our vision. Three more big crashes almost together, Charlie's stunning voice much the loudest. Answering crashes from the ridge. More Browning, stuttering raggedly to a stop. I have not yet eaten my biscuit. I take a bite but hesitate to break the silence by munching the hard crumbs.

Andy: 'Has that Jerry gone home then?'

Me: 'It sounds as though he's gone to one of his homes, earthly or eternal.'

Harvey: 'The gold-lined slit trench in the skies.'

Andy: 'That little lot should help Stan to snooze.'

Stan: 'Stan is trying to snooze off, counting sizzling pork chops plopping on top of a dish of hot chips and peas.'

Harvey: 'Hey, Stan, you know that spare head you saw an hour or two ago? I can see it now.' (Harvey is sitting temporarily in Stan's seat.) 'It has gone all sort of pink. And bugger me if it isn't still watching us. Unblinking. I reckon it'll follow us around when we move. Sort of ghostly.'

Stan: 'That's done it. I never could sleep after my Mum had told me a ghost story in bed. Who else wants a snooze down here?'

**20.15 hours:** Cautious movement at the gap behind us. A Black Watch Corporal comes suspiciously through the hedge, sniffing like an overgrown golden retriever. Behind him is a Black Watch officer with drawn revolver. I wave to them. They relax, wave back, tread carefully over the rough vegetable field. Today's infantrymen do not trudge like clodhoppers but tend to do ballet steps over ground likely to be infested with anti-personnel mines. They prowl along the hedgerows looking for suitable machine-gun posts and fields of fire.

**20.35 hours:** The Highland Captain scales the front of Stony Stratford like a novice scaling a rock face. He stands by the turret, wipes his hands and smiles.

'Hullo, Yeomanry. We've located some good positions. We'll

be down to join you soon. Any idea how far along the gully is clear of the Hun?'

'It looks as though they've given up the idea of trying to hold the gully, sir. They seem to have felt that the skyline would be more comfortable.'

'Aye, not much comfort in those burned-out cornfields.' He turns to go, then, 'Why the puzzled look, commander?'

'Oh, just a wasp sting, sir.'

'Not exactly beauty treatment, what?' He laughs heartily, shuns the climb down the tank front and takes a leap off the side. Staggers once or twice. Then marches off more confidently than when he arrived.

**21.00 hours:** The sun is now dipping towards sunset point. As it swings westwards, it touches the extreme tip of the tallest tree beside the gully. Huge shadows point towards us. The tracery of the leaves on the trees resembles a stained glass window already beginning to blush with the resplendent hues of sunset. I am beginning to drift into fantasy when a movement behind me brings me back to mundane matters. Hughie is coming to visit us. He hauls himself up onto the turret.

'Right! The good news: we are pulling out. The bad news: not until 23.00 hours. Furthermore, we go last. So it's likely to be 23.30 before we can move away. Laager at Hubert Folie, east side of the village. Usual form for the night march: wireless silence, green marker lights, white tapes around minefields, tanks to use tail lights only – except you. Our Troop order to be Able, Charlie, Troop Leader, Baker. There will be nobody behind ye. We think the country behind us now has been cleared but we may stir up the odd Boche. So keep watch all round. Especially to the rear. There will be a bit of an artillery stonk to cover our retirement.'

Me: 'So that Jerry won't guess . . .?'

Hughie: 'Oh, definitely not. I have that on highest authority. As there will be wireless silence on withdrawal, the signal for pulling out will be by torch."Roger" three times in Morse. Reply "Roger Baker".'

Me: 'I see the Chief Scout has been at work again.'

Hughie, grinning: 'Ye could, of course, chalk a "gone home" sign on a convenient stone?' He leans into the turret and shouts, 'Everybody OK?'

Variations of the 'OK' responses include Stan: 'Top of the evening to you, sir.'

Harvey: 'Any week-end passes going, sir?'

Bookie: 'Can you send up a plate of ham and eggs, sir?'

Andy: 'Lot of undisciplined sods on this crew, sir. Not like our tank!'

Chorus: 'Creeper!'

Relationships between junior officers and Troopers are usually extremely cordial in the Yeomanry, especially as quite a proportion of tank crews come from a similar background to the new officers. There is a clear demarcation line between casual banter and serious communication which depends on mutual understanding.

Hughie replies to Andy: 'Ah, yes, Trooper Briggs. I thought that putting one of my own crew on this tank would improve the tone a little . . .' He stands up and looks towards the descending sun. Checks his watch. 'Do your best to keep them awake another couple of hours. I doubt Jerry will produce any more surprises this evening. But it pays to be alert with the resourceful Hun.'

'Good soldiers, sir.'

'Too bloody right. Too bloody good.' He drops off the back of the tank and walks away to the rear, a small packet of high-quality Caledonian humanity.

I hear bits of desultory conversation down below . . ., 'That Omar Bradley's a good bloke – the best of the Yanks . . .' 'Alexander the Great? Wasn't he with Monty at Alamein?' . . . Bookie: 'Who's this Annie Ball and her elephants? Is it a circus act?' 'Why can generals retire, but not troopers?' 'If we pulled out after twenty missions like RAF crews, we'd be due out now.' 'I used to play with pearl-handled revolvers when I was a kid.' ' 'is 'ead is as fat as 'is ass, and that's some!'

A file of Black Watch (blacker than ever in the shadows!) keeps good step through the gap behind us. These Highlanders tend to be a jaunty lot. Not like some other lead-footed soldiers with whom we have worked. Our Captain friend, accompanied by a Lieutenant, issues instructions, down front of us. The files split up and spread out. I climb down.

'Now, commander, if I site a bren in this gap, shall I be impeding your field of fire?'

'No, sir, but some of your lads might catch sore ears and sudden sunburn if we have to fire the 75.'

'What's the likelihood of that?'

'Nothing for an hour or so past. Unless a German hornet appears . . . We have very few rounds left to bang off.'

'If a German tank should appear, nobody will mind catching ear-ache. We'll dig in there, then, Sergeant.'

The Captain exchanges salutes with his Sergeant, acknowledges my own gesture and walks away west with his Lieutenant. The sun is now lodged like a burning bird's nest in the branches of a tree along the gully. The two Highlanders' backs are black in the eye of the setting sun, their heads shimmering in a haze of light, almost a parody of a wedding in Hell! The individual shadows of the two moving figures trail behind them like the long trains of wedding dresses, long, black, sinister trains. And the golden halo around the head of each black figure. To complete the black enchantment, the silence erupts and a horde of screaming lost souls flies over our heads. The earth spits blood.

A splurging overflow from Hell blazes up along the hedgerows where the remnants of the enemy may be lurking. The Black Watch Sergeant and his party pause, look up in the air, listen, bend again to the task of secreting their own little piece of infernal machinery deep within the innocent Normandy undergrowth.

**21.45 hours:** Epic moment. The unseen sun touches the earth's rim and sets off its own conflagration in the sky, shaming the day's human efforts. For some time now the sun has been invisible beyond the purpling mass of woods. Now the subtle change of light marks the onset of true sunset. In peace, sunset is a time for poets to dream, shepherds to close the gate of the fold, and lovers to go walking. In war, sunset is the moment which changes the battle from the grand panorama of massed manœuvre into a stealthy, creeping feud of individual hunters carrying on their bloody craft in the dark.

The 1944 tank is of little use as a defensive weapon after dark. We have no night sights. The creeping, crawling infantryman is suddenly at an advantage, especially in close country. So we withdraw most nights behind the front line, where our own 'soft' vehicles can come up with loads of petrol, ammunition, water and food, and we can strip guns, maintain engines. Consequently sunset is the moment of truth for the tank man. Having survived through the long day at the crucial point of battle, he has now up to an hour in which to continue to survive. Guns fire, soldiers die in the gloaming between sunset and nightfall. Each sunset, for the tank man, means a daily armistice, a safe refuge, a retreat into thankful obscurity. In those moments hope awakens again after sleeping through the torrid day.

Me: 'Harvey, come up here. You're not doing any good sitting down there staring at birds' nests. Come and lend me an extra pair of eyes. This light is bewildering.'

Screeching winds hurtle at us again. Duck! Hope! Crashes and crunches spaced along the hedges. A spout of dirt in front of the Black Watch gun pit. A huge clang on the front of the tank. Silence.

Harvey (appearing beside me and taking the mike): 'Right, now! I have taken over this tank in the name of the workers of Britain. The revolution has begun. I have appointed myself General by the democratic election of the proletariat – meaning me. You will obey mein orders, or be shot, like the former Fascist Trooper commanding this tank.'

He sits on the commander's seat while I perch on the turret with my field-glasses. The tank is still, but I notice the gunner's and operator's periscopes moving gently and regularly as Stan and Andy continually probe their appointed area of the front, as they have done all day.

More shrieking birds of prey swoop from the skies. Minnies! Duck again. Flat on the engine covers. Listen to the neat crump-crump-crump-four-five-six. Rock a little as the tank takes the concussion of the nearest bomb. Squint through tightened eyelids at the carefully spaced gouts of flame, earth, smoke along the hedge behind us. One long, last waspish shred of shrapnel buzzes over the tank and expires in the hedge in front of us. Look up. Meet the eyes of the Highland Sergeant in his pit. Wave a question. He gives me the thumbs up sign. Our artillery again rumbles away, fishing along the skyline for the German Minnie master who won't go home.

Sunset hour.

**22.15 hours:** Like the eastern RAF fires of last night, the sunset has lit chains of incandescent colour behind those western trees. We have watched the sky fires burn down into night-grey ash. And the background music, the fury of the enemy's Minnies, the more violent responses of our own artillery, has died down too. A little gloaming remains. A sliver of lurid light still shows through the lower branches of a few trees. With my field-glasses I can see the German bodies on the gully slopes, already invisible to the naked eye, blobs of lighter grey on the darkening slopes.

I think that in this war we, the rankers, are able to develop much more appreciation of the greater strategic implications than many officers in former wars, even though we see things in

very simplistic terms. I see laid out before me the entire slope from which the Germans have tried to drive us back, encircle us, obliterate us. Today! Failing that, the Falaise trap will eventually close on them – tomorrow, the next day, soon. Their 7th Army will surrender or disappear. France will be open to the allies. Hitler's defeat will be inevitable this year. Or next. His Thousand-Year Reich will crumble into a ten-year disaster.

So today someone behind the German lines, an SS General undoubtedly, scraped together the final Old Guard of SS, the toughened tank aces from the Russian Steppes and the fanatical boys from the Hitler Youth, and sent them across the cornfields and along the gully. Now even the SS have to accede to death, burning, wounds, exhaustion, shortage of ammunition. And the Black Watch, Gay Gordons, Canadians, Poles still stand firm with us on the disputed ground. The wedge is in the hinge, and the hinge is eaten with rust. The narrow pioneer trail which Tom Boardman opened up last night is already a major route giving access from the assembly lines and reinforcement depots of Britain and America, and from the fields and farms and factories of fifty allied countries. The fragile wasp's nest of our early morning infiltration, the yawning gap behind us inviting a German counter-stroke, have been replaced by a firm lodgement which will not now be displaced.

This little nook in the hedgerows has become a personal possession for us. Stan and Harvey, Bookie and I have known more terror in an hour here than a human being should experience in a lifetime. But there was nowhere safer to go, so we clung to our primeval refuge in the hedges, fearing the latter-day armoured dinosaurs coming against our fragile bows and arrows, realizing the physical vulnerability of our nest but appreciating its gift of furtive concealment. Now we have a sense of ownership of this place, perhaps even more than the French farmer who owns it. I register that thought. It could be useful in the future. A French farmer treading this field which he believes is his own, and for which he has deeds registered in Caen, but we have a more compelling ownership claim than . .

Andy: 'Ken, it's getting dark or I'm going blind.'

Harvey: 'They say you do go blind if you do it too often.'

Me: 'We'll go soon. Hang on, Harvey. You're promoted to Trooper-in-Charge. I'll go see the Jocks.'

I do a little helter-skelter down the front of the tank. The Scots Lieutenant and Sergeant are sitting on the edge of their trench, eating biscuit and corned beef. The two Highland privates are

staring resolutely into the landscape which is for ever engraved on our own minds.

Lieutenant: 'Evening, Ben Hur. Sorry we have no bully to spare.'

'Not a bit of haggis stowed away in reserve, sir?'

Sergeant: 'Och, phwit would I give for a guid plate of the haggis the noo! Nay sae much o' this Camembert stuff.'

Lieutenant: 'Sergeant Fraser refuses to believe that Camembert is cheese.'

Me: 'I've seen some that had a good proportion of meat. But speaking of supper, we're going to have to move back now, sir. Too dark.'

Lieutenant: 'Aye, well, fade into the night. But we'll be looking for the Yeomanry in the morning.'

Me: 'It's nice to be wanted.'

Sergeant: 'Right, lads. Tanks are moving so ye'll need to depend on your ain eyes noo.'

Me: 'Hope to see you in the morning, sir. Have a good night.'

Lieutenant: 'No doubt ye'll find us still sitting here, eating our bully.'

I salute and get a wave of hard biscuit in return. Lieutenant and Sergeant continue to munch their supper. The two privates continue to stare into the gloom. I go back up the sloping plates of Stony Stratford.

'OK, Harvey. Back to work. The Revolution's over. You're a worker again. Start up. Ready to reverse.'

The last light has taken moth flight from the highest leaves of bushes and trees. The black creepers of night have wound upwards around all but the tallest trees. Stony Stratford is only a dark shape detaching itself quietly from the darker mass of hedge and gliding back on gentle murmurs of its engine, from the point of farthest advance. Already from up top the Highlanders are unrecognizable in their slit trench.

'Driver, can you see the track? It's a bit lighter up here now. Turn left on to the track. "Left!" I said. Front armour still facing the Hun. That's it. Halt. Reverse back up the slope. Slow. We're coming level with Hughie. Halt. Gunner, keep your gun straight down the track. Loader, keep an HE up the spout.'

**22.40 hours:** Harvey: 'Now what are we waiting for?'
Me: 'For higher intelligences to churn out a logical thought.'
Stan: 'Such as?'
Me: 'Pull out for the night.'

Harvey: 'I wish they'd hurry. I'm hungry.'

Me: 'Which means you're still alive. Give thanks! Anyway soon we'll be surrounded by boxes of lovely Kompo rations. Not to mention chlorinated water.'

Bookie: 'Fine! But we've got another hour to stay alive yet.'

Stan: 'Oh, stow it, Bookie. Jerry's thrown all he's got at you, and it just bounces off your nut. He's gone home in disgust.'

A fast-firing Spandau has started aiming short bursts through the darkness. Nuisance value only. But enough to make us keep our heads down. Perhaps the Highland Lieutenant is not going to get a quiet night after all. Our new position is higher up the slope, and we have a more extensive view of the darkened countryside. I steady my binoculars and look for signs of the Spandau. He is not firing tracer but in the darkness his muzzle flashes could be visible.

Bookie: 'Pesky sod, that Spandau. This time of night! It ought to be against the Geneva Convenience.'

Stan: 'Convention, you twit.'

Bookie: 'What?'

Stan: 'A Geneva Convenience would be a Swiss WC.'

Bookie: 'Why must you talk about WCs now? Gawd, pass me an empty ammo tin, Stan . . .'

**23.00 hours:**  Our artillery is putting down a general stonk. That is presumably to cover our withdrawal, although Fritz will notice the noise of many engines in between the individual shell bursts. In any case, Fritz is himself addicted to clockwork systems and will be expecting our tanks to move back about now. Once again we are treated to a firework display as clusters of shells send up chains of flame: shells over Robertmesnil, shells on the Falaise road, shells in the cornfields, shells in the glade where 2 Troop died. They will not wake Sonny.

The Spandau is still spitting intermittently at the Black Watch. From their low-down gun positions the Jocks do not seem to be able to locate the Spandau and fire back. For long enough I have been scanning the dark woods (which I cannot now see as woods, but only as thicker darkness upon lesser darkness) looking for some sign of that 'pesky sod'. Now, between shell clusters, I see through my field-glasses a faint stutter of sparks, corresponding to another volley of Spandau fire. Tiny sparks in the skyline hedgerows, right of Robertmesnil.

'Gunner, traverse right. Slowly. Steady. On. Right a bit. On. Almost on the skyline. You should be able to tell the lighter

darkness of the sky. Watch for sparks. Get your crosswires on them. Range about twelve hundred.'

On the front of our turret there is a thin, vertical piece of metal, a rough sighting marker, which the commander can use to position the turret approximately on a target. It is not much used but I have lined it on the spot where I saw those sparks. This should be close enough for Andy to be able to cover the actual spot in his telescopic lens. If the Spandau sparks again, Andy should see it. Behind us the booming of engines in low gear means that the first Shermans of the Regiment are moving out. Going home.

'Ken, there it fires! See it? Sparklers! Very clear in my sights. Muzzle flashes. Crosswires on.'

Me: 'OK for line. Now elevation. Give it bursts of co-ax. I'll tell you up or down. As soon as you are exactly on, I'll say "Fire!". Then fire 75. Operator, be ready to reload. We'll give it three rounds rapid 75 HE.'

Although Andy can get his direction exactly by focussing his crosswires on the sparks, he has no way of judging distance in the dark or observing accurately the fall of the HE or adjusting his sight to that fall.

'Co-ax, short bursts! . . . Oh no, up, up three hundred. Whoops! Not so much . . . Gently down . . . slightly more . . . Fire!'

Our big gun's muzzle flash illuminates the universe. In the immense, brief light I clearly see all the tanks of our Troop lined up to the right. Black Watch men leaning on the edges of their slit trenches around us. Trees with branches and twigs and leaves. Green, blood-green grass. Then dazzling darkness. Darkness wrapped around a speeding point of tracer which leaps away to the skyline and, in a smaller reflection of our muzzle flash, momentarily paints a vivid, ruddy picture of hedges, trees, grassy banks, all bleeding with fire.

Again the dazzling darkness! 'Gunner, co-ax again . . . gently, very slightly down . . . on! Fire!' His second shot rips a red star out of the darkness at the same spot as before. 'Gunner, give it a touch right. Co-ax . . . down a bit . . . Fire!' A freak salvo of our artillery shells follows our shot, like a pack of dogs chasing a hare. Our gash of flame dies on the skyline but a necklace of fiery rubies illuminates the rubble and smoke of our shell, still descending. I fancy the Highland Lieutenant may get his quiet night after all.

Stan: 'Skipper, do you realize that leaves us with two, I repeat,

figures two HE rounds? After that we're ruddy bankrupt, mate. Skint! Kaput! Horse dee Combat!'

Me: 'I did remember. Reload with one of your figures two HE, just in case. You can have the other figures one to cuddle in bed tonight.'

Harvey: 'Do I hear sweet music? A Squadron and RHQ buggering off?'

Stan: 'I can hear engines left, too.'

Me: 'That will be B Squadron. Or a Tiger counter-attack.'

Bookie: 'Gawd, man, don't joke about things like that. Say a thing and it happens. Twenty minutes to go and a dozen bloody Tigers come out of the forest. Just our blinding luck.'

Stan: 'Too true. We're more vulerna . . . brrrr . . . vul-ner-able now than we have been all day. Or last night. Half the Regiment brewed up. No ammo to speak of. Now half of the half-a-Regiment already gone home. Us stuck out in front of everybody else. Not able to fire a gun properly. I reckon we'd find there's no Poles on our left and no Cannucks on the right. What would happen if Jerry hit back right now?'

Me: 'We would sit here and watch them all crashing into each other. *If* Jerry was going to attack, *if* he had any Tigers left, he would have sent them in before nightfall when they could still see us.' Stan: 'What about "Tiger, tiger, burning bright in the forests of the night".'

Me: 'Blake wasn't a tank commander. And he didn't know about gun sights.'

Stan: 'Fair enough, oh Socrates. But I get nervous. Real bleeding scared at this time of the day, with only minutes left before we light out.'

Me: 'Then try to concentrate on something else. Try singing Nelly Deane backwards.'

**23.12 hours:** Bookie: 'Come on, Hughie. Put your whisky flask away and let's go home to a decent pub.'

A screeching shower of mortar bombs falls in the orchards which A Squadron has just vacated. Nothing unusual in that. Brief blazing pictures flicker up and out, between the apple trees. Then a heavier sound, like an aeroplane coming in to land too fast, rushes close overhead and dives into a deep, concentrated thunderclap back in the village. The cart track shudders underneath us, and I wonder for an incredulous moment if that was really a crashing aeroplane. Then its twin grinds overhead and again pulverizes the village. A third monster shell mills the

air close down over our heads and lashes tornadoes of flame, noise, steel out of the village lane behind us. Nearer! Too . . .

Me: 'The next lot is ours. Hold tight!'

I grab the turret hatches, pull the release bolts. The high-pitched screaming starts overhead. I duck and pull the armoured hatches down over my head . . . angry flame lashes into the dark tank through periscopes and filters through cracks in the hatches. Stony Stratford lurches back, keels left, shudders epileptically, rocks back. Near impact lashes me against the turret wall. Or flings the turret wall against *me*! Lung-wrenching, nostril-compressing, ear-battering concussions slam against us, right, front, rear. We are a grey rock assaulted by a seaquake, lashed by storm tide, raked by lightnings, rended by tempest.

Harvey: 'Gordon Bleeding Bennett!'

Stan: 'No! Moaning Muckie Minnie!'

Andy: 'Ruddy SS that must have been. No decent Fritz would do that to us at this time of evening.'

I open the hatches to a stench of explosives, burnt vegetation and thick smoke. The grass is on fire ten yards to our right. The usual mushrooms of smoke and dust are still subsiding around us, two of them showering more filth on the tank. Another oversize shell skids over the turret and belches furnace flames in the night two hundred yards behind us. Jerry is aiming a slow but regular barrage of extremely heavy shells precisely on our escape route.

'Hullo Roger 3 Baker,' I call. 'Suggest we go to Loch Lomond by the way I'll be in Scotland afore ye. Over.'

'3 Baker . . . oh, yes, agreed. Off.'

Our 'high road' is being systematically pounded by shells large enough to cause us serious harm. But there are a couple of 'low roads' which we can take if Hughie can find them. But not yet!

I can now discern Hughie's tank lit by rolling waves of light, so that the tank appears to be rocking on the tide. Hughie's little head protrudes from the top of his turret. Red wrath war-paints his face, Red Indian style, and he too is staring fascinated at the flames streaming like blood down the burned-black sky. Once more the very air seems overheated, overcharged, ready to explode. To our left, a rumble of engines. That will be our 1 Troop or 4 Troop. Behind, a ghostly galleon sails the crimson-tinted night. That will be Hank or Bill Fox going home.

**23.23 hours:** Flashlight spots flicker in the darkness. From the direction of Hughie's tank: short-long-short; short-long-short; short-long-short. 'Hip! Hip! . . .' I put my hand down to pick up my torch. Cannot find it. Scrabble around in the dark interior of the turret. 'Confound it!' Feel Stan's hand offering me the torch. Point it towards Hughie's tank: short-long-short; long-short-short-short ('Roger Baker'). As if in response, the artillery opens up again, this time aiming far away into the skyline, probably searching for the enemy's heavy battery which is hitting the village. The light from the new area of inferno, much more sporadic and much less intense than in the previous stonk, is still sufficient to illuminate Hughie in a dim, blushing, wavering glow.

'Driver, start up. Come around in a right about-turn as we stand. Don't worry about their cricket pitch! Gunner, keep your turret pointed at the enemy. Co-driver and driver, you will be looking for rear lights but *we* shall not use lights.'

Harvey: 'Aren't we even using rear lights?'

Me: 'No. There should be nobody behind us.'

In the flickering, warm artillery gloaming the vague elephantine shapes of our Able and long-nosed Charlie Firefly move slowly off, leading the way home. Hughie swings away in their dusty wake. Suddenly his tail lights glow bright. (Visible in Berlin, I think.)

Stan: 'There you are, Harvey. Your favourite sign, the red light!'

Me: 'Driver advance. Home, James . . .'

Chorus: '. . . and don't spare the effing horses.'

Me: 'Andy, can you see a pair of goggles down there?'

Stan: 'Imperial Chinese army, him go riding white horses home after fighting filthy Mongols. Big Mandarin, him sit up top waving Chinese lantern. Music man him bang gong, sing regimental march until him come by Great Wall China.'

I don't know where Stan read or saw his Chinese Imperial Army episode – possibly some Saturday morning kids' film – but he goes through this routine religiously every time we turn our backs on the front line. The repetition of this meaningless litany at this meaningful moment of release is as reassuring as a familiar Latin prayer.

Stan: 'John Peel, him sit on white horse. Him see fox. Him shout. "Tally-ho!" All China soldier sing: "Peel's View Hall-o-o-o-o! would awaken the dead, and the fox" . . .'

The long drawn-out 'Hallo' – a regimental tradition – is an

invitation for all to join in and sustain the note until lungs
collapse. I join in too. Then realize that a Black Watch NCO is
standing watching the tank, waving as we roll by and obviously
convinced that I am yelling 'Hallo' at him. (Is he the Corporal
with half a cigarette still neatly stowed in its packet?) But then
you couldn't expect the Black Watch to know about John Peel
and the Imperial Chinese Army and the white horse of Hanover.
This is all part of Stan's battle-release procedure. To the watch-
ing Jock we must look just like any other dusty, battle-bruised
Sherman trundling rustily back towards rendezvous at the end
of the day.

Hughie swings right, following the minor road around the
village rather than the equally narrow 'high road' through it. We
swing past the large farmyard where we waited and watched
this morning. Past the bend in the lane and the waxwork
German motor-cyclist, still spread-eagled in the ditch. Past the
dark church. Left, along the village street. A Black Watch medic
in a dimly lit doorway. Two Scots officers talking. Waving to us.
Right, into our narrow alley of early this morning (an eternity
ago). No longer a terror-ridden, anonymous death-trap but now
a busy side street where Highland cooks squat by a roaring field
kitchen in a stable yard.

The lane opens into a vast, remembered field. A green lamp
burns on the ground. Beyond it, discernible traffic ruts lead
between white tapes towards another green lamp. And another.
And another. A safe, wide route with Hughie's tank blundering
along, squarely between those parallel tapes which indicate that
the lane has been cleared of mines. A bright flash catches the
shape and pose of bodies lying along the edge of the lane.
Sleeping? Unlikely. The attitudes are not of rest but of torment.
The helmets are alien. And we doused this area with bullets at
dawn this morning. Another flash confirms the cramped,
clutching rigidity of death. Now they can only send up their
stench to offend us.

We run smoothly across the field. Hedge 'Fly by Night' looms
solitary, forsaken, superfluous. Rather like Beecher's Brook after
the National Hunt season has ended. A vast, untended hedge
disappearing into the gloom. Now, across the empty landscape
there stretches a highway, pricked out in merry green lights and
bounded by clean white tapes. This is the method of the bridge-
head. Tanks avoid the circuitous, overgrown medieval lanes and
blaze new trails of Roman directness, straight across country.
Julius Caesar would have been at home in a tank. So we

steam-roller our own routes. Yesterday a rutted, cratered track. Tomorrow an autobahn.

I am struggling to remember something. Something which I have forgotten. Obviously I have forgotten it, otherwise I would not need to struggle to remember it. This exercise in logic occupies the entire waking part of my mind. So much so that I cannot remember what I have forgotten, for the effort of analysing how I am trying to remember. Or why I am trying to remember. Or what . . . There is something that I should be doing, besides commanding a tank, riding in a tank standing in a tank thinking in a tank trying to remember in a tank trying to keep awake in a tank trying not to go to sleep in a . . .

Got it! 'Operator and co-driver, unload all guns. Gunner, traverse front.'

Andy: 'I am traversed front.'

Me: 'No, you're not, you idiot. Can't you feel you're riding backwards?'

Andy: 'No, I'm riding frontwards. It's the tank that's going backwards.'

Stan: 'He might be right at that.'

Me: 'Andy! Andy! Wake up! Are you awake?'

Andy: 'Yeah . . . of course . . .'

Me: 'Then traverse the gun.'

Andy: 'Left or right?'

Stan: 'Oh, my gawd.'

Me: 'Either way. Oh, traverse left.'

Stan: 'The big bum's going right after all that.'

Me: 'Leave him, poor kid. He wouldn't have slept last night on Hughie's tank. Gunner, on! Stop! Andy! Stop! You've been right round twice already. On! Adjust your gun and lock up.'

Andy: 'OK. Sorry! I'm sorry bloody so. I mean, so bloody tired. I can't think straight.'

We are now way out in the emptiest deserts of darkness. This morning it was horrific, fearsome, energizing. Tonight it is monotonous, mesmerizing, enervating. Nothing but darkness. The land dark. The tank dark. Ourselves dark. Hardly enough light to blanch the Nubian blackness of our skins. And this dark, rumbling, gently rocking vehicle sways us, levitates us, leaves us weightless, feelingless, purposeless, absorbed into its warm, stinking, fetid obscurity . . . like a drifting boat . . . like a floating bed . . . like a rocking cradle . . . like a pulsing womb . . . like a snug shroud on a slow hearse . . . a warm, descending tomb, a long barrow in which to rest to sleep for the mind to disengage

and go drifting along darkened, warming landscapes floating pulsing rumbling sinking . . . looming . . . glooming . . . drooming . . . swooming . . .

Stan: 'Harvey!'

Stan: 'Harvey!'

Stan: 'Harvey! Hold it! Hold it! We're going over! Hell, man, we're going . . .'

I wake up to feel the tank keeling over, keeling, keeling, slipping, slithering, sliding, forwards, downwards and sideways. In a dark tunnel. Can't be. Can be. Tunnel. Ravine. Pit. A deep pit. Not on the green-lit highway. Harvey slams on the brakes, the tracks grind and crunch on loose earth. We crash to a stop in formless dark.

Harvey: 'Where the Hell are we? We're not on the road. We're down a bloody coalmine.'

Bookie: 'You must have been asleep. You ripe idiot.'

Harvey: 'And what were you doing meanwhile? And everybody else?'

Me: 'OK! OK! We are all tired out. That's not the point now. Hold everything while I get some light on the scene.'

I find the torch and play it in front of us. Around us. Behind us. We are at the bottom of a huge crater. Like the one we drove into deliberately when going down into Caen. Too deep for us to be able to see out over the sides at ordinary ground level. Ahead the crater ends in a steep earth wall. A knocked-out German Mark IV has toppled into the crater and stands half perched up against the front wall as though it is trying to crawl out. On either side crumbling slopes loom up almost sheer into the blackness.

To our right lies a dead German SS man, grinning up at us, half face, half skull. His legs are trapped under our tracks. Behind us the slope is less precipitous but is made precarious by adjoining, overlapping, countersunk shell holes. That was the way we came in. That is the way we must go out. The task is made more difficult because we obviously side-slipped from a straight course on the way in. How do we do a reverse side-slip upwards? That is something which we did *not* learn at the Training Regiment.

'Andy, get out. Go behind us up to the top of the slope and shine the torch down so that we can see something of the way.'

Andy: 'What about our spotlight?'

Me: 'And attract all the Jerry moths in the neighbourhood – SS stragglers, artillery observers, Heinkels and Dorniers? Torch

please, mate. Driver, we are going back up the way we came . . .
we hope! So don't touch the sticks unless I tell you. Bookie and
Stan, dismount. If we end up balanced on our turret, you can go
and fetch the AA man.'

Andy, Bookie and Stan dismount, muttering rebellious
curses, typical of the tank man who is given the chance to get out
while his mates are in jeopardy.

Me: 'Bad-tempered lot!'

Stan: 'Hogging all the glory!'

Bookie: 'Me, I'm off down the Green Man, then.'

'Driver, steady at that. Bottom gear all the way.' Harvey lets
the tank roll back slowly on its tracks with no change of direc-
tion. A tank track packs tremendous demolition power once it
starts to skew on a slope. The tail of the Sherman begins to lift.
The dead SS man grins even more frightfully as the track runs
back over his legs. But what concerns me more is that there
may be live SS survivors still lurking in holes like this. Stony
Stratford's tail continues to lift, but we also begin to tilt to the
left. The slope is very broken and irregular. If we do not get out
the first time, we may cause so much damage to the crater that
escape will prove impossible in the dark. We may have to stay all
night. We may have to be pulled out on the end of a crane. We
may go down in Yeomanry history with Preece W. in the miry pit
at Weston. 'Gone to ground' is an expression known to hunts-
men.

'Right stick, gently! Straighten!' Our tail is high in the air. And
still climbing into the vertical. The earth under our left track
subsides and we tilt that way. Fate digs away a dribble of earth
under the right track and we level off. More or less level off. At
the lip of the crater our tail is so high that we seem to be about to
somersault. Thirty tons of armoured steel cartwheeling! Petrol
and live ammunition cascading about our ears and brewing up!!
The entire tank slamming down to dig and seal an immediate
grave!!! Bad enough for me, wedged tight in the turret hole.
Worse for Harvey, unseeing in his prison cell. He revs the
engine desperately, alarmingly, not needing my order.

'Keep reversing, mate!' Stony Stratford slams down back-
ward, its tail crashing solidly from a horrifying height. Banging,
bruising, tearing heads, elbows, knees on unsympathetic iron
projections. But down. Down. Definitely, safely down! On solid
land. Andy waves the torch over towards our right. There the
main route swings sharply to avoid the crater and the tiny,
hypocritical green lights grin back at us whom they so nearly

betrayed to our doom. Andy arrives on the turret, grinning hugely. Stan appears behind him.

Stan: 'Take that smirk off your face on parade, Trooper Briggs. You didn't join the army to be amused!'

We have now returned to the ravaged, inhospitable land, a terrain so scattered with humps and bumps and potholes and pits that no map could contain them all. The ground is torn and battered to the extent that it is impossible to say where ground level is. There are no visible horizontal lines. A squandered heap of bricks, once a cottage, is strewn across mounds and into craters so that the floor level of the original house could be anywhere within a couple of feet, higher or lower. Even the detritus of battle, rifles, boxes, packs, shell cases, bodies – none of them lie horizontally on a flat surface but all perch at angles through differing levels.

And here the stench is as bad as anything I have encountered in Normandy's hot summer. This local smell must be extraordinary, for it intrudes into the tired consciousness when our nostrils have long become accustomed to the incontinence immediate upon death and the decomposition consequent to it. Purposeless shells drone and rumble overhead, coming from a point of no heard firing and travelling unhurriedly to a point of no heard explosion. From what we can hear, these shells may be travelling round and round the earth's surface without ever landing. Faint flickers from time to time suggest that this is mere fantasy. During those faint flickers we get glimpses, as in a very old and faded film, of the variations on the theme of unending craters and rubble. Here an abandoned Sherman: is it the *Swan Lake* Sherman of last night? There a shattered body which, in the next flicker, proves to be the incomplete limbs of a cow mixed with the disconnected portions of a human torso and head. A few such Dali-style compositions will explain the exacerbated stench.

And everywhere the incalculable proliferation of mess, of massed articles, of imbecilic inventories, of millions of particles: shed shrapnel side by side with neat, shining cartridges and shell cases; wrecked timber alongside unpacked boxes of stores; pitiful rags and tatters of uniform hanging on barbed wire not far from rows of tidy bodies in full kit, lying along the earth as though on parade – every pile of earth as full of detail as a mine dump alive with gleaming pyrites. These impressions flicker into the mind as the far artillery flashes stipple the immensity of darkness. Loneliness. A lost world.

A place for massacred warriors and wasted materials.

'Hullo, Roger 3 Baker. I don't see you. Roger 3 Baker, over.'

'Hullo, 3 Baker. We have just had a pit stop but are back on the track headed for the chequered flag, over.'

'3 Baker. You're ten laps behind. No champagne for you . . .'

Stony Stratford bounces and topples down into another vast, shallow multiple crater too big for the green lights to avoid or detour. So the route plunges down into an open grave with rows of dead laid along one side. I pinch my nose to keep out the smell, but my mouth and throat feel infected. We move up and out of the hole onto what passes for level road. A ghostly cloud materializes ahead. A pair of red tail-lights wiggle cheerfully no more than fifty yards in front. We have closed the gap rapidly.

Harvey: 'Tally-ho! The wee Macgregor laddie ahead. Och aye the noo!'

Stan: 'If I know our Harvey, he's gone a complete circle and that's either a Tiger on its way back to a sauerkraut dump or even a Russian T34 bashing it back to Stalingrad.'

My body, from the chest down, is immersed in a tiny, hot, reeking haven of human affinity. My head and shoulders travel through a chiller, alien, devastated region pervaded by the unseen vapours of death. Hughie's head, a dark, mis-shapen blotch above his turret, sways gently within his dust wraith, the two red dancing sprites of rearlights luring us on.

Day's end. Battle's rest. Deserted land. Tired eyelids. Rancid mouth. Aching ankles. Vacant stomach. Booming engines. Dust. Ceaseless crunching of tracks on rough ground, ceaseless rumbling of tracks over drums, ceaseless screeching of tracks over sprockets, ceaseless booming of engines, ceaseless calling of lost voices trying to reach us through the ceaseless atmospherics of the wireless, ceaseless . . . swaying . . . swinging . . . swooning . . .

### 9 AUGUST 1944:

**00.05 hours:**   It is like turning out of the Sahara Desert into the railway terminus of a great city. One moment we are travelling across a barren, formless land hidden under a vast darkness, the desert theme accentuated by the clouds of dust thrown up by the four Shermans of our Troop. Only the unfailing green lights and occasional torn white tapes have been there to guide us on the trackless waste through the amorphous regions where camels would have appeared more indigenous.

Suddenly a huddle of buildings appears on the left. We hit a solid road, turn left onto the road, run between two houses. And are in the midst of frenzied activity. 'Infernal' is a word which has sprung to the mind frequently over the last day or two, but this scene is like a stage representation of Hell indeed. Lurid light struggles against omnipotent darkness. Small hand-torches wave their yellow rays by the dozen. Cooking stoves flicker furtively, orange and red, on all sides. Two or three large trucks manœuvre with the aid of black-out lights, the normal headlights covered by black patches in which tiny crosses are cut. Somewhere in the background a larger bonfire diffuses a crimson and maroon-coloured glare: probably a dump of in-flammable materials set ablaze by tracer or incendiaries. An almost unbearable stink of burning rubber sterilizes the normal stench of putrefying flesh. Against and within this confused kaleidoscope of hesitant light, hordes of human figures, black silhouettes, hurry to and fro between massed vehicles.

This open space is located just before a village, Hubert Folie. The buildings are, almost without exception, ruined. There are roofless cottages and floorless cottages which have sunk into deep pits. There are buildings with three walls, two walls, one wall. Doors hang loose, doorways have been enlarged into ragged gaps, windows jut askew, oddly positioned new aper-tures give the walls the appearance of having been designed by crazy architects, dwarfs and giants. Here and there stand shat-tered vehicles, two or three army trucks, a civilian car, a hay wagon, a Sherman with the turret hanging off, the front half of a jeep. And everywhere the day's passengers, cramped from long journeyings, leap about in a grotesque ballet, exaggerating their activities in order to exercise neglected limbs.

As Harvey drives cautiously in, the first recognizable figure is a lanky English gentleman, with officer's cap and riding crop, busily directing traffic: Hank, the Squadron Leader, more intent than ever to see us safely in and to count his distressingly small roll of survivors. He speaks to Hughie and waves him to the right, where there is some spare space close against a derelict farm. He signals us to stop. Harvey obeys.

'Are you definitely the last in line?'

'Yes, sir. We started last and we didn't pass anybody on the road, so there's nobody else to come in.'

'That's as I thought. Right, cut along after Mr Macgregor, and get your lads something to eat as quickly as you can.'

'Thank you, sir.'

'Well done! Driver, that way!'

We follow Hughie's tank and fall into the normal pattern of forming a square, the four tanks of the Troop tightly parked, to give a tiny quadrangle of security inside the laager. I calculate quickly that ours is probably the only Troop in A and C Squadrons which has enough tanks left to form a square. Others will form a triangle, or join onto other Troops to achieve a square. Or park disconsolately on their own.

Me: 'Driver, halt. Switch off. Operator, co-driver, check all guns unloaded and report.'

Andy: 'Is this home, sweet home on the prairie then?'

Me: 'This is the best home you're going to get tonight, brother. Operator, switch off.'

Stony Stratford ceases to be Roger 3 Able as Stan switches off the voices endlessly calling from beyond the rim of the universe – trying to keep in touch . . . (Tomorrow Stony Stratford will have a different call sign.)

Jumping to the ground without due thought, I stumble with tiredness and hang onto a welded storage box for support. Out of the darkness an excited, sweating man runs towards me. Throws his arms around me. Embraces me in a most un-English manner. I push him away. Recognize him as Corporal Landis, the Squadron cook. He is weeping and laughing at the same time. I regret pushing him away, but he appears not to have noticed.

'Young Ken! You got back. You're safe. You made it. We heard Keith was hurt. But he's OK. Gone to hospital. So has the Colonel. And Major the Honourable Peter. And a lot of others. Is everybody all right on your tank? Hey, what's wrong with your eyes? You've got a huge swelling. Blood . . .'

'It's only a wasp sting, honestly!'

'God, I thought you'd been hit. A frigging wasp sting. Hey, lads, hear this! Jerry's firing frigging wasps at our Ken here.'

Stan descends from the turret. Corporal Landis grabs him. Slapping Stan's back with one hand and shaking hands with the other. For once Stan is speechless.

'Stan Barber, you old sod. You got back. You got back.'

'I got back.'

'That's damn right. You got back. But is it true what somebody said about Sonny and Astley and . . .'

A rugby scrum of cooks, fitters, signallers, armourers, clerks, storemen, truck drivers, come running, cheering, laughing to greet the crew. I dodge round the blind side of the scrum, taking

advantage of the sloping front of Stony Stratford, and hurry towards where Hughie is talking to the other two commanders. 'Ah, yes, I was saying: all I know yet is that we go back into the line at first light. I will call you for Squadron Leader's conference later. But, for now, clean guns, stock up on everything, rations will be coming round, eat and then get your lads down to sleep. But don't skip anything. Your life may depend on one of those guns firing tomorrow. That's it for now.'

From the dark centre of the square laager of four tanks parked nose to tail, I emerge into the fitfully but more clearly lit outside lane A great voice booms above the hubbub, and a large, smiling face thrusts itself through the common herd. The RSM himself!

'Come on, my merry men. Load up with everything you want. Father Christmas is here. See what you've got in your Christmas stockings! Petrol, ammo, water, rations. Move yourselves, you lazy stay-at-home cooks. These lads have been in a battle. Come on, you yeomen. You're supposed to be helping my lads here load up their tanks. How many AP, boy? How many HE? How much Browning? Your Uncle George is in personal charge of ammo as befits an old gunner from the Somme.'

And burly, bustling George Jelley, Regimental Sergeant-Major by appointment but Uncle by adoption, himself grabs a large 75mm shell and, with arms which could juggle a beer barrel, hurls the live shell with such force that it nearly knocks the catcher, Andy, off the turret.

A different voice cuts in. 'C'mon, c'mon, c'mon. Another thirsty tank here. Don't bother the driver. Get the petrol cap off. Get passing the jerry cans. Get pouring that petrol.' The ferocious staccato of words pours from the ferret of a man who contrives to look immaculate, even at this hour. This is the Squadron Sergeant-Major, a contrast in every way to larger-than-life George Jelley. 'Hey, hey, hey! Have you been facing up to Joe Louis or Tommy Farr, my lad?'

I sigh resignedly. 'Just a common or garden wasp, sir. No doubt fired from an 88.'

'Bloody dirty fighters the SS. Be firing snake's teeth next time. I'd get it looked at by the quack Corporal some time, though. Don't want you to go home to your mother looking like that. She'll think we don't look after you.'

A more plaintive voice sounds from the running board of another truck. The Squadron Quartermaster Sergeant is a tall, sandy-haired, shy man who used to look after pedigree bulls in civilian life. His loudest shout is no louder than a summer breeze

amid the grasses. 'Stop me and buy one! Here you are, Stony Stratford. Pass your water cans. Fill up with best spring water. They call it spring water because it was springtime when it was first flushed down a Paris loo. Been purifying in the sewers ever since.' He continues his running commentary as HQ(A) men jump from the lorries and start piling supplies on the back of the tank. 'We've made up ration boxes for each tank for twenty-four hours. Double rations because of our casualties, including fags and chocolate. All for the fighting troops. Eat as much as you like tonight. That's it, Corporal. Give them two boxes.'

RSM Jelley bangs the tank plates at my feet to attract my attention. 'That's all, my boy. Fully loaded. AP, HE, Browning. Small arms. Mills bombs. Yellow smoke. Have you been eating them?'

'Thank you, sir. It's been a great help at this time of the night to have so many blokes willing to help.'

'Willing? *I've* been willing them, with a boot up their pants. Did you hear? The Yanks bombed us. The most accurate bomb-aimers I've ever encountered. Right down our throats. Up our backsides. Blew up a three-tonner and HQ Squadron Leader's jeep. Only we weren't the enemy! Huge great Flying Fortresses and Liberators. I looked up to see once. I didn't look up the second time. I was half way to Australia down a slit trench, digging with these ten great shovels called fingers.'

'Sorry about the Forts, sir.'

'Nothing to it. Except we lost three good lads, that ginger-haired fitter and the signaller with glasses and a new lad. Took a thousand-pound bomb right on top of them. No trace of 'em afterwards. Not even a hand to shake goodbye, like you found in the old 14–18 trenches. Gone in tiny globules all over the field.' He slaps the tank again. Pulls out a big khaki handkerchief. Blows his nose. Wipes his eyes. Turns to the men behind him. 'Right! What you lot waiting for? Haven't you got any homes to go to? Knock off now! Get your bed-rolls down. There's an early start tomorrow. Move, then, move!'

I turn to the remainder of the crew, who are on top of the tank or in the turret hatch. 'Hang about a bit, lads. Harvey, do your driver's check and maintenance. Bookie, clean your gun and then help Harvey. Stan, turret gun and check ammo storage. I'll help Andy with the 75 and barrel. Whoever finishes first can think about brewing up for supper.'

Stan: 'Do you think that Browning should be looked at by the Armourer?'

Me: 'It only misfired once, didn't it? Come on. Don't let's stand here like a lot of village yokels gossiping outside the pub after closing time.'

Harvey: 'Oh gawd! Don't mention the word "pub". Frothy beer. Jivey music. Willing skirt. Log fires. Fairy lights. I'm off down the bowels of General Sherman before I go mad with frustration.'

Stan, forever the idiot, slams a flashing salute at me: 'Permission to carry on, Colonel?'

Me: 'Permission granted, Sarn't-Major.'

From a nearby tank, invisible in the flickering darkness comes Graham Harris's impersonation of the RSM. 'Take that man's name for h'imitating 'is Superiors! 'is feet won't touch!' It's a choice between raising a laugh and falling asleep. We laugh rather hysterically as Andy and I assemble the long handles of the barrel brush, last used for the benefit of a roving war photographer, was it a thousand years ago and a million miles away?

Andy: 'Why are the press photographers conspicuous by their absence at this hour of binges and parties?'

We are standing at the outside end of the 75 barrel. Inside the turret the breech block is open, and Stan, there in the turret, can hear us. He puts his lips to the breech, and his reply comes, like the voice of the Oracle at Delphi, sonorous, *basso profundo* and vastly echoing, down the long barrel. 'Wot! No photo boys? Wot! No red-braid staff officers to welcome us? Wot! No vestal virgins?'

Harvey's voice sounds even more remote, as though from the grave: 'Oh, lay off the poor staff wallahs, Stan. They'll be exhausted with the effort of carrying all those medal ribbons around on their chests all day. Give 'em a chance.'

**00.25 hours:** An anonymous voice shouts from another laager. 'Put that light out! The Air Raid Warden's coming.'

Another disgruntled voice from the other direction: 'Oh, go visit a taxidermist and get stuffed.'

'There's supposed to be a black-out.'

'Well, then, go get the Fire Brigade to put that flaming great blaze out in the village.'

As the voice says, there is supposed to be a black-out. But in order to refuel and replenish and check tanks at twenty minutes past midnight, an element of light is necessary. This is another reason why we have to quit the front line. Torches flash

frequently. Cooking fires of some kind are necessary, seeing that each tank is responsible for brewing its own tea and cooking its own food. But even without the torches and the cooking fires the entire scene would be lit by the large fire burning somewhere in the village.

'Give us a light, Ken.' As usual Bookie is having problems in getting his machine-gun fixed back in its mounting. I switch on my torch, hand it to Bookie and then myself get the gun into position and secured. I pull the cocking-handle, press the trigger once or twice. It works. It may need to work tomorrow: which is already today! In fact for us today started yesterday and has now spilled into tomorrow.

This precise minute is, however, the time for me to go to the commanders' conference. Andy quips, 'Don't forget the workers!' And Bookie: 'Six to four on, we'll be lead Troop again. Wot! No takers?' Just beyond the HQ(F) laager someone has draped a large waterproof tank cover over the walls of a ruined, roofless barn, making a kind of low hall. Dim lights glare here after the relative darkness outside. The floor is uneven with shining, tumbled straw. Hank, seated on a camp stool, his cap straight, his knees together, his jaw set, doodles in pencil on a map cover. Bill Fox, his cap pushed perilously back, his knees splayed wide as though on horseback, his jaws chewing industriously, flicks his riding crop at imaginary flies. The SSM stands behind them. Hughie squats in the straw. Only one other Lieutenant is present out of our original team of eight officers. And only six other commanders out of a Squadron of nineteen tanks at yesterday's count. Suddenly I am back with Harvey's Pop in the 1914–18 lot, and his tales of forever marching back from the front line with pitifully few survivors. Here I can see the remnant which has survived of our Squadron.

'All here? Yes, I suppose that is all,' says the Squadron Leader in a tired voice. Then he visibly straightens his back and raises his voice to a more matter-of-fact tone. In the distance there is a spatter of machine-gun fire like gentle summer rain on leaves in the night. A faint drone of planes like busy bees on the August evening. Spasmodic rumbles which could be heatwave thunder or searching guns. Here, inside this ruin, we could be in the Bethlehem stable, the tableau set, waiting for Mary and the baby. A dark, musty stable with what could be flickering rushlights hardly strong enough to illuminate the broken-down walls. Outside, someone is softly singing, 'Red sails in the sunset . . . way out on the sea . . . oh, carry my loved one . . .'

Hank grins a moment. Is serious. 'You don't need me to tell you. You can all count. We have ten tanks left of the entire Squadron. The good news is that our lost sheep, Sergeant Pearce, has turned up with the 144 RAC. Tomorrow we shall merge A and C Squadrons for the day to form one unit. I have to tell you that we, the Regiment that is, have lost twenty tanks. But we have destroyed at least twenty of the enemy, at the very least. Including probably five Tigers and several SP 88s. All-in-all, our own operation has been a conspicuous success. We have carried out novel tactics with total target achievement, more success than was really anticipated by high authority. A message received from the Supreme Commander congratulates us all on achieving a significant victory.'

He breaks off and listens as the unseen singer changes from 'Red Sails' to 'Tell me the old, old story'. He joins in the general laughter. 'Sergeant-Major, do you think our singer could hear what I was saying?'

'No, sir. I regret to suggest that the choice of hymn was purely coincidental.'

'Perhaps it is fair comment, anyway. The old, old story is true. The remainder of the battle seems to have come unstuck. Some of you saw what happened when the Poles were sent on a cavalry charge in Shermans across open ground in broad daylight towards 88s firing point blank. A damnable massacre!'

'Bloody shambles again,' growls Bill Fox.

'Tomorrow, or rather today, we go in again,' continues Major Bevan, 'and stand at St-Aignan until other troops can come up and advance past us on either flank.'

Hank's co-driver comes in with a couple of mugs of tea for the Major and Captain. 'That's bloody poor fare when a man's been out hunting all day,' barks Bill. Hank takes a sip or two, wrinkles his nose and passes the mug to Hughie. Bill Fox does likewise and passes his mug to the nearest Sergeant, saying, 'Have a drink, Sergeant. I've breathed on it and that's as near as you'll be getting to the whisky bottle tonight!'

David Bevan continues: 'Orders! Tonight no tank crews will stand guard. Rear echelon will find all guards. Tomorrow, by which I mean today: Reveille at 03.30 hours. That's nearly three hours away yet! Start at 04.30 hours. 3 Troop lead. Then HQ(F). Then 1 and 4 as a composite Troop. By 05.15 hours be in the individual positions which your tanks held yesterday at the close of battle. Counter-attack positions only. If you listen hard, you may hear Poles and Canadians and other varieties moving

up and past us. Expect to stay in the line all day. Without relief
. . .' He stands up, beginning to show weariness. 'Well, tomor-
row, or should I say today, will be difficult. Sleep will be a worse
enemy than the Hun. Right! I don't know about you, Bill? I'm off
to bed.'

'Bloody good idea, David, I wonder why I never thought of it.'
There is tired but good-humoured laughter.

'Commanders . . . 'shun!' The SSM snaps a midday salute and
gets a midnight wave in return, a nod of the head and a casual
'At ease . . . and see your lads eat and sleep now. Never mind
anything else . . .'

He heads out into the dark night. Bill Fox follows him. They
move towards deeper, flame-irritated darkness. We follow,
stumbling a little on the uneven ground. I wait while Hughie
speaks to the other Lieutenant. I lean against a tank . . . Hughie
slaps me hard on the shoulder. 'It'll be more comfortable in bed,'
he laughs. I had gone to sleep standing up. I apologize. He
laughs again. 'I think only an advanced course in flagellation
would keep any of us awake for much longer.' He turns at
Hank's voice. Says over his shoulder to me, 'Find your own way
home?'

'I'll walk to the sound of sea breakers!'

The night is purple black, the twinkling stars above and the
flickering stoves beneath only serving to accentuate and confuse
the sepulchral darkness, vaguely bulked out by ponderous
tanks, shaped like oriental mausoleums. Three or four Troopers
crouched around a hissing Primus stove plaintively singing 'the
blue-hoos. . . . in the night'. I turn my bleary eyes up to the sky,
find the Plough, the North Star. My tank was about fifty paces
north . . . Or was it south?

**00.50 hours:** Stan: 'What news, skipper? We've finished
maintenance and loading up.'

Me: 'Gather round . . . Bookie, where are you? . . . First the
bad news. Reveille 03.30 hours. Ready to move 04.30. Back to
St-Aignan-de-Cramesnil.'

Stan: 'Oh, crickey! 03.30 hours? We'll never wake.'

Harvey: 'And what's the good news?'

Me: 'No guards. Also, Sergeant Pearce and his lads are safe –
with 144.'

Harvey: 'Whack-ho! I've got the best news. There's two tins of
corned beef each. Not per tank. Per person. Plus various tins for
heating up, meat and veg., pork and veg., etc. Also tins of fruit,

rice pudding, jam. So let's have your orders, mates. Who wants something hot, apart from tea?'
Nobody does. Not at this time of night.
I say: 'I'm going out into the desert to contemplate the stars.'
Harvey: 'Here's the spade. I've just been. Counted up all the stars ten times while I was squatting. Got a different total every time. I'll have a cuppa ready, *if* you find your way back.'
I take the spade and head for the deeper darkness. Count the paces. Ten, sixteen, eighteen, twenty . . . We go around France doing our best to strew the countryside with dead bodies, spent shrapnel, ruined houses, but at the same time we have rigid sanitary regulations which the Regiment considers more important than shiny boots or snappy salutes. Those wishing to respond to the calls of nature must dig themselves an individual hole at least twenty-five yards from the nearest tank. And fill the hole in at the end of meditation. At twenty paces out into the field I see something white at my foot. White tape, laid by sappers at the edge of the area cleared of mines. If I venture beyond the white tape, I may tread on a mine. Lose a foot, a leg, even a life. Here is a convenient large bush. Nobody in sight. I duck behind the bush and start digging my little private safe deposit.
'What the bloody Hell goes on 'ere, Trooper? 'Aven't you read h'orders? Can't you bloody well count? Din' your mother send you to school? Twenty-five effing yards from the nearest effing tank, is the order. What do you think you are doing, crapping almost in your comrades' supper tins?'
I did not see him lurking in the dark. I can still only discern him as a gnome-like figure, leaping up and down in agitation – a human-shaped splurge of lesser darkness. But I recognize the raucous, unschooled voice, as well as the adjectival niceties, of the fearsome Sergeant Dawlish.
'I'm only digging for gold, Sergeant. Anyway there's a white tape. It's not safe to go farther.'
'Who are you to say what's safe when you're in the face of the h'enemy? Where would we be if, every time the Squadron Leader gives a h'order, some bloody useless Trooper says, "H'it's not safe, Sergeant?" You're not here to be safe. There's a War on. P'raps you a'n't noticed yet? Hey?'
'Well, I think you're taking it a bit too far . . .'
'You a'n't took it far enough! The Squadron h'order is twenty-five yards. Figures two five. And twenty-five effing yards you will go to dig your stinking cesspit, Trooper!'

'But why? When it's too dark to see whether we *are* in a minefield?'

'For figures two reasons – one: Squadron h'orders says so. And two: H'I, a Sergeant, says so. And three: who wants your ruddy stink polluting their supper because you're too effing lazy to squat at the regulation distance? . . . and four! Because, Trooper, you are bloody yellow-livered, bloody yellow-livered-scared-of-mines . . .'

'I'm not yellow-livered. I've been farther forward than you today. While you were skulking in that hedge, I was over the other side of the gully. With my head stuck out! And my body stuck out, too, some of the time. And nobody asking me if I was more than twenty-five yards from the nearest Jerry tank. Which I wasn't!'

The little Sergeant, his eyes hardly level with my chin, grabs the lapel of my denim overalls and begins to pull rhythmically, emphasizing his shouts. 'Well, bloody well listen to me, Mister Big 'Ead. You're disobeying h'orders. And you're being h'insubordinate. And if I say you don't shit until you get to Berlin, then you effing well don't shit until you get to Berlin. And if you do, I'll have you on a fizzer! At the double! Throw the effing Book at you . . .'

'Aha . . . ah . . . wait a moment, Sergeant. What's going on here?' In the moment of silence Captain Fox moves into the area of starlit visibility, his riding crop tapping the Sergeant's hand where it still retains hold of my lapel. 'What's all this about, Sergeant?'

'Trooper, 'ere, sir, not twenty-five yards from nearest tank and according to Squadron h'orders, sah! I'm putting 'im on a charge, sir. Also for h'insubordination, sah! Says there might be mines, sir. Says it's not safe, sir. I tells 'im 'e's not 'ere to be safe, sah! Yessir!'

'Quite right, Sergeant. None of us can be safe, Sergeant. Now you've had a busy day, Sergeant. Been well up the front all day. You go back to your tank, Sergeant, and leave this Trooper to me.'

'Yessir. Very good, sir. If you say so, sah!'

'I do say so, Sergeant. And you heard me, Sergeant!'

'Oh, yessir, sah!'

He slams a salute at the Captain, in the darkness a salute so vicious that it burns the air as it travels up . . . two-three . . . down! Then he does a slightly drunken about-turn. At this time of night his feet have forgotten the parade ground and he

stumbles, rather than marches, away to his invisible tank. (I don't think he will be waiting for Bookie tonight.)

'Goodnight, Sergeant. Now, Trooper, what's all this about? Like a howling dog and a cat on heat scrapping and squawling in the night, keeping the whole camp awake.'

'I know it isn't precisely twenty-five yards. But we *have* crossed a white tape, sir.'

'Aha . . . ha . . . yes, damn dangerous things, white tapes! Get mixed up with your boot laces. Best avoided. Well, we've all had a bad day. The little man means well, even if he can't always pronounce it. Aha . . . ha . . . yes, now, Sergeants must be obeyed. Why don't you pick up your shovel and dig a pit over there, behind that other bush, d'you see?'

'But that's nowhere near twenty-five yards . . .'

'I'm not going to measure it. You're not going to measure it. Sergeant Dawlish isn't going to measure it. Even the Supreme Bloody Commander isn't going to measure it. Look, leave your illegal little hole here and cut off over there. What say you?'

I realize that he too is carrying a spade. 'Well, I suppose this was rather an ambitious bush for a mere Trooper, sir.'

'Yes, far too large a bush for other ranks. Definitely a Captain's bush. Off you go then. And try not to make it too musical. Don't want all the sleeping Troopers to think you are sounding Reveille yet. Goodnight to you.'

'Goodnight, sir.'

The stars above twinkle with laughter in the chilling air. And some humorous German artillery Captain chooses this moment to send a few random shells sailing over to burst in shreds of blinding flame, a couple of hundred yards down-wind. I feel too tired even to duck. I am ducked anyway. I hear Bill Fox behind his bush grunt and announce, 'I don't know which is the biggest damn menace – the Hun gunners or Sergeant effing Dawlish!'

**01.05 hours:**  At last. We sit down to supper. That is not strictly correct. If we sat down, we would fall asleep. Keel over and sprawl there, like so many dead cockroaches. Stan sat down and has already gone through the motions of a sinking ship. He is looking totally waterlogged but trying to keep afloat. The rest of us are walking about, holding our mess tins. One of my mess tins holds an entire tinful of corned beef plus some cold baked beans. I wolf the food, thankful for the decency of darkness. Another salvo of shells slides overhead, does a rub-a-dub-thub

rhythm well beyond us. A distant voice calls clearly. 'Dear God, turn 'em round and ram 'em up Hitler's ass!'

Hughie Macgregor creeps out of the shadows and beckons me. 'Can ye spare a moment between mouthfuls? I've just been talking with the Squadron Leader. Put up that stripe again that you wore with the Reserve Troop on the way over. Your promotion will be in orders tomorrow. Keep command of Stony Stratford until this engagement is over. After that you are to alternate as a kind of all-purpose substitute wallah. When a commander gets knocked out, ye'll go up and take over.'

'Thanks very much, sir. Just one question. Do we need to dig in tonight?'

'Oh no. Simply drop your bedding roll where you want and get down to it. That's what I'm going to do. Now! Have a good night. What's left of it.' He turns back to his own tank. Darkness absorbs him totally within three paces.

Stan: 'What saith Hughie?'

Me: 'Told me to put up a stripe.'

Harvey: 'Yeah, bloody acting, unpaid, unrewarded, no Union rates, in the face of the enemy, mate.'

Stan: 'At least you can swear at Bookie now.'

Harvey finds the energy to scramble, monkey-like, up the track, onto the engine covers, loosens the rope and kicks our bedding rolls off the back of the tank. I lean against the tank, mug of horrid tea in hand, and stare at the stars. In this moment I feel a wild exhilaration. I am still alive. Drinking the chill night. Seeing the vast jet canopy of skies, with the stars big and mobile and flickering like a plague of silver, luminous moths. I am alive. Safe. Fit. Young. And throbbing with hope and ambitions, running wild in a strange country, hazarding life, wolfing food, escaping fate, building confidence, enjoying the undemanding but loyal companionship of other youths who, like me, are quick to fun and slow to anger.

'Our camels sniff the evening and are glad,' quotes Stan, watching me inhale the darkness.

'We take the Golden Road to Samarkand,' I reply.

This fragment from Flecker is, like the Imperial Chinese Army, one of our routine salutations. But Stan does not realize that I borrowed the habit of quoting it from Siegfried Sassoon, who used to exchange the same words with another such as Stan in another war. Sassoon's books are my manuals of war. I appreciate his anti-war protest and the fact that afterwards he went back to the trenches and found a strange fulfilment there.

What am I doing here? Like Sassoon, I am anti-war but caught up in the compulsion and mystery of it. Perhaps it is because there are worse things than war? For instance, the beating and killing of little old men and women because they are Jews – by armed thugs without a declaration of war. Desecrating life is worse than taking it in order to prevent further desecration.

God, I can't stand here all night. I will wash my face. Clean my teeth. My tin mirror grins back at me. The wasp sting has caused my forehead to swell so much that I look like Charles Laughton in *The Hunchback of Notre Dame*. There is dried blood on my cheek. I was unaware of it. Scrub it away. A long, jagged scratch remains. Thorn branch or shrapnel or nervous fingernail? Deep age lines cleave right down vertically from my eyes to the sides of my mouth, twin gullies like parallel plough furrows. Shall I ever lose those lines? Or shall I for ever be stopping them up with glazier's putty?

'Falling in love again?' asks Harvey, who is untying his bedding roll, his hair still dripping from his brief but determined ablutions.

**01.15 hours:** 'Lost something, Bookie? Has your ball rolled in under there?' asks Andy as Bookie crawls ponderously under the tank.

'I'm flooding well not sleeping in the open. Last time I slept in the open somebody pissed on me in the middle of the night.'

Andy: 'And where was Sergeant Dawlish *then?*'

Me: 'Hang on, Bookie. Let's test the ground first.'

We were all horrified by the story of four crewmen who went to sleep under a tank. In their weariness they had not dug a slit trench. Nor had they noticed that the ground was boggy. During the night the tank sank on top of them, silently smothering the life out of their bodies. We stamp around the outside of the tank tracks. 'You buggers putting in some square bashing?' calls a voice. The ground is absolutely hard. Midsummer hard.

Stan has slumped against the track, his legs stretched out in front of him, head lolling on one side, mess tin tightly clutched, corned beef half eaten.

Me: 'Andy, help me lay out this stiff decently before you kip.'

Andy: 'Poor kid, he's not waking however much we jolt him.'

Me: 'Poor kid yourself! How old are you?'

Andy: 'Two thousand years old, and then some,'

Harvey: 'Gawd, you're still a babe in arms, compared with the way I feel.' Harvey is snuggling into his blankets on the warm

engine covers, his favourite place. He calls, 'Sleep well, skipper. Cripes, it's warm up here. Room for two.'

'No thanks. My mother told me to beware of strange men.'

'It was your sister she told that to.'

'I never had a sister.'

'Lucky sister!'

I pull the blankets closer around Stan, who is still fast asleep. I recall Sonny's face. Sonny and Stan look very similar, faces pale under the stars. Except that Sonny's face is relaxed and serene in the truth of death, whereas Stan's is still strained with the hypocrisies of life.

**01.20 hours:** I lie back on the bumpy ground. Two hours to sleep. I pull up my rough blankets, look and listen. Look up at the numberless campfires of the stars. Listen to the faint rumours and rumbles of war. A rolling barrage somewhere remote, like the rumble of a train transmitted through the earth whilst still miles away. The throb of a plane high above us. The brief, dull thud of bombs. These faint war sounds are coming from all points of the compass around us. We are still lodged in a precarious conquest area well ahead of friendly armies. Suddenly I am wide awake. Savouring the wildness of this forsaken place. Safe within the laager of friends and silent guns. But with strange, Neanderthal responses stirring to the evil grumblings and rustlings of the night. Sensing the laager's safety all the more because we, the herd, the pack, the flock, the litter, the brood, the clan, are at bay, surrounded by enemies.

Two hours to sleep. Comes another day. Sleep, I must sleep. How shall I sleep? Count sheep? Count German tanks, crossing a gully? Count brewed-up tanks? Pillars of smoke? Broken waxworks? German war widows queueing up for pensions?

**01.26 hours:** by my watch in the dim torchlight. This is the witching hour, and this is the hour when there is no today but only a yesterday and a tomorrow and the rumbling scenery moving slowly round under the circling stars.

A soft tread shuffles through the coarse grass. A sten-gun taps against a piece of metal equipment.

'What's up, mate? Can't you sleep?' It's Corporal Landis, the cook. Normally cooks would never dream of standing guard. They are privileged persons. But tonight is different. He squats beside me. 'What was it really like up there? Was it bad?'

I think about the question for a moment or two. 'Well, really, in the line you don't see much at all. Just the trees and the fields

and the occasional puffs of smoke. No blood or anything. You hear more, of course. But there is little to see. If it sticks its head up to be seen, it gets its head promptly shot off.' He nods and grunts sympathetically. And waits. 'Of course, in another sense, it is all rather horrific because you can hear the wireless reports coming in and you can visualize what is going on. Like floating over the battlefield watching it all. Our tanks brewing up. German tanks milling round. Half the Regiment blazing. Masses of German infantry crawling through the corn . . . but all you can do is watch the empty landscape.'

He straightens up. 'Glad you got back. Sorry about Sonny. Must go patrol a bit. Give Jerry the shits, sees me with this gun.'

'You scare *me*, never mind Jerry. Do you know which end is which?'

'Got the book of instructions in my pocket, old son. Go, sleep. Don't worry about the war. I'm winning that.' He moves off across the grass, crouching slightly, rather like a superannuated Red Indian.

**01.31 hours:** That means . . . 1 hour 59 minutes left for sleep. Can't sleep. Stan can. Sonny certainly can. Look up at the shining, ageless, unfeeling stars. Wonder about the human wastage. Sonny Bellamy asleep beyond the gully. What profit in cutting off the life of so young a man, who, had he lived, might have enriched many people by his charm and friendliness?

A quick answer might be that Sonny destroyed three Nazi tanks before he was destroyed. Fulfilling a life purpose in a few minutes. A small blow against despotism. A second simplistic answer, culled from my own upbringing, would be that this life, through its toil and travail, is only preparatory to the real, the better life 'above'. A third answer could be that Death ennobles the living who remain. I am ennobled for ever by knowing Sonny. By having looked on him sleeping in the sun. By having seen him, in the midst of the horrifying catastrophe, pretend to be playing drums, assert that he himself had some comical overdrive power to control it all. Which, in a way, he had. For the echo of laughter persists far beyond the echo of the gun.

Lord! What a subject for obsession, when Reveille is less than two hours away. The ground is hard and uneven, a penance couch for back, hips, shoulders. A corner of my haversack sticks in my ear. The wasp sting aches. An excess of corned beef sets my gullet on fire. And now ghosts marshal themselves down the subterranean corridors of my subconscious. A battered wax-

work in a motor cyclist's uniform, a Panzer tank commander curtailed at the waist, a British commander frozen in a mock Hitler salute, a headless thing wearing Trooper Judge's uniform, a bevy of howling Minnie bombs transformed into real witches riding the skies and able to home in on the target human who runs hither and thither but cannot escape . . .

   Today, yesterday, I have seen people killed. In a tank one does not so often see people die. The tank is a nice, clean, hygienic and civilized method of slaughter. Press a button and the enemy drops out of sight, but undoubtedly dead. You don't even have to wipe your bayonet or wash your hands. A kind of 'humane killer' device which causes no pain at all – to the killer! (The night breeze swings to another compass point and catches the stench of some human cess-heap.)

**01.34** by my watch. A rustle of blankets and Harvey's voice comes from above. A faint whisper. 'Hsst, mate. Are you awake? Are you worrying about that stupid sod Dawlish? We heard him bollockin' on out there.'

   'No, I'm not worried about the old fellow.'

   'It's often the little things that niggle most. Bloody death on all sides but it's Bookie's stink tin that niggles me most. Going to have another try at kipping. Dream it's an ice-cream van I'll be driving tomorrow . . . along the prom at Colwyn Bay.'

   Harvey grunts and wriggles restlessly. My mind switches back home too. My mother, at the night hour, will be putting her faith in a Supreme Power who can divert bullets. (Sonny Bellamy and the Fritz motor-cyclist probably had mothers praying too, with less success!) My father will go to sleep proud that I am a square-shouldered soldier but anxious as to what I may encounter.

   I realize the difference between the two wars. Stan's Pop always marching back from the same bit of the front line. Then going up again after rest. The same bit of line. Countless thousands of soldiers sharing the same experience of the same sodden bit of deep-dug trench, the same parapet, the same rats, the same festering bodies, the same scrawled jokes. Whereas we fight a moving war. We find our little nests in the hedgerows, like military cuckoos, and our crew may be the only people ever to use that nesting point or slit trench. They are private preserves, memories shared with no one else. Even the glade where Sonny lies, along a vital track, will be visited by only a few troops in rapid transit.

   What we all share, fathers and sons, writers of that war and

readers of this, is the close intimacy with Death; the crude jokes at His expense; the comfortable, warm fellowship with comrades living; the unspoken love relationship with comrades gone the dark road which we too may have to explore. But when this is all over, shall we each travel for ever through a dark night of loneliness, looking for the road back to St-Aignan? For nothing will ever be the same again . . .

Sleep! I must sleep! Count! What shall I count? Count the hours since last I slept! Since 8 a.m. yesterday. No, not yesterday. Some other day. Long ago. Far away. $24 + 12 + 4 + 1\frac{1}{2}$. That's $41\frac{1}{2}$ waking hours. Now how many *minutes* is that?

**01.37 hours:**   Someone screams in the night!

The voice burbles into incomprehensible muttering. A second voice grumbles, 'Bloody Hell! Stuff a blanket over that man's head!' A third voice rejoins sleepily, 'Oh, leave him. It's Lankie. He's probably dreaming about that Jerry he shot.' The argument babbles on in three voices: I shot some effing Jerries meself, din' I? All right, so you're a bleeding adult. Lankie's only a kid still. No, I didn't. No I didn't. Don't shoot. Don' shoot. Don' shoot don'shoo'don'shoo'. Aw pull the bloody trigger pull your own it's big enough I tell you I din't I din' I din' I gorrd fetch the vet aw leave the kid can'you musn't shoot's a white flag s'a white s'white ruddy mother's boys did 'ave a mother anyway . . . and the three voices overlap, gradually subside into sleep, leaving three unfinished sentences hanging in the gently pulsing night.

The far-distant thunder, of guns or of August storm, now produces little more reverberation than a highly strung bass drum responding to the caress of a child's finger-tip. Little more disturbance than the failing pulse of a dying man. Empty your mind they say. Empty . . . thenthebumps go bumpbumpbubump . . . two miles away? Five miles away? Flashes that are lightning. Or not lightning? Or both lightning and not lightning? Empty your mind . . . Sonny Bellamy, of course, his face not covered . . . another, a waxwork in a ditch . . . gullies and gaps in hedges . . . Hank out strolling . . . 'Bloody shambles again!'

'Hullo, 4 Able. Hullo, 4 Able . . .' But 4 Able never did answer. And somewhere out on the ether, escaped pulses of radio carry the message on for ever – on, on through a void, reaching to where 4 Able is and will be ever . . . 'Hullo, 4 Able . . .'

Remember then! I hold on to the day that is now yesterday because that day is safe. In that day I live and do not die. Do not become mashed into a ball of writhing pain. So that day is mine. To hold on to. I turn my guns on the advancing field-grey masses

of sleep and fight to hold on to this little island of time, this melting iceberg of moments. Tomorrow is alien territory. No Man's Land . . . enemy country . . . a new St-Aignan. So I hold on by remembering while chill battalions of sleep rustle through the undergrowth of my mind, waiting to take me unawares, waiting to leap, waiting to explode vast mines of nightmare . . .
     'Hullo 4 Able' . . . I wonder where his spirit has gone, playing imaginary drums . . . little grey sacks in the woods . . . a pale German in a trench, nameless and for ever unmoving . . . you've mashed up a Jerry . . . mon Kamerad Heinrix, smoken Sie that . . . a rugby scrum of cooks, fitters, signallers, armourers, clerks . . . laughing and crying at the same time . . .
     'Hullo, 4 Able. Can you not . . .' trying to keep in touch . . . trying . . . 'Oboe 2, Nasties, right front' . . . walked all the way from Alamein . . . keep away from them kipper-smoking furnaces . . . 41 hours, 41 minutes, 41 seconds . . . sounds like rats' claws scratching on the side of the tank . . .
     Bale out! Bale out! Tally-ho, Tiger! Come in 4 Able! 4 Charlie has brewed! Oh God! Oh God! Hullo 4 Able 4 Able 4 Able are you there? . . . will you ever be there? . . . any more? . . . radio pulses from over the world's edge, the universe's edge, oblivion's edge . . . trying to keep in touch . . .
     You're not asking me to shoot a *cow*? . . . a man, yes . . . Oh 4 Able, can you not hear me . . . 4 Able . . . 1 Charlie . . . Roger 3 Baker . . . That's *US* . . . Roger 3 Baker . . . answer, can't you? . . . my hands frozen . . . cannot press . . . cannot speak . . . cannot halt the pulse of radio, speeding away, away from me, speeding for ever through the empty unknown wastes . . . oh, my God, answer, shout, scream . . . calling for those who are trying to keep touch . . . through the gloom . . . past innumerable worlds . . . forever night . . . beyond . . . Oh, 4 Able . . .
     'No trace of 'em. Not even a hand to shake goodbye to, like you found in the old trenches . . .' . . . hark! listen! silence! . . . 4 Able? Is that us? . . . a pulse . . . for ever more . . . trying . . .
     Oh, hello, 4 Able report my . . .
     Hello 4 Able . . . hands frozen . . .
     4 Able . . . cannot . . .
     4 . . .
     4 give them, Father . . .
     4 they know not . . .
     4 Able . . .
     trying to keep in . . .
     trying . . .